100 ARTISTS

OF THE WEST COAST II

TINA SKINNER

Schiffer Publishing Ltd

4880 Lower Valley Road Atglen, Pennsylvania 19310

Covers and book designed by: Bruce Waters
Type set in Aldine 721 BT

ISBN: 978-0-7643-3271-5
Printed in China

Schiffer Books are available at special discounts for bulk purchases for sales promotions or premiums. Special editions, including personalized covers, corporate imprints, and excerpts can be created in large quantities for special needs. For more information contact the publisher:

Published by Schiffer Publishing Ltd.
4880 Lower Valley Road
Atglen, PA 19310
Phone: (610) 593-1777; Fax: (610) 593-2002
E-mail: Info@schifferbooks.com

For the largest selection of fine reference books on this and related subjects, please visit
our web site at **www.schifferbooks.com**
We are always looking for people to write books on new and related subjects. If you have
an idea for a book please contact us at the above address.

This book may be purchased from the publisher.
Include $5.00 for shipping.
Please try your bookstore first.
You may write for a free catalog.

In Europe, Schiffer books are distributed by
Bushwood Books
6 Marksbury Ave.
Kew Gardens
Surrey TW9 4JF England
Phone: 44 (0) 20 8392 8585; Fax: 44 (0) 20 8392 9876
E-mail: info@bushwoodbooks.co.uk
Website: www.bushwoodbooks.co.uk

Contents

Introduction

In the many months that it took to assemble this group of wonderful artists, so much has come to the fore. We've brought together living artists who were at the forefront of revolutionary new expressions in the 1960s and 1970s and are still plying their trade today, as well as emerging artists, both young and old, who are sharing their voices and visions in gallery exhibitions on the West Coast and beyond. Sadly, though, we've watched the world in which these visionaries exhibit shrink. In the course of economic toil, galleries have been closing their doors, their venues forever lost both to the artists and to the communities they benefit.

It is truly an honor to be able to represent these artists in this lasting, permanent form. The goal in publishing this volume is to provide a reference that will serve this and future generations in identifying influential artists, and to add value, both intrinsic and financial, to their work. The publisher, the artists, and the galleries herein hope that you'll find old favorites along with new artists to love. And that you'll become one of the special and crucial supporters of their efforts.

The artists selected for this book have been chosen from up and down the West Coast, from Vancouver to San Diego, and arranged alphabetically, along with the names of galleries that represent them. Their personal website, if they have one, is given with the Index. The galleries are listed in the back of the book, and eagerly await your call. Their websites offer a wealth of information about these artists and others you will enjoy.

I hope you agree with me that a book offers an experience like no other, one that can be revisited time and gain, and shared at appropriate moments when the conversation summons it off the shelves. In this volume, words have been limited in order to keep the focus where it should be – on the work. Still, together with the pictures, the artist statements and histories tell stories of passion, obsession, joy, and bewilderment. There are brief summaries of old favorites and their accomplishments, and for those searching for something new there are plenty of fresh faces to reinvigorate your enthusiasm.

Tony Angell

Foster White Gallery / Gerald Peters Gallery / Spanierman Gallery

While studying English at the University of Washington, Tony Angell fed his love of nature sketching bird life in the Northwest. Upon graduation, he was signed with the first gallery he walked into, Foster-White, and his career as a painter and sculpture was launched.

For me, the character of a place is defined as much by the life there as it is by the configurations of shapes, smells, and sounds. In nature it is often the spirit of the animal that memorializes where I've been and what I remember of it. My sculpture, to a degree, is a tangible realization of memory – a "touchstone" that over time is a measure of the quality of my moments in places I've been. Again, for me, these spirit companions are guide posts in the endless search for the understanding of oneself.

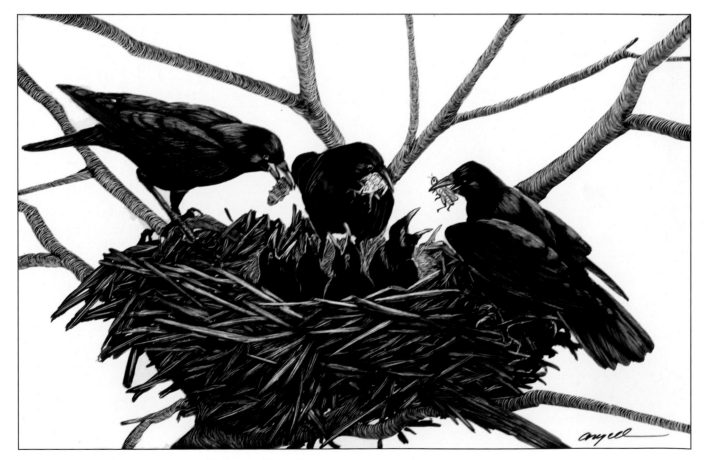

Crow Pair and "Helper" at Nest, 2006. Clayboard, 7" x 11".

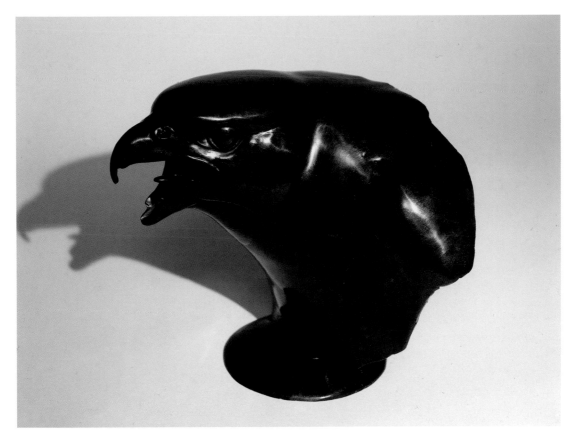

Black Gryflacon 3/20, 2005. Bronze, 8.3" x 6.8" x 8".

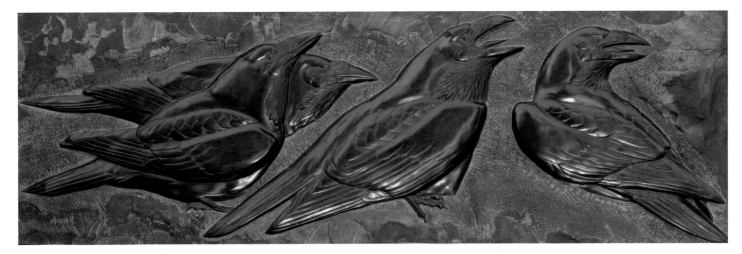

JPGRaven's Wall 1/3, 2007. *Bronze*, 18" x 44".

Tony Angell

Kathy Aoki

Swarm Gallery / Smith Andersen Editions

Kathy Aoki received her M.F.A. in printmaking from Washington University in St. Louis in 1994. For the past 15 years, Aoki has exhibited her work in local, national, and international venues. You can find her prints and artist books in numerous permanent collections such as the Fine Art Museums of San Francisco, the Harvard University Art Museums, the New York Public Library, and the City of Seattle. She is currently an Assistant Professor of Art at Santa Clara University.

I am a sneaky feminist. I use humor, as well as familiar visual formats such as historical illustrations and Japanese cartoon styling, to lure the viewer into the work. Once I have the viewer's attention, I impart my gender-agenda. For my current body of work, I re-envision history, recreating documents and illustrations with an eye to the beauty myth. Past art series include the "Construction of Modern Girlhood," a visual allegory wherein teddy bears represent girls manipulated by the media, and "Women with Tools (as a phallic metaphor)."

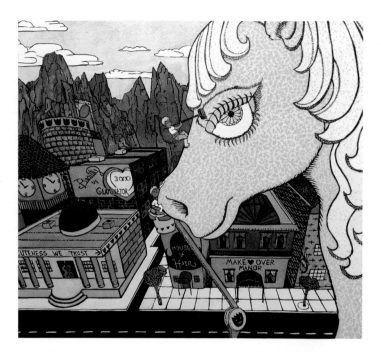

Pink Granite, 2007. Two-plate Linoleum cut with watercolor, 14" x 15". *Courtesy of Swarm Gallery, Oakland.* Part if the Construction of Modern Girlhood series, this image depicts a "pretty pony" monument being polished by bear workers. The city buildings reflect the media's pressure on girls.

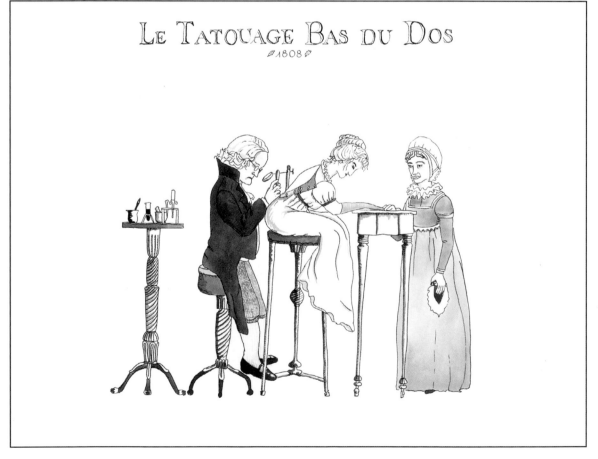

Le Tatouage Bas du Dos (or "Lower Back Tatt"), 2009. Pen and ink with wash, 9" x 12". *Courtesy of Swarm Gallery, Oakland.* Part of current series of mock historical works addressing the beauty myth.

Battle of Kawaii, 2008. Mixed media on wood, 8" x 18"x 14". *Photo by David Pace, Courtesy of Swarm Gallery, Oakland.* Battle scene comprised of shaped, painted wood pieces that are mounted onto the wall at different depths. Imagery includes characters from my Construction of Modern Girlhood Series.

Battle of Kawaii (detail), 2008. Mixed media on wood, 8"x 18"x 14".
Photo by David Pace, Courtesy of Swarm Gallery, Oakland.

Kathy Aoki

Laura Ball

**Swarm Gallery / Peter Miller Gallery /
Morgan Lehman Gallery**

Laura Ball lives and works in San Diego, California. She received her MFA in painting from University of California, Berkeley in 2004. The characters in her watercolors and oil paintings are represented by her sisters, her mother, and herself often engaged in play-fighting, struggling against a torrent of water, or battling swords. Joseph Campbell's *The Hero With a Thousand Faces* provides a road map for guiding Ball's heroines through tests and rituals, across thresholds of transformation and rites of passage.

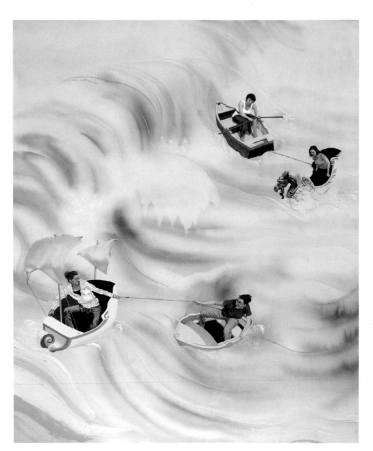

Tug Boats, Journey Across the Sea, 2008. Oil on canvas, 70" x 57". *Courtesy of Swarm Gallery, Oakland, California.*

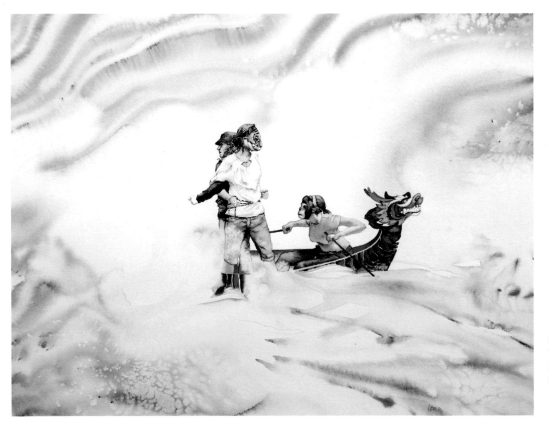

Crossing the Siren's Sea, 2008. Watercolor on paper, 16" x 20"., *Courtesy of Swarm Gallery, Oakland, California.*

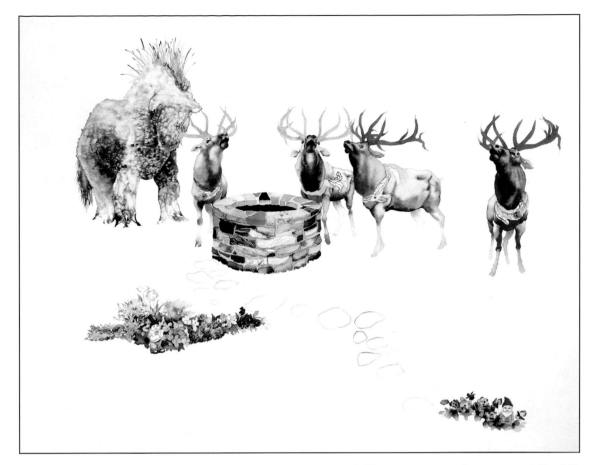

Calling, 2009. Watercolor on paper, 25" x 30".
Courtesy of Swarm Gallery, Oakland, California.

Path, 2008. Watercolor on paper, 20" x 16". *Courtesy
of Swarm Gallery, Oakland, California.*

Laura Ball

Ursula Barnes (1872-1958)

Ames Gallery

Ursula Barnes was born in Germany, but moved to San Francisco when she was about twenty years old. Some of her colorful history has been uncovered over many years, and reveals her to have been a dancer on the New York stage, the wife of an itinerant evangelist, a Hollywood actress, a parlor maid in Chicago, and finally a pastry cook in San Francisco. She only completed about thirty paintings and never found an audience for her art during her lifetime. Few knew of her paintings; even her family was unaware of her talent. Barnes' canvases were found in 1958, at the time of her death, by the San Francisco County coroner.

Barnes' painting, "Cat and a Ball on the Waterfall" was the inspiration, and the title, of an exhibit in 1986 at the Oakland Museum that surveyed 200 years of California folk painting and sculpture. In addition to the show at the Oakland Museum, only two other exhibitions of the work were ever presented, at now closed San Francisco galleries, in 1959 and 1961. Barnes' paintings are filled with melodrama. Fanciful costumed characters prance across her large canvasses. An occasional portrait, animal, or landscape peppers the collection. Much of the works are multi-faceted, energetic combinations of imagery — reminiscent of her colorful life.

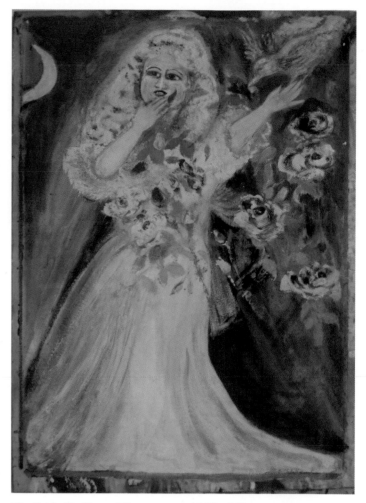

The Bride, No Date. Oil on canvas, 42.5" x 28". *Photo by Sherry Bloom, Courtesy of the Ames Gallery.*

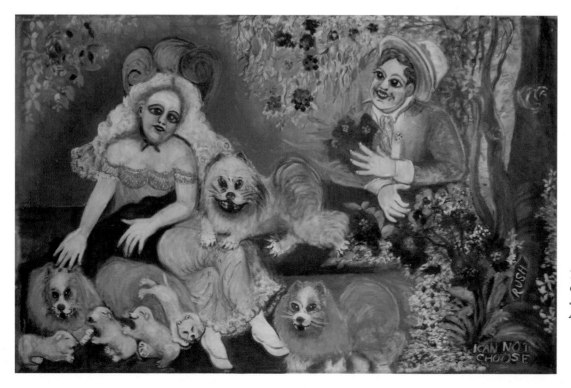

The Suitor, No Date. Oil on canvas, 40" x 60". *Photo by Sherry Bloom, Courtesy of the Ames Gallery.*

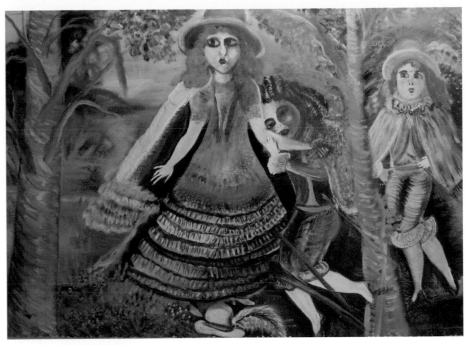

Goodbye, No Date. Oil on canvas, 39.5"
x 59". *Photo by Sherry Bloom, Courtesy
of the Ames Gallery.*

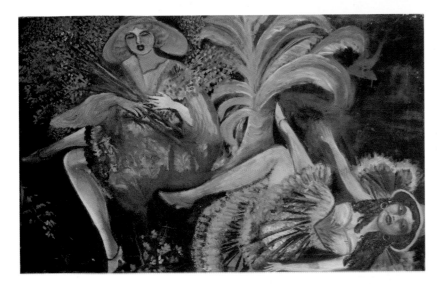

Bouquet and Two Girls, No Date. Oil on canvas, 34" x 53".
Photo by Sherry Bloom, Courtesy of the Ames Gallery.

Eve, No Date. Oil on canvas, 34" x
52.5" *Photo by Sherry Bloom, Courtesy
of the Ames Gallery.*

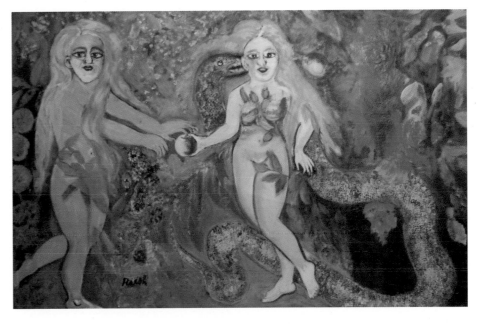

Ursula Barnes

Theresa Batty

G. Gibson Gallery / Imago Gallery

When I was thirteen years old I got my first camera and fell in love with film. That camera was an irresistible calling to photography and film-making. Then I saw films by Fellini and Kurosawa and was completely enchanted. I explored filmmaking and eventually segued to the use of photography in mixed media.

Photographic images are endlessly intriguing and I'm particularly attracted to older photos. Glass is a material I've worked with often but it is not the only material I'm drawn to. Rubber, lead, wax, yarn, copper, tar, and many others have a resonant beauty to me. I want the materials and the processes to reveal something that I couldn't anticipate.

I spend a lot of time on the water, and inspiration and ideas can come to me as I'm rowing in the morning. It's the liquid qualities of glass that I'm attracted to. Those liquid aspects provide optical distortions that I want to continue exploring. I like to use old glass and found materials. There is a genuine quality to things that have been around for a while that just can't be manufactured.

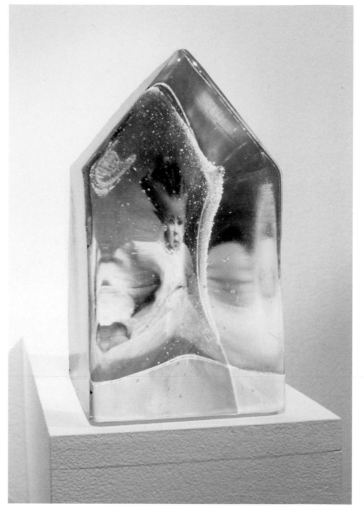

Haircut, 1999. Cast glass and photo emulsion. 6" x 3" x 5". *Photo by the artist.* This is from a series I made using antique portraits of children on thick house shaped cubes of glass with a convex surface that stretched and pulled the image.

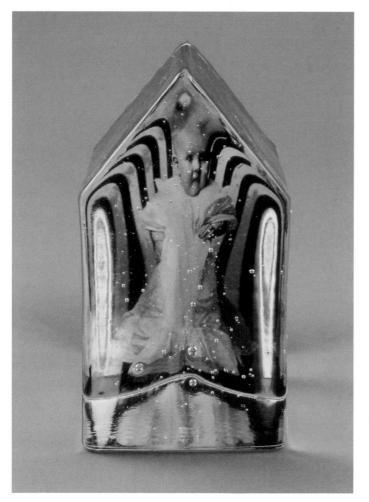

Baby with Stripes, 1998. Cast glass, photo emulsion, 6" x 3" x 5".

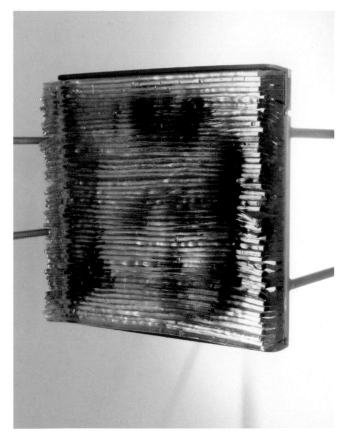

Tektite II Lavender, 2001. Fused glass, photo emulsion, steel, 7" x 7" x 10" post mounted. From a series I made while on residency at Bullseye Glass factory. I used the trimmed edges of sheet glass and fused them to a sheet of colored flat glass I then printed a photo on the flat glass.

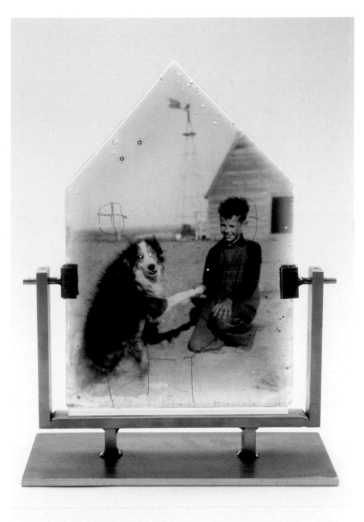

Bow Island, 1994. Cast glass, photo emulsion, steel, 14.5" x 10.5" x 4". *Collection of Mia McEldowney.* A sand cast glass piece with a photo of my father as a young boy.

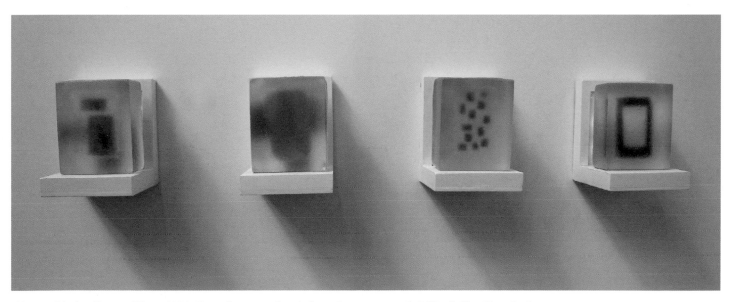

Chroma Blocks -Group of Four, 2006. Cast glass, powdered glass pigments, wood, 7.5" x 5.5" x 4" each. A series I started while teaching at a school on an island in the Baltic Sea. They are studies of light and color originally inspired by the variety of colors in water that I noticed while flying over Greenland.

Theresa Batty

Caryn Baumgartner

Tag Gallery

Caryn Baumgartner was raised primarily in southern California, spending her high school and early college years in Eugene, Oregon. She currently resides in Long Beach and works from her home studio.

My first memory of creating art was when I was three years old. Being three, my field of vision was pretty low. To my mother's horror, I proudly presented my first drawing of "bugs on the kitchen floor." As my mother was (and is) an impeccable housekeeper, I can only presume that my imagination was already taking form.

My subject matter has evolved a bit since then. My most recent work has been concerned with the dreams, fantasies and imaginary lives of childhood and our imperfect memory of it. I am exploring new palettes and methods with these pieces to help convey the experiences, fears and joys of childhood that in many cases linger on and still haunt us as adults.

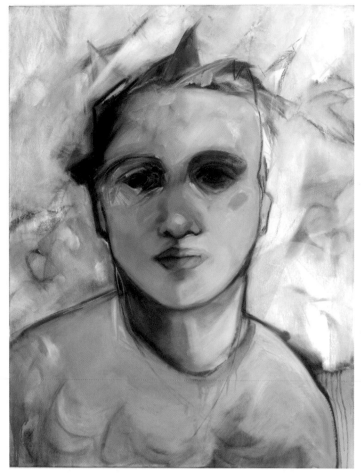

Boy, 2007. Mixed media on canvas; oil, wax, charcoal, 30" x 40". *From "Evidence of Being."* This portrait is of an imagined youth and is from "evidence of being," a body of work that explores the connection between dreams and consciousness, object and attainment.

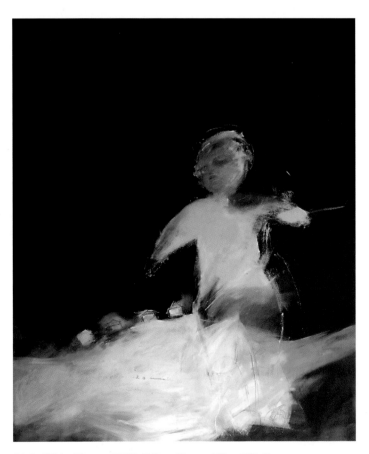

Little White Houses, 2007. Oil on linen, 48" x 58". *From "Evidence of Being."* This particular piece is about journey, naiveté and imagination.

Pinky, 2007. Oil on canvas, 20" x 24". *From "Evidence of Being."* Like many of the imagined portraits, Pinky underwent multiple transformations of gender, age and emotion throughout the painting process, much as we do throughout our own lives.

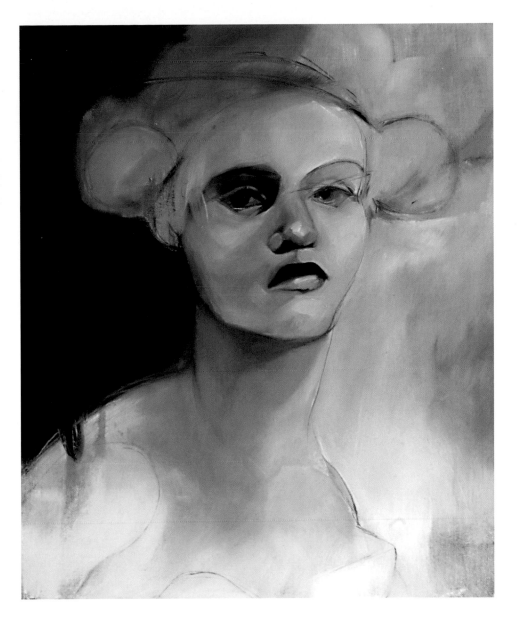

The Nest, 2008. Mixed medium on canvas, 61.25" x 37". *From "Evidence of Being."* The faceless, solitary figure holds a found object in a cold and silent forest. Thematically, the nest ended up becoming a complex metaphor for nurturing, abandonment, loss, and ultimately, hope.

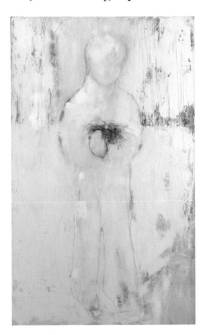

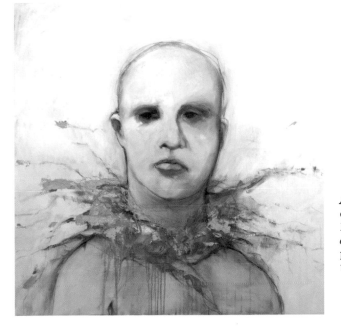

Adorn, 2008. Mixed media on panel; oil, wax, charcoal, 36" x 36". *From "Evidence of Being."* This imagined portrait is further exploration of object and self.

17

Caryn Baumgartner

Larry Bell

Frank Lloyd Gallery / Bernard Jacobson Gallery / Jacobson Howard Gallery

Larry Bell's work emerged in the mid-1960s and is often included in major exhibitions of Minimal art. His work was shown in the first exhibit to focus on Minimal art, "Primary Structures," at the Jewish Museum in 1966. Bell's work was also included in the seminal Museum of Modern Art exhibit, "The Responsive Eye" in 1965.

Bell is one of the most prominent and influential artists to have come out of the Los Angeles art scene of the 1960s, first showing at the Huysman Gallery, and then at Ferus. He became associated with the most important movements at the time, such as Light and Space art and what was described as "Finish Fetish" (a term coined by the late critic John Coplans).

Larry Bell was born in Chicago in 1939, and now maintains studios in Taos, New Mexico, and Venice, California. Having grown up in the San Fernando Valley, Bell attended Chouinard Art School in Los Angeles from 1957 through 1959, where he was a student of Robert Irwin. Bell's work is in public collections throughout the world, including the Museum of Modern Art, New York; the Art Institute of Chicago; the Solomon R. Guggenheim Museum, New York; and the Los Angeles County Museum.

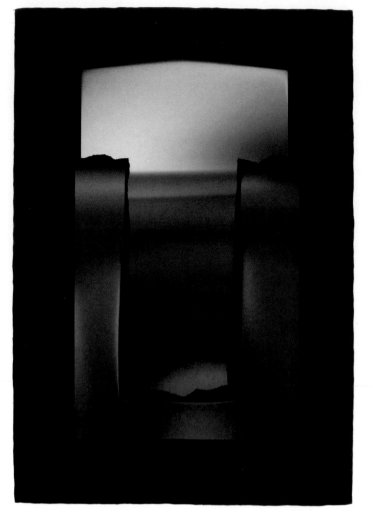

AAAAA 99 (2007) Mixed media on paper 47.25" x 32.75". *Photo by Alan Shaffer, Courtesy of the Frank Lloyd Gallery.* These dramatic collage works display an expansive spatial sensibility. Bell's illusionistic space is complemented by a dense array of color, achieved by his use of vaporized metallic particles on the surface of the collaged elements. All works are mixed media on paper, the next step in the artist's continuing and inventive process.

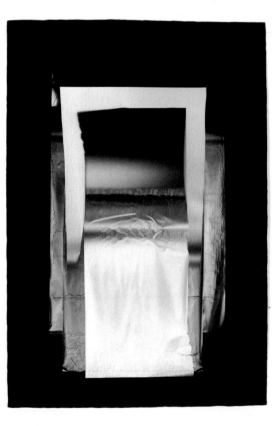

AAAAA 108, 2007. Mixed media on paper, 47.25" x 32.75". *Photo by Alan Shaffer, Courtesy of the Frank Lloyd Gallery.*

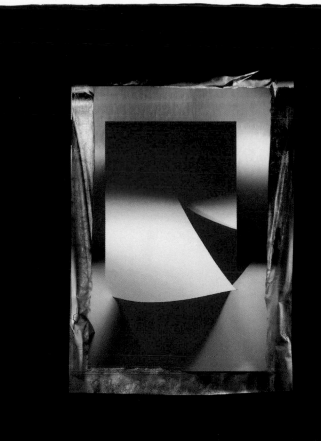

AAAAA 114, 2007. Mixed media on paper, 41.75" x 41". *Photo by Alan Shaffer, Courtesy of the Frank Lloyd Gallery.*

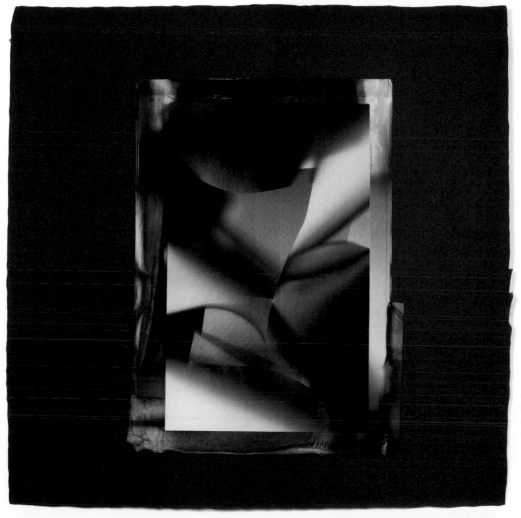

R 30, 2007. Mixed media on paper, 41.75" x 41". *Photo by Alan Shaffer, Courtesy of the Frank Lloyd Gallery.*

Larry Bell

Evan Blackwell

Benham Gallery

Evan Blackwell was born in New Rochelle, New York. He completed his Bachelors of Fine Arts with a focus in ceramics from Alfred University in 1999 and moved to Seattle, where he creates and exhibits his art. He worked as a potter for Orcas Island Pottery and has taught ceramics at the University of Washington, Pottery Northwest in Seattle, and The Haystack Mountain School of Craft in Deer Isle, Maine. He has assisted with a number of public art projects for Norie Sato since 2005. Evan was an Emerging Artist in Residence at the Pilchuck School of Glass in Stanwood, Washington, in 2003. In 2005, he was a finalist for the Seattle Art Museum's Betty Bowen award and a recipient of a PONCHO Special Recognition Award. In 2006 he received an Art Patch grant and in 2007 was awarded a residency at the Takt Kunstprojecttraum Residency in Berlin, Germany. Evan completed his Master of Fine Arts in ceramics at the University of Washington in the spring of 2008 and received the de Cillia Teaching with Excellence Award.

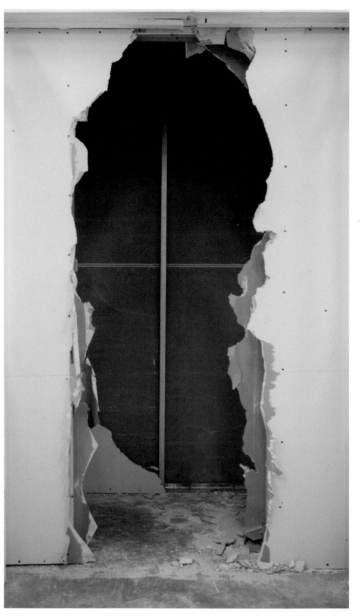

How Did We Get Here? Entrance, 2008. Sheet rock, steel studs, acrylic, video, sound & light projections, dimensions variable.

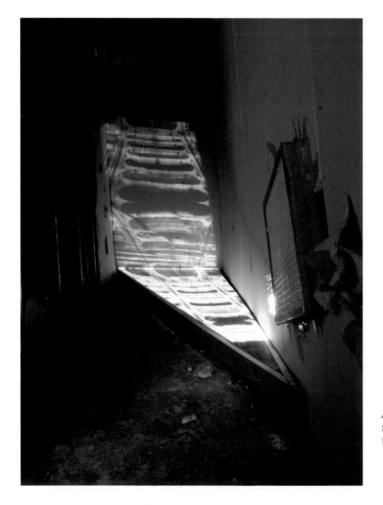

How Did We Get Here? (Reflection Room), 2008. Sheet rock, steel studs, acrylic, video, sound & light projections. dimensions variable.

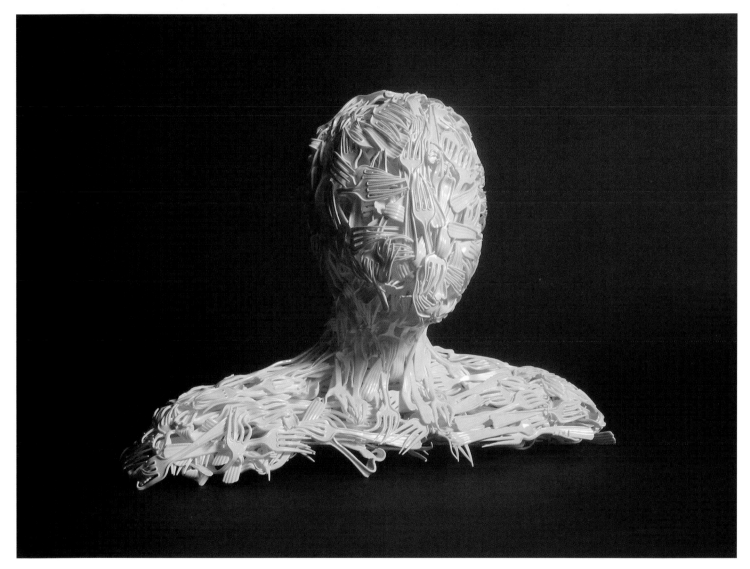

Disposable Hero, 2005, Plastic forks, 17" x 22" x 10".

Evan Blackwell

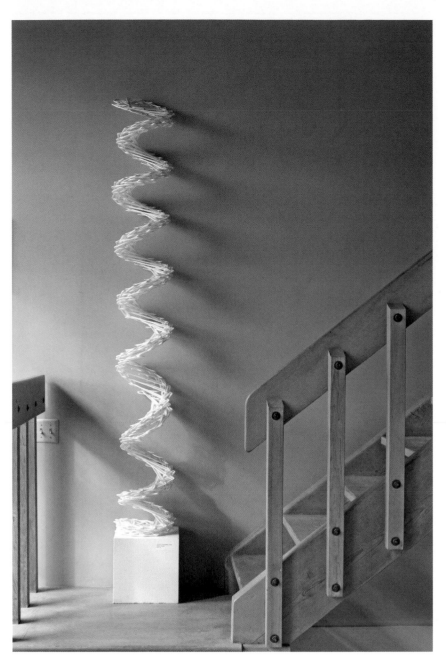

Spiral, 2006. Plastic hangers, 80" x 12" x 12".

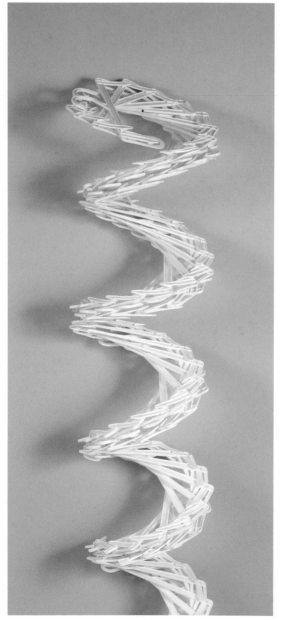

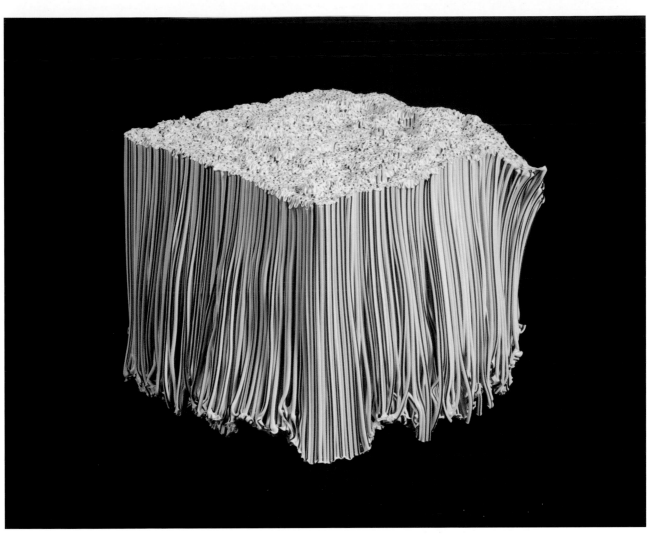

Unconscious Melt, 2005. Plastic straws, 8" x 7" x 8".

Evan Blackwell

Bratsa Bonifacho

Bau-Xi Gallery / Foster White Gallery / Herringer Kiss

Born and educated in Europe, Bratsa Bonifacho has worked and exhibited in Vancouver since the 1970s.

The source of my art is the comprehension and channeling of strong emotions stemming from observation, current events, or epiphanic memory: thoughts of environmental devastation; or blatant injustice; or peak moments of optimism and ecstasy. I see subjective awareness as the fuel of creative fire, and for a sustained body of work the emotive energy must be profound. I ride these obsessive crests like a surfer, until they subside in my consciousness. One cannot artificially rehearse, buy, or borrow this energy, which is one reason I cannot subscribe to popular generational or interest group issues of the day. My current series explores tensions between the logical, linear scripting of computer virus programs and their capacity for destruction. In the simplest terms, it imitates the effects of computer viruses and worms by scrambling letters and messages in large-scale oil paintings. This work carries the elegance of programming code. It also indicates the deep layers of chaos and confusion caused by viruses.

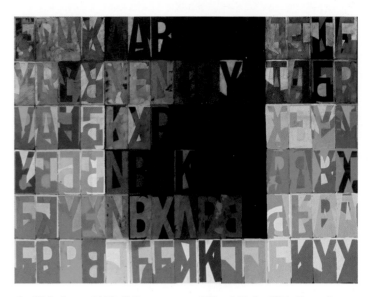

La Vida Loca, 2008. Oil on canvas, 42" x 54". La Vida Loca is from an ongoing series of grid-like paintings that I started in 1997 called Habitat Pixel. Through the use of letters and symbols I explore the tensions between the logical linear scripting of virus programs and their capacity for the massive destruction of our digital-dependent world.

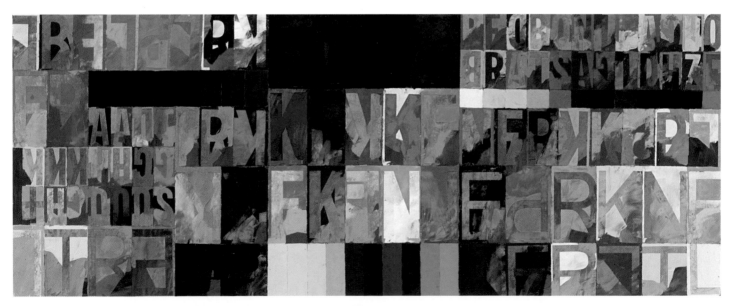

Nomina Attributti, 2008. Oil on canvas, 32" x 80". *Courtesy of Foster/White Gallery, Seattle.*
Another Habitat Pixel painting, Nomina Attributti, presents a more deeply layered, chaotic scenario of the destructive potential of computer viruses and worms.

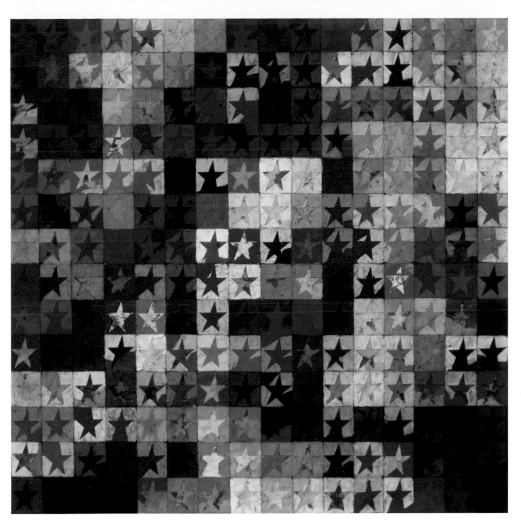

Annus Mirabalis, 2007. Oil on canvas, 54" x 54". Annus Mirabalis, which in Latin means "a year of wonders," also belongs to the Habitat Pixel series, but this time I used the star as a symbol of positive energy.

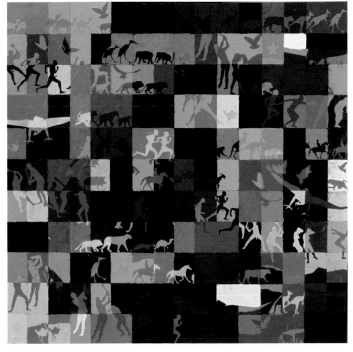

Kings Crossing, 2008. Oil on canvas, 54" x 54". This paintings is part of my new series, Human Farm, a play on the title of the book *Animal Farm* by George Orwell. In this painting I've used iconographic symbols of human figures and animals to symbolize the stress of the present world situation with humankind reverting to a primitive state.

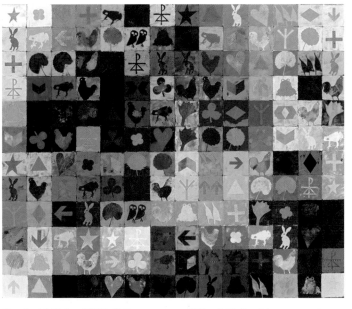

Poesia del Falso, 2008. Oil on canvas, 46" x 54". In this composition, allied to the Habitat Pixel series, I've used an array of icons in a colorful and playful way.

Bratsa Bonifacho

Ken Bortolazzo

Scott White Contemporary Art / Sullivan Goss, An American Gallery / Carl Schlosberg Fine Art

Born of the Santa Barbara sun, wind, and waves, Ken Bortolazzo's sculptures examine the dichotomy between object and nature. Substantial and delicate, his metal works can be a metaphor for both human sturdiness and frailty. He has collaborated with many prominent artists, including Julio Agostini, Kenneth Noland, and most importantly, George Rickey. During their twelve-year working relationship, Ken evolved from studio assistant to Rickey's acknowledged colleague. He remains a conservator of Rickey's work for the estate. Bortolazzo skillfully mastered the use of stainless steel and the custom designed pivots and bearings used in Rickey's renowned kinetic works. This valuable experience inspired Bortolazzo's own work, and his highly geometric shapes soon emerged with greater regularity; taking on a persona of their own. Today Bortolazzo's sculptures span many artistic modes, from small, intimate pieces and works of kinetic playfulness to large monumental sculpture. He brings aesthetics, science, mechanical skill and an illusionist's insight to his intricate, interlocking, geometric forms. His later, kinetic works of burnished perforated stainless steel, move and create a physical phenomenon known as optical interference patterns, a moiré effect. Bortolazzo's sculpture can be seen in regional galleries, museums, and public collections, including the Santa Barbara Museum of Art, the Museum of Outdoor Art, Denver, and Microsoft corporate headquarters, Seattle. His work is also collected and represented throughout the United States, England, Japan, and New Zealand.

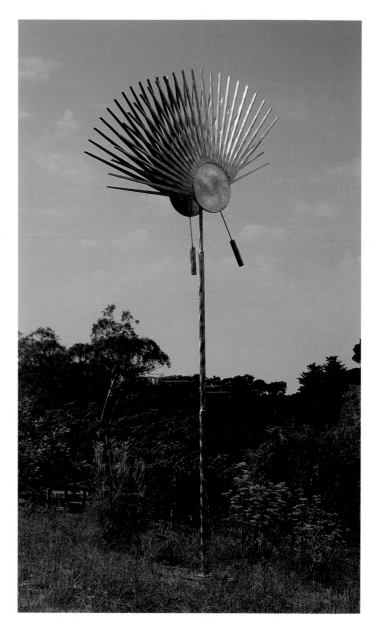

Estacas Large, 2006. Stainless steel, 171" x 86" x 86". *Photo by Ken Bortolazzo, Courtesy of Scott White Contemporary Art.*

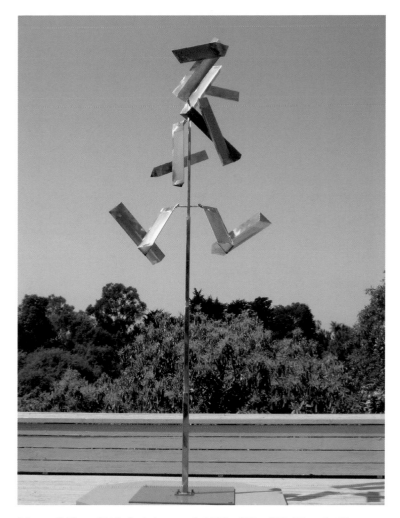

Mazzo di Fiore, 2005. Stainless steel, 120" x 50" x 50". *Photo by Ken Bortolazzo, Courtesy of private collection, Malibu, California.*

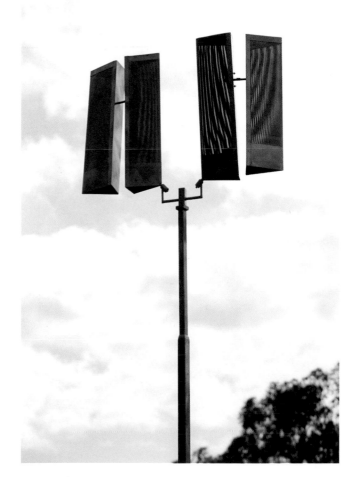

Quadraphenia, 2005. Stainless steel, 120" x 52" x 6" at rest. *Photo by Ken Bortolazzo, Courtesy of Scott White Contemporary Art.*

Christine Bourdette

Elizabeth Leach Gallery

Born in Fresno, California, Christine Bourdette received her BA in art from Lewis and Clark College in Portland, where she now works.

The compelling issue that has driven my work for over twenty years has been the paradox of the human condition: its ornery, goofy illogic and the fact that we are all in this together. I have expressed this fascination via the human form, its body language and its group dynamics. In the past, I have appropriated the tools we hold in our hands as metaphors for various dilemmas, then adapted and anthropomorphized animal imagery in order to hold up a mirror to ourselves. Recurring themes include mortality, transformation, mobility, and deception (both self-and otherwise). A turning point came in the early '90s, when I abandoned literal depictions of the figure and began to explore essences of our humanity in a more pared down, elemental form. Reducing and abstracting the figure to vessels of structure, volume, and skin begged metaphors of filling and emptying, harvesting, safekeeping, abundance, and greed – perhaps a reflection of the times. Another decade of organic progression has brought me around to the figure in its literal form again. The undercurrents, or in some cases the overt qualities, are variously dark, peculiar, vulnerable, and humorous.

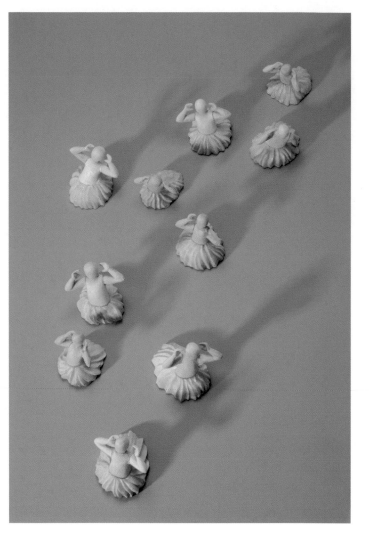

Listeners, 2007-08. Balsa wood, basswood, and epoxy resin, variable dimensions. *Courtesy of the Elizabeth Leach Galley.*

Whisper Campaign I, 2008. Charcoal, and watercolor on paper, 40" x 32". *Courtesy of the artist and the Elizabeth Leach Galley.*

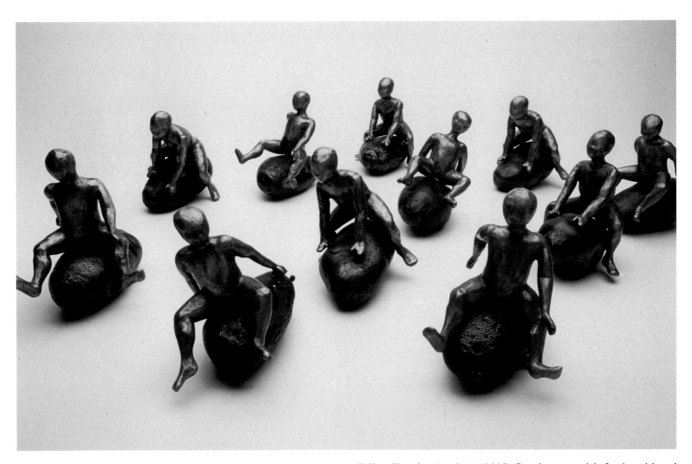

Fellow Travelers (various), 2005. Cast bronze with ferric acid and silver nitrate patina, 5.5" x 4" x 5.5" each, Edition of 3. *Courtesy of the artist and the Elizabeth Leach Galley.*

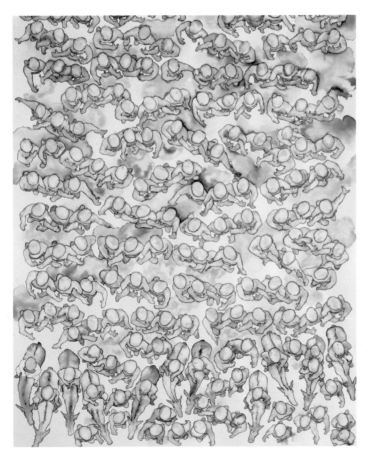

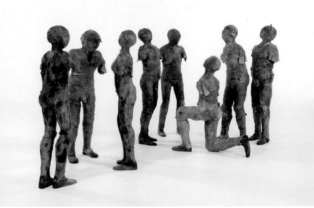

Asides, 2005. Leather, wax, pigment, wood, 43" x 13" x 9" each. *Courtesy of the artist and the Elizabeth Leach Galley.*

Tide, 2008. Ink on paper, 40" x 32". *Courtesy of the artist and the Elizabeth Leach Galley.*

Christine Bourdette

Joel Brock

Lisa Harris Gallery

My recent group of works includes pieces that are paintings of simple, rather conventional houses. I was in the grocery store buying soup, looked up to see Andy Warhol's "Can of Soup," and I thought to myself; 'How could he take a simple can of soup and describe the entire psyche of America?' This is what I have tried to do with my art. Instead of a soup can, I use little houses, the places we live –simple farm buildings and structures seen in our daily lives. In this way I hope to capture the essence of American life.

I grew up in the farm country around Carmel, California, and relocated to the Pacific Northwest because of the particular quality of light I found in the Skagit Valley. My studio is near a dike on the edge of a slough and my home is in the middle of farmland. One of the big influences in my development as an artist was Wayne Thiebaud, with whom I had the privilege of studying at University of California, Davis. My Californian roots are probably still evident in my approach to light and my tendency to deconstruct still life or landscape into essential elements.

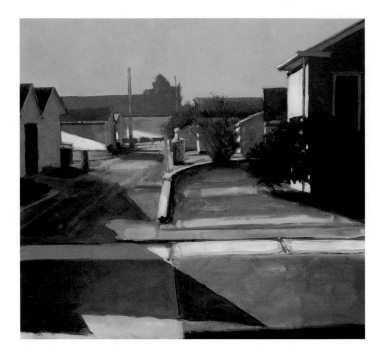

Alley Shadows, 2008. Acrylic on board, 36" x 38". *Collection of Patricia Stonesifer and Michael Kinsley.*

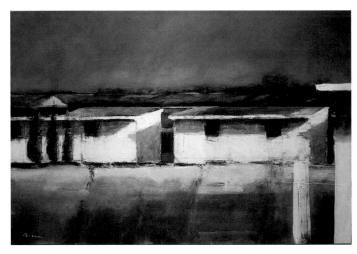

Bow Mill Migrant Camp, 2004. Acrylic, charcoal and pastel on mahogany panel, 30" x 44". *Collection of Eric Peterson and Barbara Pomeroy.*

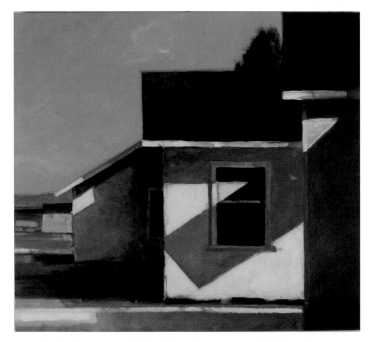

Houses of Edison, 2008. Oil on board 36" x 39.5". *Collection of Hilary Pennington.*

Italian Plums, Wine, and Brie, 2004. Pastel and charcoal, 9" x 9". *Collection of Robyn Thorson.*

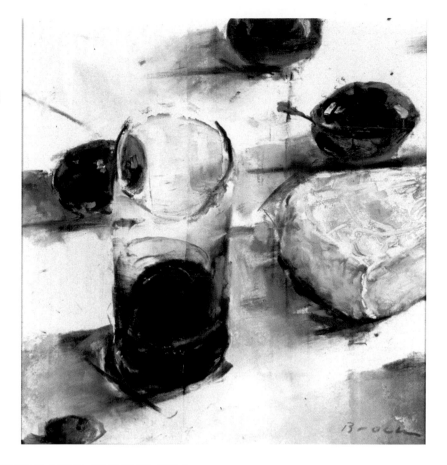

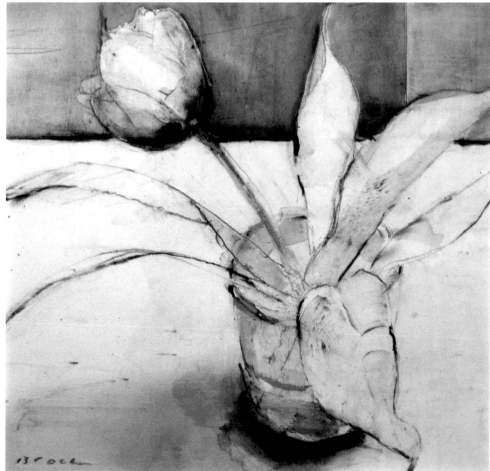

Still Life with Flower, 2008. Pastel and acrylic, 11" x 11". *Collection of Drew and Kayla Brodkin.*

Joel Brock

Christopher Brown

John Berggruen Gallery / Paulson Press / Edward Thorpe Gallery

Christopher Brown was born in Camp Lejeune, North Carolina, in 1951. He received his BFA from the University of Illinois at Urbana-Champaign in 1973 and his MFA at the University of California, Davis in 1976. He has held teaching positions at the University of California, Berkeley and is currently a professor of painting at the California College of the Arts. His work is represented in numerous museum collections including the San Francisco Museum of Modern Art, the Modern Art Museum of Fort Worth, and the Sheldon Memorial Art Gallery. Brown has been honored with several awards since the beginning of his career, including three National Endowment for the Arts awards. He currently lives and works in Berkeley, California.

The experience of painting is an experience of trying to bring up something in me, a kind of consciousness, a relationship to the world that's a visual experience that makes me think of my awareness of the world when I was four and five years old, when I was first interested in art.

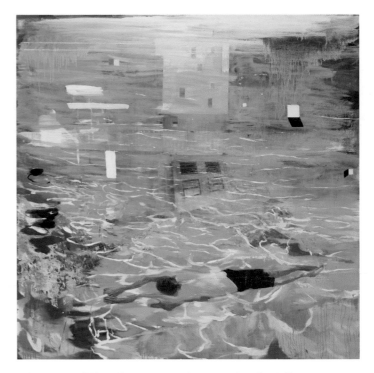

Diver, 2008. Oil on linen mounted on panel, 80" x 80". *Courtesy of John Berggruen Gallery.*

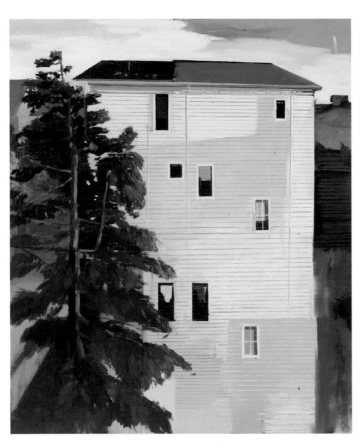

A First Study, 2008. Oil on linen, 48" x 40". *Courtesy of John Berggruen Gallery.*

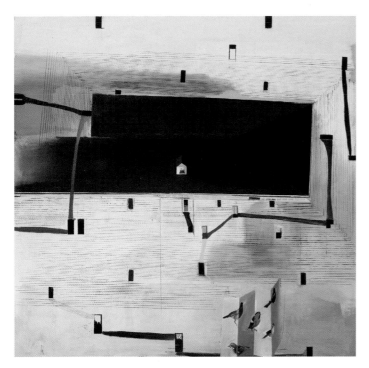

Flight Patterns in the Maze, 2008. Oil on linen, 80" x 80".
Courtesy of John Berggruen Gallery.

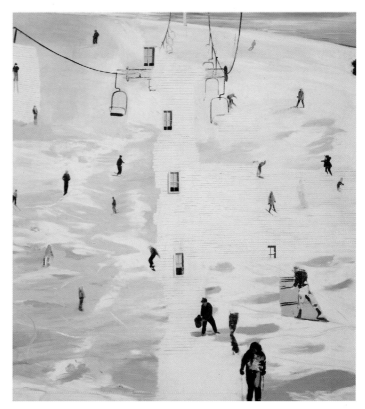

Mountain Home, 2008. Oil on linen mounted on panel, 85" x
75". *Courtesy of John Berggruen Gallery.*

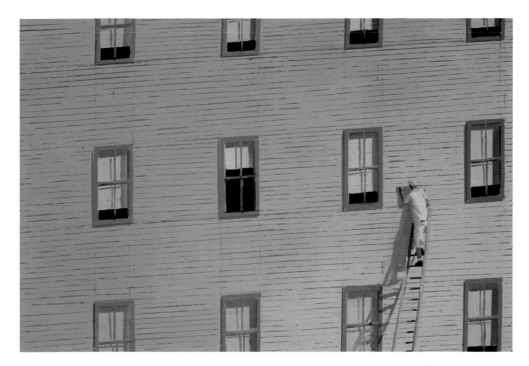

Painter, 2008. Oil on lincn, 30" x 45".
Courtesy of John Berggruen Gallery.

Christopher Brown

Joe Brubaker

Sue Greenwood Fine Art / Donna Seager Gallery / Selby Fleetwood Gallery

My sculptures and carvings involve a merging of passion, discipline, and abandonment. I attempt to give myself to the process of the work and follow or pursue it to completion. I'm interested in making work that is meditative, that balances between the associative energy of abstraction, and the narrative power of totem and effigy images.

My carvings are clothed by the associations the viewer brings to his/her confrontations with the work. I think of my sculptures as objects of contemplation. I hope that they are also sources of inspiration for those who live with them. My stylist models are Southwest Santos carvings, some American folk art and African carving, and Egyptian funeral effigy figures, as well as the sensibility in certain Japanese wood carvings. I hope to produce work that interacts responsively with the transcendent issues we confront, such as our ephemeral state of being, issues of decay and transformations, and of beauty. I am particularly interested in the paradox of spirit being contained within the fragile vessel of the physical body.

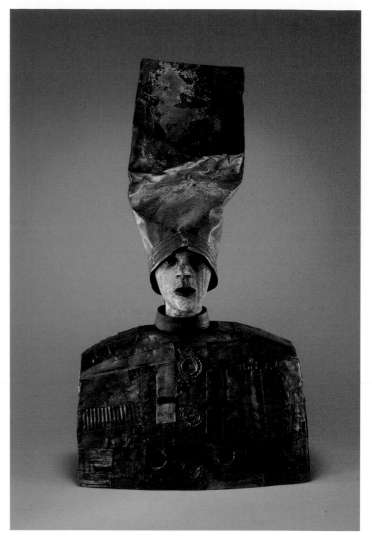

Oliver, 2006. Wood, acrylic paint & found objects, 26" x 15" x 6". *Photo by Black Cat Studios.*

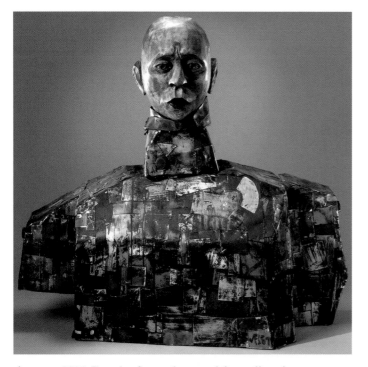

Augustus, 2007. Douglas fir, steel, enamel & acrylic paint, 30" x 28" x 10". *Photo by Black Cat Studios, Courtesy of Sue Greenwood fine Art.*

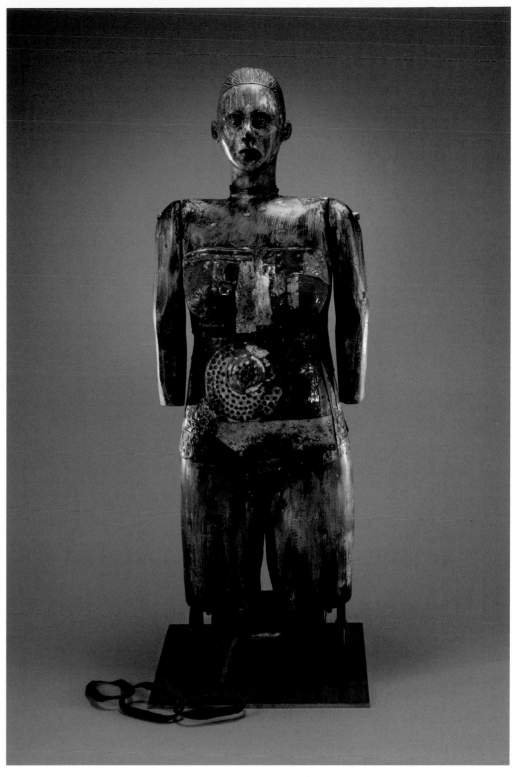

Trojan Woman #2, 2006. Wood, acrylic paint, metal & found objects, 35" x 12" x 3".
Photo by Black Cat Studios.

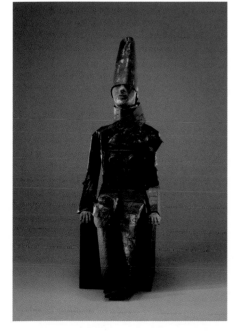

Charles #2, 2007. Wood, acrylic paint & found objects.
12" x 8" x 22". *Photo by Black Cat Studios.*

Joe Brubaker

Michael Brunswick

Anne Reed Gallery

It is not my way to use my art to hype a revolutionary image or attitude. I see art as a way of taking responsibility for my ambition and life's view. I have always been someone who strives to be the best that I can be and I have always had to work hard to achieve my goals. I create my work because I love it; my paintings are full of direct hand manipulations and chance operations.

That said I gain strength from my family and the human spirit of survival. I try to create art that reflects a sense of rebirth and regeneration using a high saturation of color and paint, which often appears wet (like pools of water) as a source of beginning and future without end.

Painting 45, 2005. Oil on canvas, 69" x 73". Photo by Kenneth Cawan, Courtesy of Anne Reed Gallery.

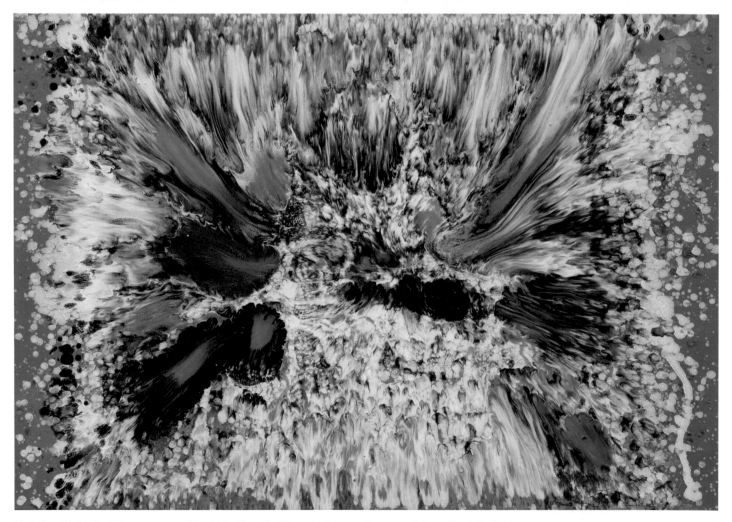

Painting 44, 2008. Oil on canvas, 69" x 99". Photo by Kenneth Cawan, Courtesy of Anne Reed Gallery.

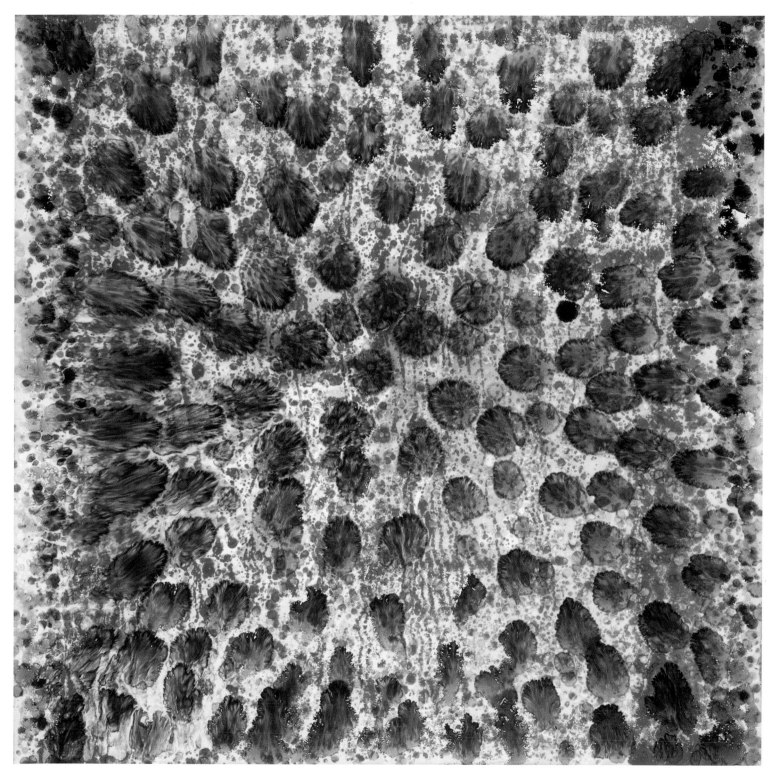

Painting 52, 2008. Oil on canvas, 78" x 78". Photo by Kenneth Cawan, Courtesy of Anne Reed Gallery.

Michael Brunswick

Drew Burnham

Bau-Xi Gallery

Even if a painter or sculptor, etc., can write well, I don't know why anyone would read an "artist's statement" about his work. It would be like meeting someone and having that stranger hand you a "person's statement" about himself.

Almost by definition, a painter's, etc., communication is his or her work. The person's job is making the work talk to those who would look. Just as with people whose presence you can feel, whose character you recognize immediately, a song which catches you without it's words, a real piece of artwork will engender a special feeling in you. As with great people, or great music, you will recognize your response when you see great works, no matter the genre, medium, content, color, or style. That is what counts. I would suggest that is all the communication one needs.

Head Of The Inlet, 2008. Oil and acrylic, 36" x 54". *Photo by Image This Photographics, Inc.* All kinds of lives are lived out in these places; weeds, trees, crabs and people among them.

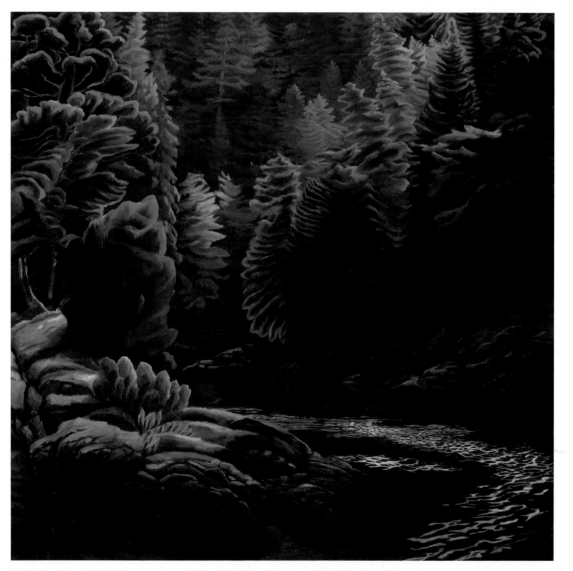

Inlet Evening, 2008. Oil on canvas, 48" x 48". *Photo by Image This Photographics, Inc.*

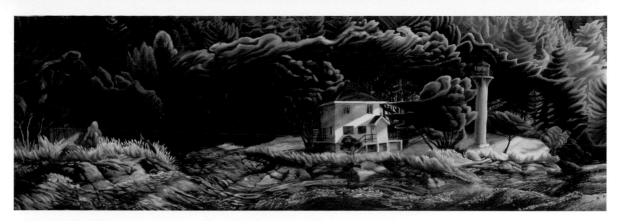

Mayne Light, 2008. Oil & acrylic, 36" x 108". *Photo by Image This Photographics, Inc.*
Past the light the sea onions float, rafts of them, moving in time with the trees.

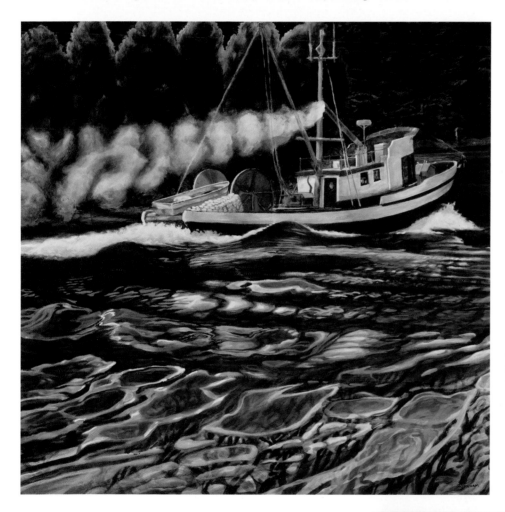

Out of the Grounds, 2008. Acrylic on
canvas, 36" x 36". *Photo by Image
This Photographics, Inc*

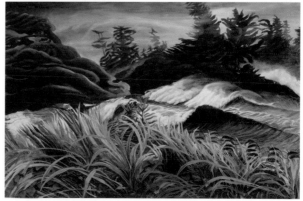

Waves in Cox Bay, 2008. Oil & acrylic, 36"
x 54". *Photo by Image This Photographics,
Inc.* If you stood long enough on the sand
out here, you too might be blown into
waves by the wind.

Drew Burnham

Squeak Carnwath

John Berggruen Gallery / Paulson Press / Pete Mendenhall Gallery

Carnwath maintains a studio in Oakland, California, where she has lived and worked since 1970. Born in Abington, Pennsylvania, in 1947, she received her MFA from California College of Arts and Crafts in 1977 and has taught at the University of California since 1982. Carnwath was a SECA (Society for the Encouragement of Contemporary Art) award winner, given by the San Francisco Museum of Modern Art, in 1980 and received grants from the National Endowment for the Arts in 1980 and 1985. Her work is included many private and public collections, including the San Francisco Museum of Modern Art, the Brooklyn Museum, and the Oakland Museum.

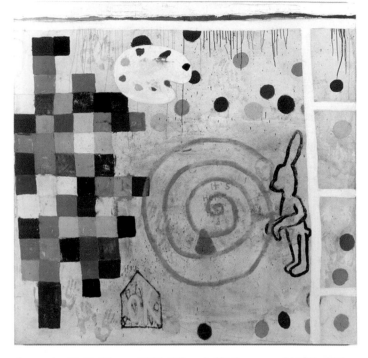

Attempting To Be Happy, 2000. Oil and alkyd on canvas, 70" x 70". *Photo courtesy of John Berggruen Gallery.*

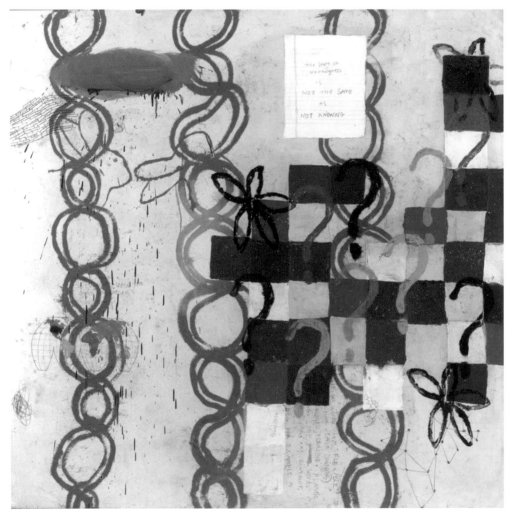

Eclipse, 2004. Oil and alkyd on canvas over panel, 50" x 50". *Photo courtesy of John Berggruen Gallery.*

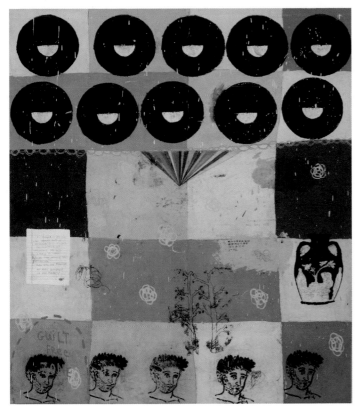

More Like US, 2007. Oil and alkyd on canvas, 75" x 65".
Photo courtesy of John Berggruen Gallery.

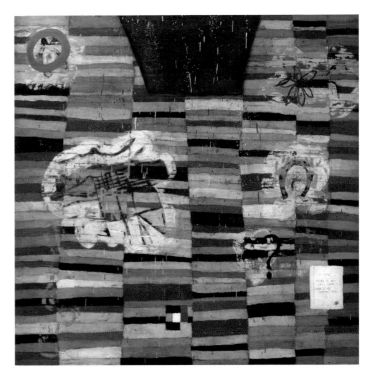

No Nothingness, 2004. Oil and alkyd on canvas over panel, 77" x 77".
Photo courtesy of John Berggruen Gallery.

Sox And Balls, 1991. Oil on canvas, 42" x 42".
Photo courtesy of John Berggruen Gallery.

Squeak Carnwath

Warren Chang

Hauk Fine Arts / Principle Gallery

Warren Chang was born in Monterey, California and graduated from the Art Center College of Design with honors in 1981. After twenty years working as a freelance illustrator, Chang transitioned to a career in fine art in 2002. Since then, his work has won many awards and has been featured in many publications, including the covers of *American Artist* and *International Artist* magazines. Primarily a figurative artist, Chang paints the human figure in contemporary environments, including interiors and outdoor genre subjects such as the fieldworkers of Monterey County where he grew up.

His paintings of interiors are largely biographical and include self-portraits and scenes of home and studio life. They are concerned with capturing an ambiance of mood and emotion through manipulation of light and environmental space. His paintings of fieldworkers, though contemporary in subject, are inspired by the works of the past. Influenced by the work of Francois Millet (1814-1875) and many 19th century Naturalist painters, he depicts the fieldworker in a honest and non-idealized way.

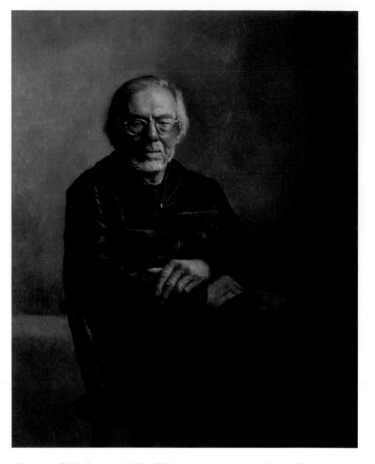

Portrait of Mr. Leeper, 2008. Oil on linen canvas, 30" x 24".

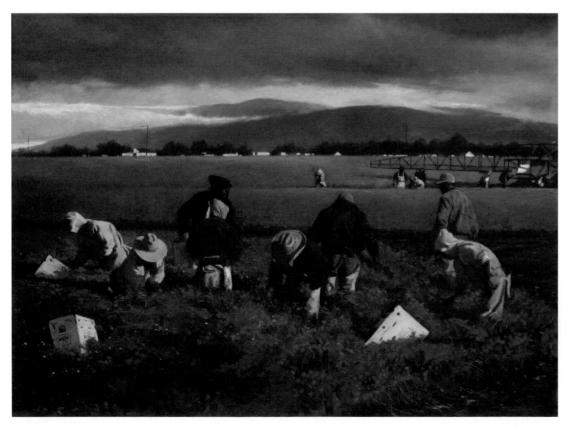

Approaching Storm, 2006. Oil on linen canvas, 30" x 40".

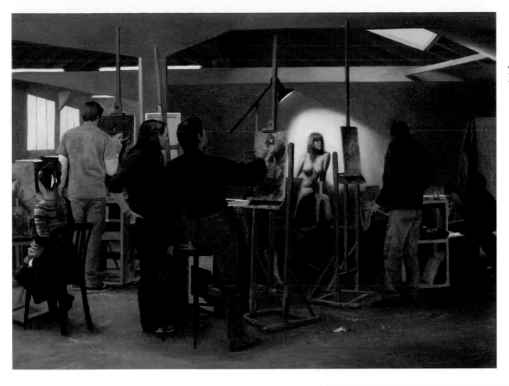

Studio At Chestnut, 2006. Oil on linen canvas, 30" x 40".

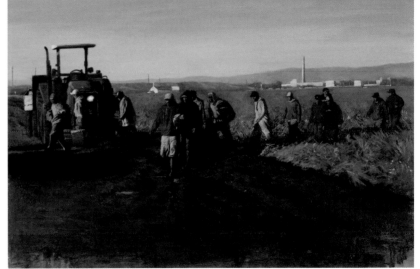

Days End, 2006. Oil on linen canvas, 20" x 30".

Father and Son, 2007. Oil on linen canvas, 24" x 36".

Warren Chang

Giuseppe "Pino" Cherchi

Susan Woltz Gallery

A resident of Washington State since 1998, Pino Cherchi has worked with a variety of Northwest glass artists on many different projects over a span of twenty years. He exhibits his sculptures in Europe and the United States.

My work is designed with color and movement to draw the viewer in creating an environment for reflection and wonder. Many of my pieces reflect architectural forms that exist in different cultures; these forms contain fundamental shapes. I play with color, texture, opacity, and translucence to personalize each piece. Other pieces reflect natural forms and patterns. My inspirations are global. I have always been inspired by the rawness and simplicity found in the African and Native American cultures. The Asian culture has been a rich source of material for me as well. Some of my more recent work has been a result of experiencing the earthy, dense, colors and natural textures of the Pacific Northwest for the first time. Over the years I have developed my own unique art style using different glass media. Some artists who have inspired my work, were Alexander Calder, Wassily Kandinsky, Joan Miro', Gio' Pomodoro, and Antine Nivola.

Artists Meditation Garden, 2008. Glass, metal, 38" x 19".

Artists Garden II, 2008. Glass, metal, 70" x 19".

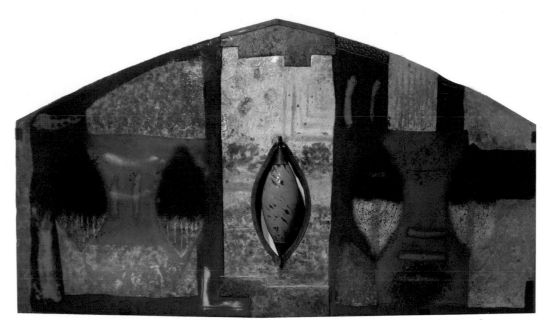

Casa, 2008. Glass, metal, 19" x 38".

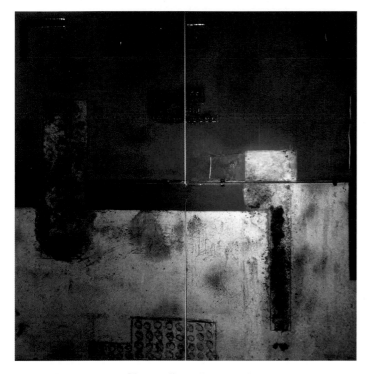

Garden Series I, 2008. Glass, 40" x 40" (4 panel).

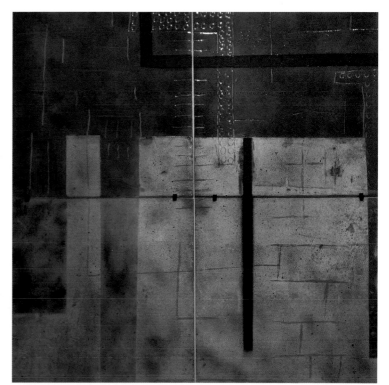

Artist's House, 2008. Glass, metal, 70" x 19".

Giuseppe "Pino" Cherchi

Linda Christensen

Sue Greenwood Fine Art / J. Cacciola Gallery

With a bachelor of arts from the University of California, Santa Cruz, Linda Christensen's career has blossomed, with numerous solo and group exhibitions, corporate acquisitions, and features in major art magazines including *American Art Collector*, *Southwest Art*, and the *LA Times*.

I get a feeling of freedom and exhilaration when I am in the middle of painting: layering, squishing, pushing, and playing as if I'm in a deep, cool, thick, mud puddle and I can stay as long as I want! Paint that obscures, shapes that appear then disappear, color that seems to move to silent music, rhythmic brush strokes that exhilarate my senses…aah! The mysteries of the composition take me prisoner and I go willingly!

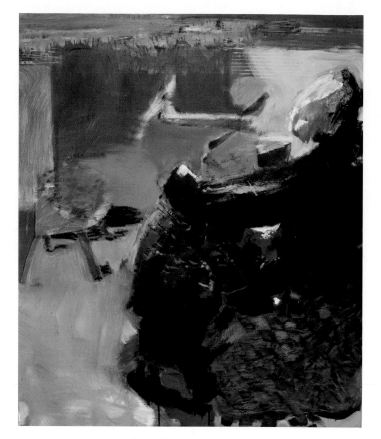

Early for Lesson, 2008. Oil on linen, 36" x 30". *Courtesy of Sue Greenwood Fine Art.*

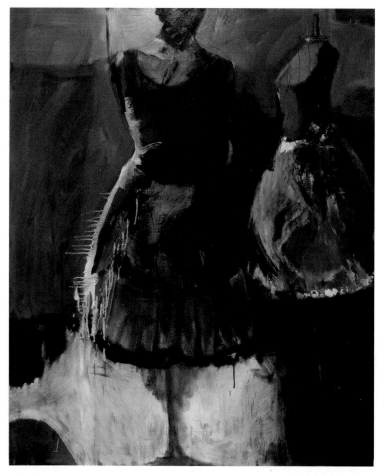

Extra Dress, 2008. Oil on linen, 60" x 48".

E, F, G, 2008. Oil on canvas, 40" x 30".

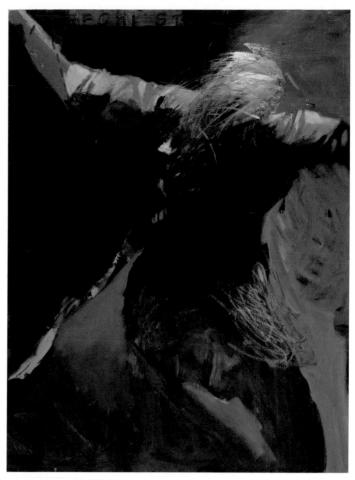

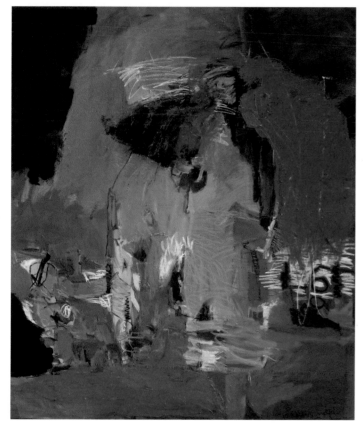

Language, 2007. Oil on canvas, 72" x 60".

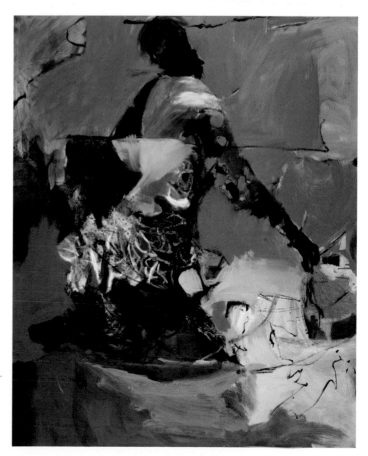

Meridian, 2008. Oil on canvas, 60" x 48".
Courtesy of Sue Greenwood Fine Art.

Linda Christensen

Judy Cooke

Elizabeth Leach Gallery

My painting has evolved from materials that have included canvas tarps, lead, copper, charcoal, and oil paint. From the past to the present, my concerns are form, scale, and the relationship of boundaries or edge to an inside shape. For the past fifteen years, oil paint on wood has been my primary method of working. Reflecting on the difference between sculpture and painting led me to a territory between the two disciplines. I wanted to make an uneasy object, one that offered some aspect of both disciplines, but an object that was still a painting. By the mid 1990s I was having forms built that resembled the shapes contained within my paintings. What was inside became the outside.

These asymmetrical forms allow me to create irregular grids, or stack one form on top of another to build an entire shape from individual parts. The work of finding an image remains a challenge; and involves, until very recently, a great deal of scraping and painting out before there is any degree of satisfaction with the remaining image. My forms are altered and reinvented until they arrive at a place where they sit, with or without comfort.

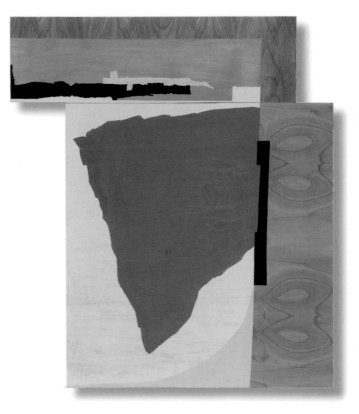

Map/Coastline, 2005. Oil and alkyd on wood, 47" x 40.25" x 2". *Courtesy of the artist and the Elizabeth Leach Gallery.*

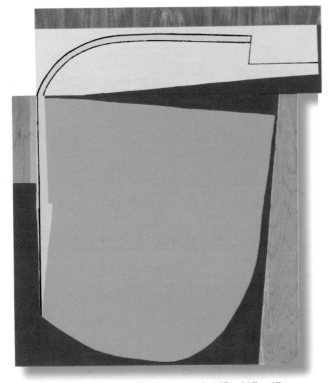

Breaker, 2005. Oil and alkyd on wood, 45" x 39" x 2". *Courtesy of the artist and the Elizabeth Leach Gallery.*

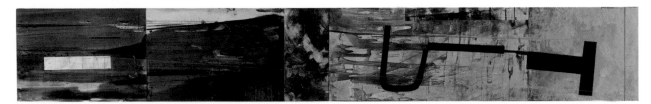

Wave, 2008. Aluminum and oil on wood, 11" x 72" x 2". *Courtesy of the artist and the Elizabeth Leach Gallery.*

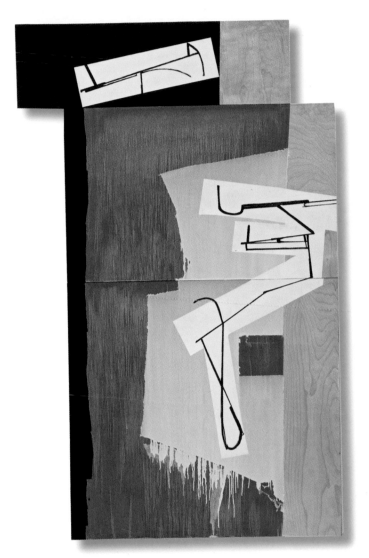

Veil, 2007. Oil on wood, 68" x 42" x 2". *Courtesy of the artist and the Elizabeth Leach Gallery.*

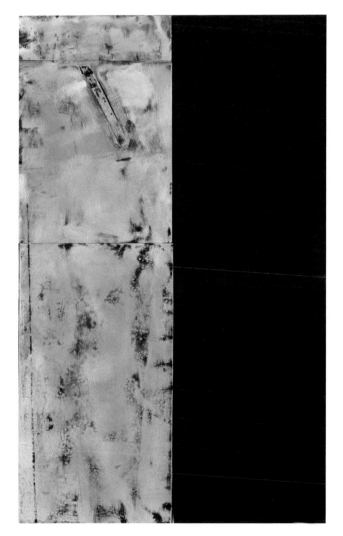

Bolt, 2007. Rubber, aluminum and oil on wood, 36" x 22" x 2". *Courtesy of the artist and the Elizabeth Leach Gallery.*

Judy Cooke

Tom Cramer

Laura Russo Gallery

Portland artist Tom Cramer graduated from the Pacific Northwest College of Art in 1982 and then studied at the Pratt Institute in New York. He has shown his work since the mid-1970s and has been included repeatedly in the Portland Art Museum's Oregon Biennial. His work is included in the collections of Boise Art Museum, Portland Art Museum, University of Portland, and Whatcom County Museum of Art in Washington. His commissions include costume and set design for the Oregon Ballet Theater and Ballet Pacifica. His distinctive painted designs can be seen on murals and vehicles around Portland.

My recent work includes both painted wood carvings and paintings with wood burning. Both techniques allow me to explore the many nuances of semi-abstract line and color. The most recent development in my work is exploring the practice of wood burning. This technique allows a more focused attention to line and the development of pattern, and can take many months to create. It slows down my creative process into a meditative state. The hypnotic intensity of this creative process leads to an emotional honesty and an abstract spontaneity, much like singing or playing music.

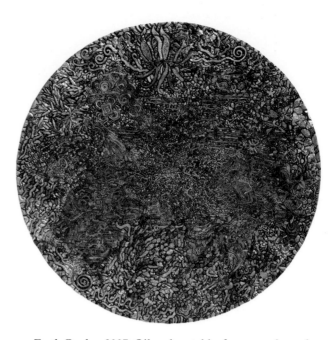

Earth Garden, 2007. Oil and metal leaf on carved wood relief, 47" diameter. *Photo by Ness-Pace.*

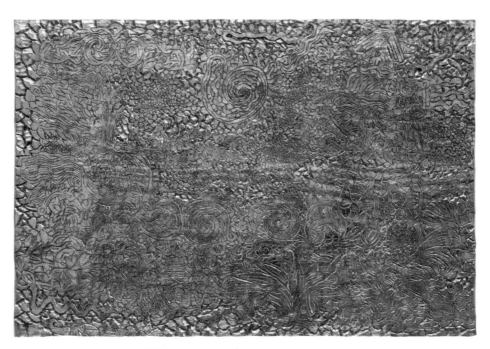

Iridescent Landscape, 2007. Oil and metal leaf on carved wood relief, 23" x 34". *Photo by Ness-Pace.*

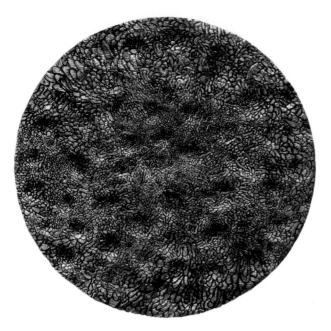

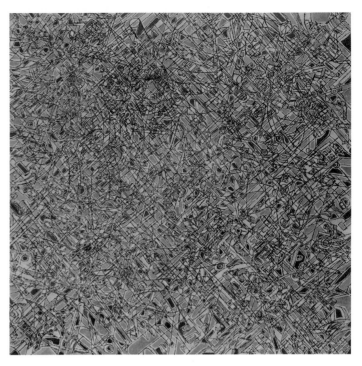

Moonlake, 2007. Oil on carved wood, 56.5"
diameter. *Photo by Ness-Pace.*

New Architecture, 2006. Oil and wood burning on birch plywood,
53.5" x 53.5". *Photo by Ness-Pace.*

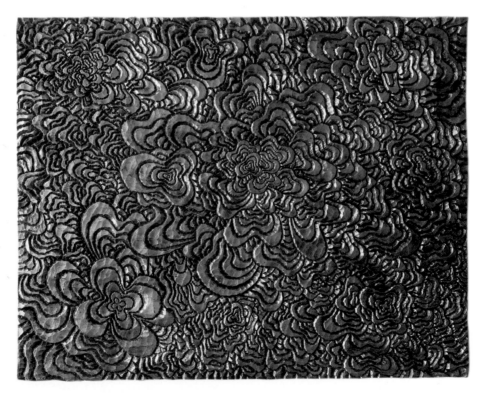

Pipe Dreams, 2007. Oil and metal leaf on carved wood relief, 27.5" x 35".
Photo by Ness-Pace.

51 Tom Cramer

William Glen Crooks

Scott White Contemporary / E.S. Lawrence Gallery

I paint landscapes, cityscapes, and figures.

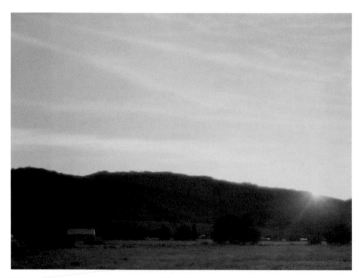

Vesper, 2008. Oil on canvas, 36" x 48". *Photo by Jeff Lancaster Photography, Courtesy of Scott White Contemporary Art, San Diego, California.*

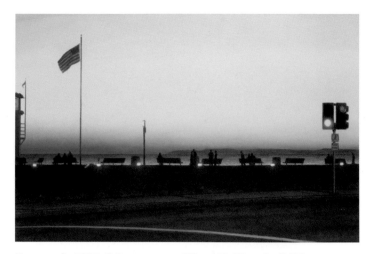

Promenade, 2007. Oil on canvas, 40" x 60". *Photo by Jeff Lancaster Photography, Courtesy of Scott White Contemporary Art, San Diego, California.*

Pacific Crossing, 2008. Oil on canvas, 50" x 70". *Photo by Jeff Lancaster Photography, Courtesy of Oceanside Museum of Art, Oceanside, California.*

Bistro, 2008. Oil on canvas, 48" x 72". *Photo by Jeff Lancaster Photography, Courtesy of Scott White Contemporary Art, San Diego, California.*

Mystique, 2008. Oil on canvas. 48" x 60". *Photo by Jeff Lancaster Photography, Courtesy of private collection, Hannover, Germany.*

William Glen Crooks

Drew Daly

Greg Kucera Gallery

Exploring issues of presence, absence, destruction, and reconstruction, Drew Daly begins simply with a readymade object, typically a piece of furniture, plywood, or a photograph. Then breaks, cuts, slices, or otherwise disassembles the object. From the remains, he painstakingly reconstructs the object in a different configuration, creating an entirely new object that contains remnants of the original object's use or appearance.

By altering objects which are experienced on a daily basis as routine, I hope to create a moment of recognition in which the viewer is challenged to question assumptions of their daily surroundings.

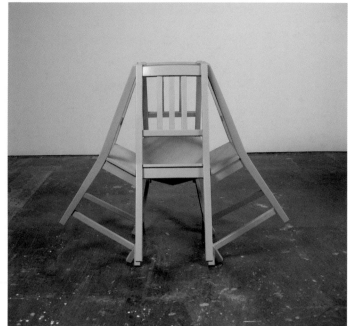

Fourlean, 2006. Four wood chairs, Bondo and lacquer, 47" x 47" x 40". *Courtesy of collection of Alexander and Rebecca Stewart.*

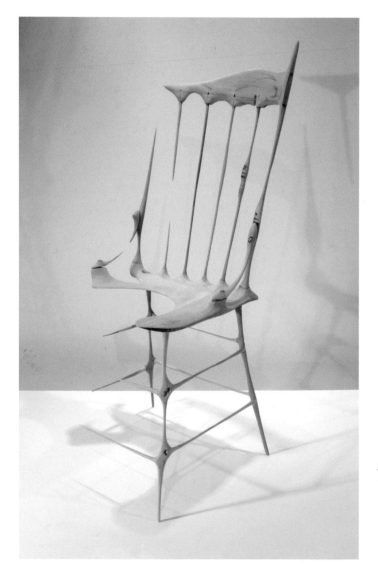

Subject: Remnant, 2004-2005. Sanded oak chair, 36" x 14" x 15". *Courtesy of collection of Dean Geleynse.*

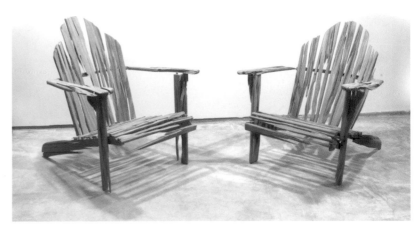

Division: Adirondack Chair, 2005. One wood chair, acrylic paint, adhesive, 34" x 35" x 32". *Courtesy of the artist and Greg Kucera Gallery.*

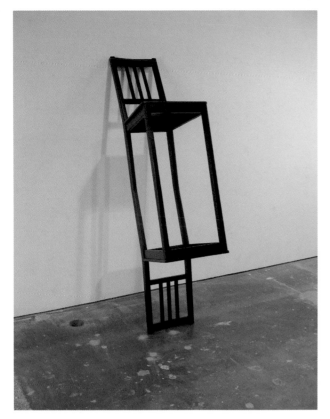

Tilt, 2007. Two wood chairs, Bondo and lacquer, 23" x 16" x 71". *Courtesy of collection of Barbara Billings and Ernie Vogel.*

Untitled (Anvil), 2006. Cut photograph, glue, Plexiglas, 30" x 60". *Courtesy of the artist and Greg Kucera Gallery.*

Gregory Deane

Miami Art Group / Lanning Gallery / Vickers collection / Vail Village Arts / Logan Fine Arts / A Gallery of Fine Arts / Martinos Interiors / Susan Woltz Gallery

Gregory Deane was the first American artist to be honored, in October of 2002, with a solo show at Accademia delle Arti del Disegno in Florence, Italy (founded by Michelangelo in the 14th Century). He had a painting placed in the permanent collection of Florence's renowned Ufizzi Gallery following the highly regarded show. His clients today include prestigious private and corporate collections. Deane's mixed media works, which can range from small to wall-sized, exhibit the artist's natural exuberance. Broad strokes of color may dominate, but subtleties are always present in the form of layers of hidden color, surprising textures, shadows, and mysterious objects.

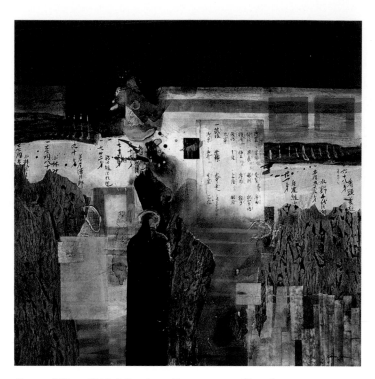

Pages of Time, 2003. Mixed media paper, acrylic paint on canvas. 36" x 36".

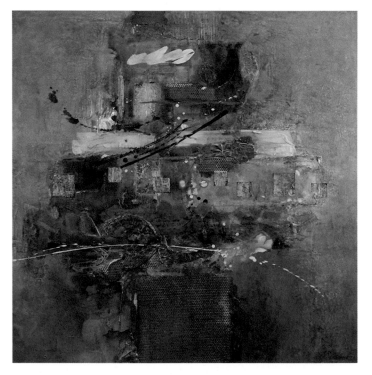

Tumbler, 2008. Mixed media paper, acrylic paint on canvas. 48" x 48".

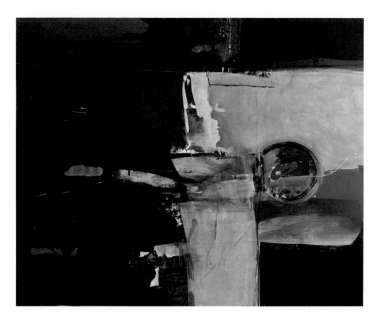

Visions Circle, 2008. Mixed media paper, acrylic paint on canvas. 60" x 72".

Xylo II, 2006. Mixed media (Asian paper acrylic paint on canvas). 40" x 30".

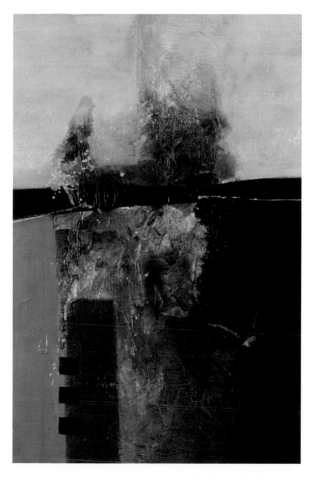

Floreo, 2003. Mixed media paper, acrylic paint on canvas. 72" x 48".

Gregory Deane

Sarah Dillon

Gallery 110

My work allows me to be naked and uncompromised through the physical act of creation as well as through my chosen subject matter. It embraces the notion of looking through a window watching obscure events that tell stories hinting at lyrics of folk songs, politics, experience, and personal contemplation.

Old things have passed away, new things have come. Change and transition are inevitable aspects of American politics and culture. I toy with issues of social reinvention, urban habitation, the political climate, migration, immigration, and freedom of passage. I have developed a language through seemingly ordinary subject matter by drawing out the meaning and charm from daily experience. Power lines often fracture the sky into an abstract rhythm of shapes, imposing a sense of inescapable order, defining a network, which ironically remains only an obstacle course for the birds.

Flotilla, 2008. Oil on canvas, 26" x 29".

For the Birds, 2008. Oil on canvas with sewn collage, 54.5" x 43". Embracing human naivety is the first step towards discovering truth. There is where I find humor, mystery and stories waiting to be told.

Bluff, 2008. Oil on canvas, 28" x 34".

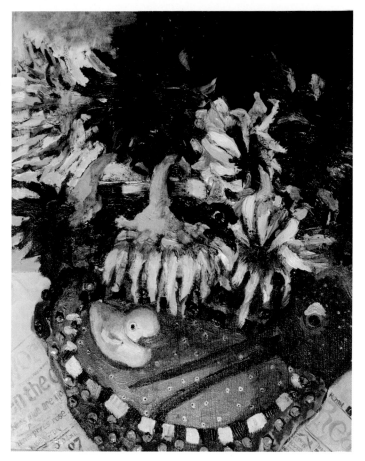

Real Estate, 2007. Oil on canvas, 17" x 22.25".

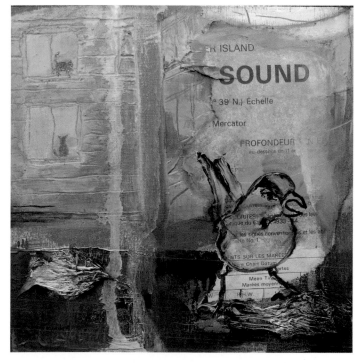

Reverb, 2008. Oil on panel with nautical charts. 6" x 6".

Dark Island, 2008. Oil on panel with nautical charts, 6" x 6".

Sarah Dillon

Stephen Filla

Foster White Gallery

I choose to work primarily in abstraction because it makes fewer presumptions about final meaning. The subject matter of abstraction in my work is that which lies between discrete states of being. Abstraction literally is change and as such it throws off the bondage of authorial intent and encourages the viewer to find his or her own connections to and associations with the piece: to literally remake the work, intermingling it with his or her own experiences, thoughts and feelings. There is no right way to view the piece, no "getting it." It is what the viewer makes it.

One of the worthwhile aspects of being an artist is to initiate this collaboration. Works of art are made and remade again and again. The object to which the experience of art is tied is created through the skill and initiative of the artist but the experience itself is a relationship and like any relationship, it is continually reestablished. By working in the studio, the artist initiates a conversation that takes place in a medium outside of language. The relationships art makes possible allow us to interact, to communicate, to learn, to cultivate an understanding of the world that follows alternate channels and encompasses divergent conceptions of existence.

It's Presence Is Revealed Only Through Its Interactions, 2008. Oil and polymer resin on panel, 24" x 36" *Photo courtesy Foster/White.*

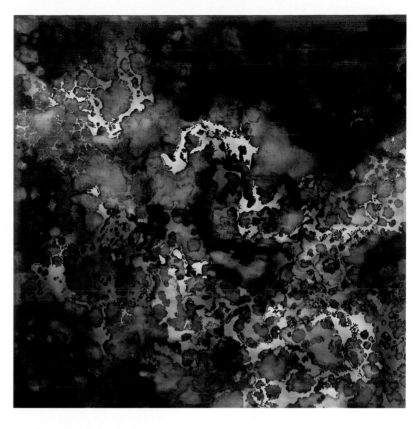

Parameters Include Turbulence Pattern Serenity and Desire, 2008. Oil and polymer resin on panel, 30" x 30". *Photo by Sarah Gilbert.*

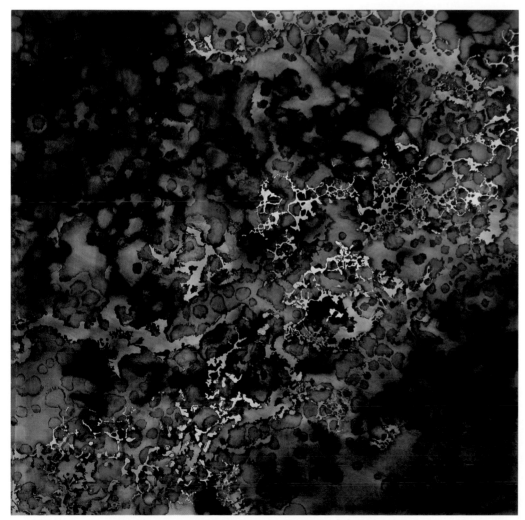

Adrift And Decompressed Is The Way I Like It Best, 2008. Oil and polymer resin on panel, 30" x 30". *Photo by Sarah Gilbert.*

61 Stephen Filla

Simona Foggitt

Susan Woltz Gallery / Artworks Gallery / Code Gallery

The tension between living and non-living components is what creates the energy that we recognize as life. The work is characterized by simplicity in form and material so that it can generate a reaction. By placing two very foreign objects together, in this case, steel and canvas, I force the components of such different materials to unite. In doing so I am forever reminded that when two molecules meet, regardless of how different they are to each other, a new energy is formed .The contrast between the two materials is what interested me and inspired me to produce this body of work. Steel, being not at all versatile either in composition, touch, or smell, is accompanied by cloth, probably the most flexible material we have discovered. Paint is used in this case, as a medium between the two, the marriage so to speak. Different textures, thicknesses, and color combinations are used to further provoke 'conversations' between the materials. If this is achieved, then it is inevitable that a dialogue between the painting and viewer is initiated. I feel that the abstraction is of vital importance in the compilation of the work so as to allow us to absorb the harmony in which two very different composite materials can be combined.

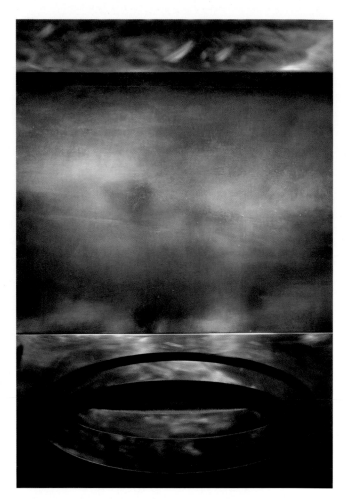

A Space Undefined, 2007. Acrylic, aluminum, 55" x 36".

Archway, 2007. Acrylic, aluminum, 36" x 60".

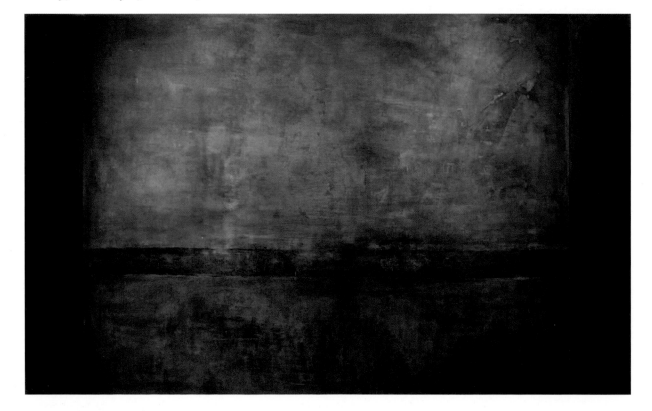

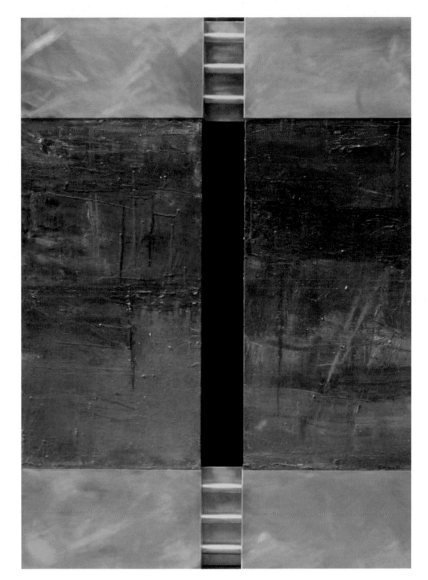

Double Trouble, 2007. Acrylic, aluminum, 54" x 40".

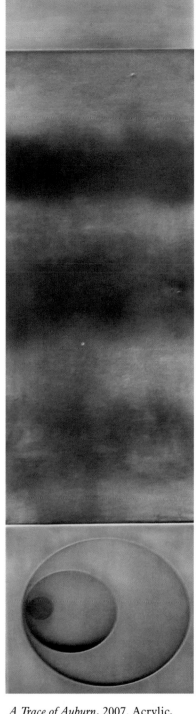

A Trace of Auburn, 2007. Acrylic, aluminum, 48" x 12".

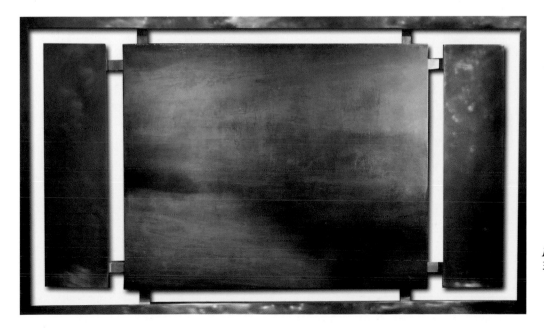

Euphoria, 2007. Acrylic, aluminum, 30" x 51".

Simona Foggitt

Karen Florek

Tag Gallery

I feel my work is most akin to the artists working in the "Mystical Nature Painting" tradition. Like them I also believe that every natural fact corresponds to some hidden truth that can be expressed as a picture. A fallen leaf or branch becomes a symbol for universal truths: birth, change, and the inevitability of decay.

I begin with black and white film images I photograph myself. Once the image is transferred to the work surface I layer paint and glaze to either enhance it, or conceal it. Some pieces are atmospheric and exude a feeling of calm. Others are purely electric and vibrate with lively color. I aspire to the sensitivity that Arthur C. Dove, Marsden Hartley, Gregory Amenoff, and Emily Carr achieved in their work.

My paintings are a refuge for me... a retreat from my urban life...a place to rest. As I explore themes of connection and remain open to my own experience, nature continues to provide insight and inspiration.

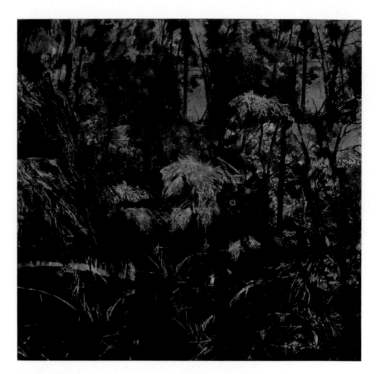

In The Woods II, 2006. Mixed media on wood panel, 24" x 24" x 2". The origin of this piece was a photograph that was cut up and reassembled to create a fractured interpretation of the grasses.

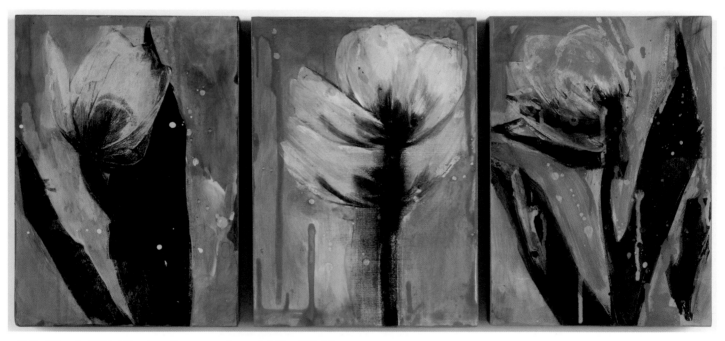

Tulip Triptych, 2006. Mixed media on wood panel, 14" x 30". These tulips photographed particularly well and placing them together shows off the diversity of their forms.

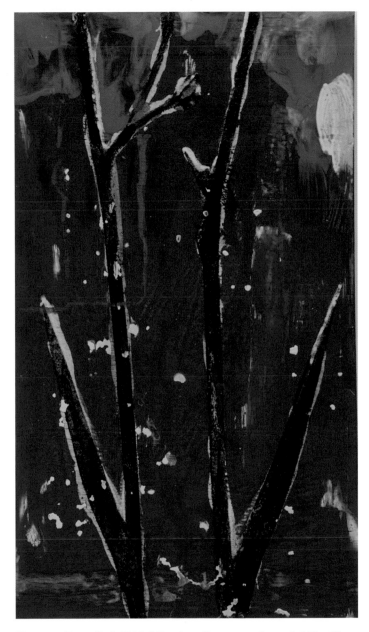

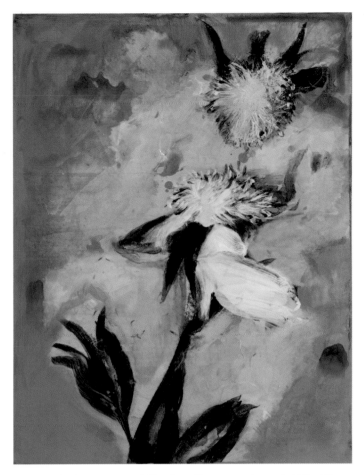

End Of The Season, 2006. Mixed media on wood panel, 12" x 9". *Courtesy of Cooper and Alicia Johnson.* Washes of copper acrylic paint heighten the luminous quality of these two stems.

Kangaroo Paws Red, 2006. Mixed media on wood panel, 14" x 8". The bare stalks of these kangaroo paws strike a dramatic silhouette. Showy whites and light blues vibrate on red and create a wintry mood.

Pink Peony, 2006. Mixed media on wood panel, 10" x 10". *Courtesy of Jim and Linda Garofallou.* Pushing the peony's form right to the edge helps to communicate the magnificence of this flower by making its size seem larger than life.

Karen Florek

Robilee Frederick

Braunstein/Quay Gallery

The shape of my artistic journey continues to be illumined with the illusive mysterious quality of light and its transformation into visual experiences. For some time, my work has been about loss and memory. Circles and labyrinths, filled with the duality of certainty and mystery, continue to appear in my work. I utilize methods of layering, whether it be multiple sanding processes or embedding gut and seed pods in layers of drafting tissue. Revealed through these layers is a reaffirming notion towards the distance between the end and its beginning. It is a continual revelation of surprises as I work slowly through these layers.

A recent trip to Bhutan has led to a new body of work. I was most taken by the deep commitment to Buddhism and the profound acceptance of all aspects of the life cycle of the Bhutanese people. In every temple I visited, seeds encased in a delicate fan-like wing were to be found. Some of my light pieces have these seeds embedded in layers of drafting tissue. These shapes have also emerged in recent paintings where circles are found swimming in an enigmatic watery atmosphere. In my mind, they are a symbol for rebirth and renewal.

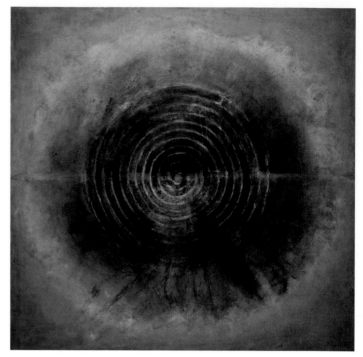

Circle of Memory I, 2008. Oil on canvas; 60" x 60". *Courtesy of Braunstein/Quay Gallery.*

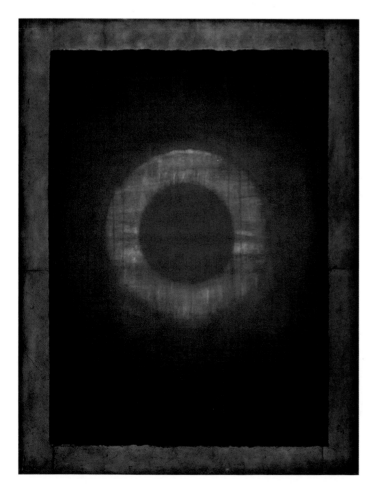

Circle of Memory III, 2008. Oil on watercolor paper, Japanese tea paper on wood, 48.5" x 36.5". *Courtesy of Braunstein/Quay Gallery.*

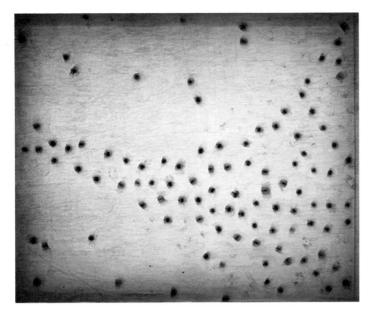

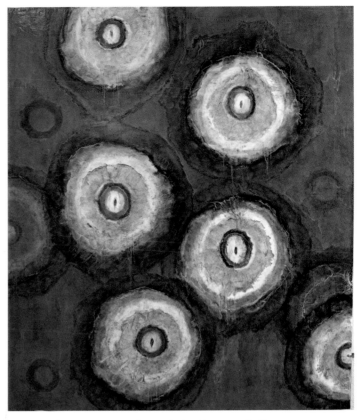

Mapping Light I, 2007. Drafting tissue, acrylic, seeds from Bhutan over neon light box, 40" x 47". *Courtesy of Braunstein/Quay Gallery.*

Light Gatherers 1I, 2008. Ground aluminum and oil on canvas, 70" x 60". *Courtesy of Braunstein/Quay Gallery.*

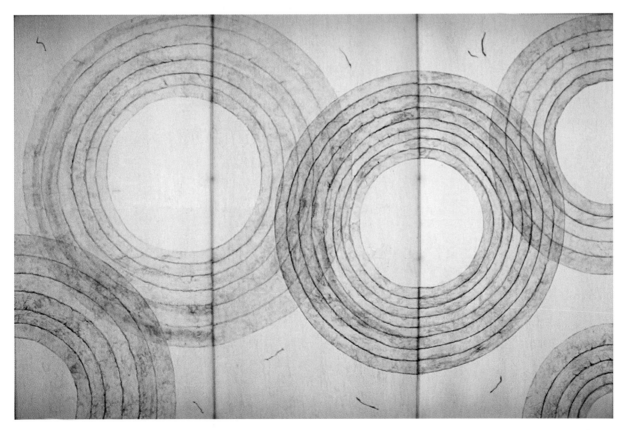

Mapping Light IV, 2008, Drafting tissue, gut (tea-dyed) over neon light boxes, 60" x 90". *Courtesy of Braunstein/Quay Gallery.*

Robilee Frederick

Mitchell Freifeld

Portland Art Museum, Rental Sales Gallery / Freed Gallery / Fountainhead Gallery / Dragon Fire Gallery

I paint cityscapes. Portland and Seattle mostly. Our cities have a very rich history and a lot of places in them are still intact from other times, and these older spaces are still being used. Our Northwest cities are endlessly changing with the seasons, the light and night and day.

My interest is in the everyday places; the places and paths that make up the fabric of our daily lives. Not the overtly dramatic, but the routine and ordinary that becomes lost to our curiosity through sheer familiarity. I try to take these places and paths and depict them in such a way that they might stir ones interest again; that they become places where we might pause and wonder about them again. I like the Places of the People. I have much more interest in the corner lunch counter then in a monument to a 19th or 20th century industrialist.

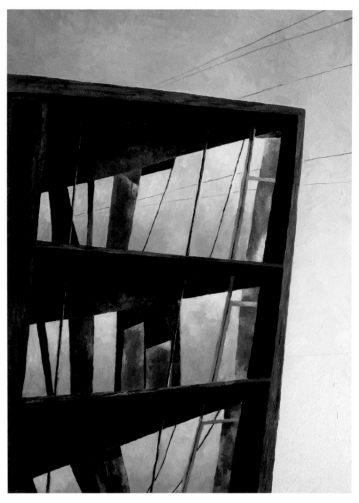

New Construction, 2009. Oil on canvas, 50" x 35". In Portland, we're losing old brick to steel and glass all the time these days. This new one is just about ready for occupancy. The late afternoon light goes through a lot of changes as it travels between sheets of glass. The light seems to want to compromise with these new spaces.

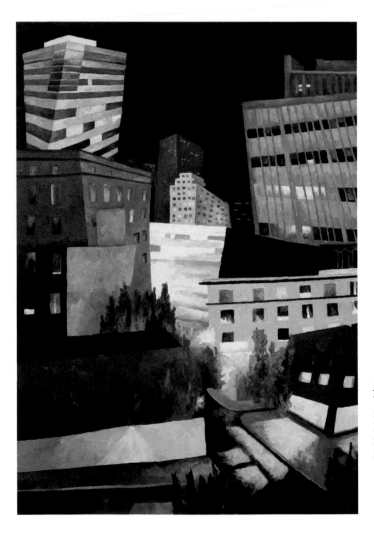

Night from the Elizabeth, 2008. Oil on canvas, 50" x 35". The clients wanted a view out of the window of their new loft in the Elizabeth. Part of the "New Portland". But they wanted it in my style. This painting hangs right next to the window that was the original source for the painting. Interesting effect.

Mitchell Freifeld 68

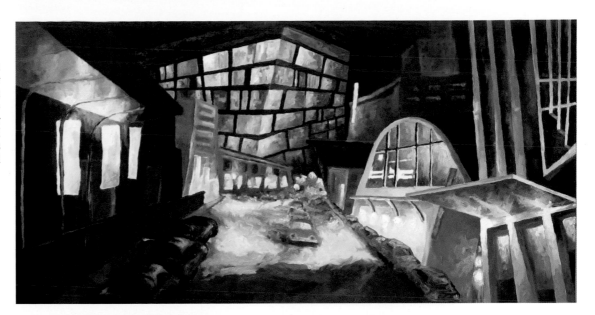

Opening Night, 2009. Oil on canvas, 30" x 50". Rainy even up near the north end of 13th Avenue in Portland. Lots of cars out for a Tuesday evening, so I figured something big was going on. Never did find out what.

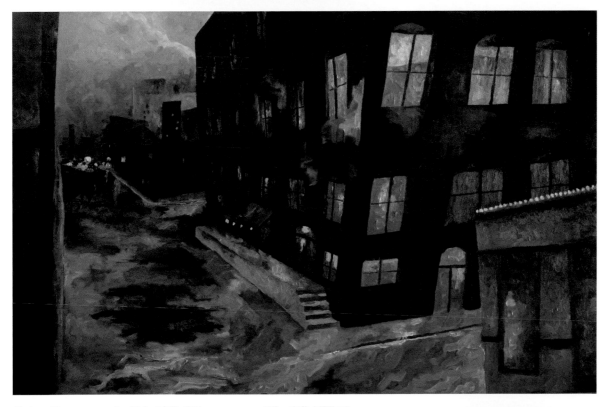

Rainy Afternoon on the 13th, 2008. Oil on canvas, 40" x 50". NW 13 Avenue in Portland is an endless source of material for me; I love this old street. Still a lot of red brick in every configuration. And in the afternoon, in the rain, it glows.

Seattle Windows, 2008. Oil on canvas, 45" x 45". Downtown Seattle has become as dense with valleys of high-rises as any of our old cities of legend in the east. I sort of flattened the perspective here so we could view all the windows as a peer group.

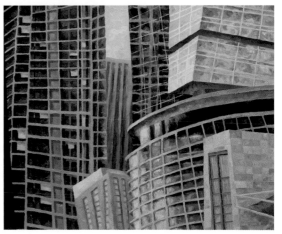

Mitchell Freifeld

Jane Schwartz Gates

Orlando Gallery

For as far back as I can remember I have always been mesmerized by the magic and the inter-connectivity of nature. My work is nothing more than an extension of my love for all things living and the symphony created when one life interacts with another, be it plant, animal, or human. I believe if we only tuned in more frequently to that harmony, we would be connected in spirit to such a degree it would be difficult, if not impossible, to interact with anything but respect and appreciation for each unique life on this planet.

Autumn Princess, 2007. Mixed media, 15" x 22".
A sprite; the spirit of the autumn.

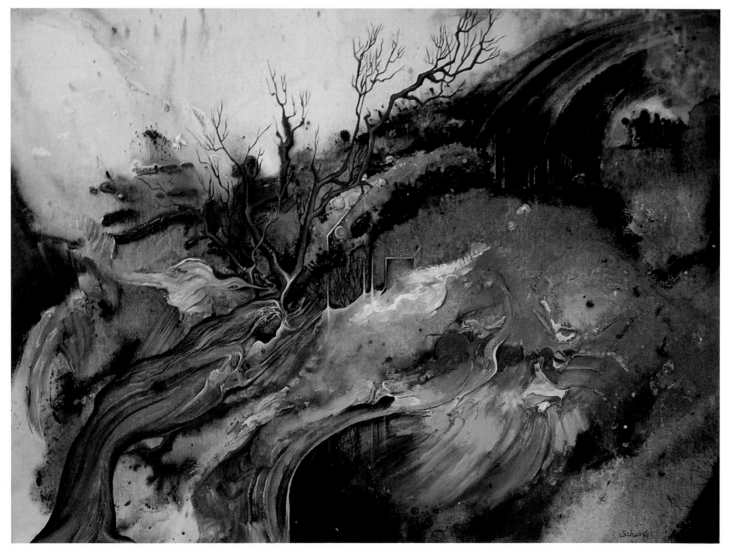

Beyond The Hill, 1997. Mixed media, 24" x 30". A landscape of soil and water, history and present, magic and mystery all flowing together.

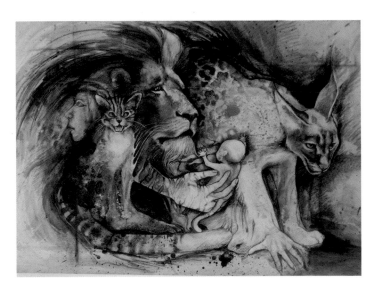

Cat Evolution, 1998. Mixed media, 32" x 42". For me, the cat embodies amazing power and grace: this painting is about the inter-connectedness of all life in nature.

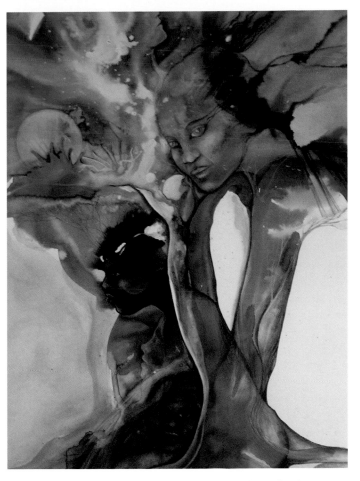

Tree of Feminine Thought, 1996. Mixed media, 34" x 28". The energy of woman grows and branches out throughout the world in people of every race, religion and creed.

Harmony, 2004. Mixed media, 22" x 34". Harmony is like visual music: we are constantly working with and against each other to create ever-changing melodies.

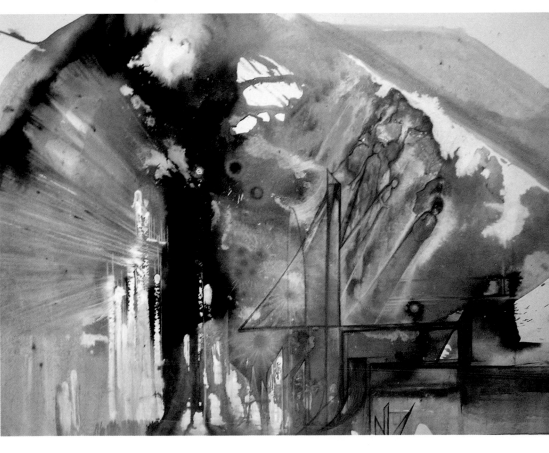

Jane Schwartz Gates

Joseph Goldberg

Greg Kucera Gallery

Joe Goldberg was born in 1947 in Seattle, and was raised near Spokane, Washington. He was educated briefly at the University of Washington until he dropped out in 1968 to pursue painting instead of academics. He has been exhibiting his work since in the late 1960s, beginning with small, surrealistic landscape drawings and paintings and advancing through an exploration of abstraction influenced by the Northwest region. Whether painting the indigo space between the glowing stars in the deep, dark night skies of Eastern Washington, or suggestions of stars reflecting in the marshy water of a pond, Goldberg has produced a sensitively wrought body of work.

Facet, 2007. Encaustic on linen over wood panel, 24" x 30". *Courtesy of the artist and Greg Kucera Gallery.*

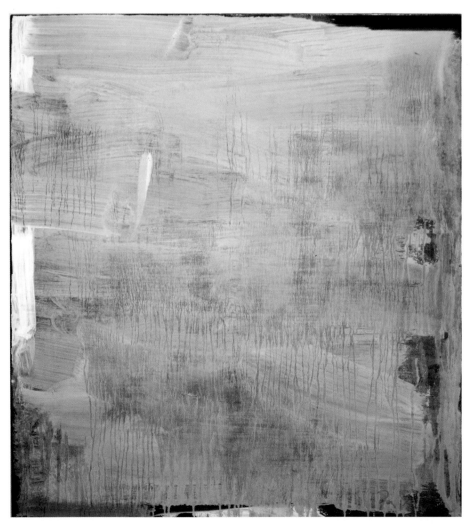

Gulls, 2008. Encaustic on linen over wood panel, 40" x 36". *Photo by Richard Nicol, Courtesy of Greg Kucera Gallery.*

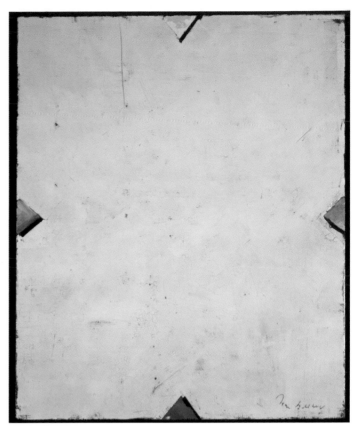

Blue Compass, 2007. Encaustic on linen over wood panel, 36" x 30". *Collection of the Seattle Art Museum, Seattle, Washington.*

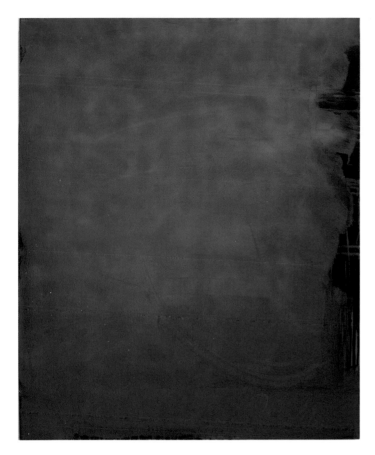

Red Black, 2008. Encaustic on linen over wood panel, 52.5" x 42". *Photo by Richard Nicol, Courtesy of Greg Kucera Gallery.*

Woods, 2008. Encaustic on linen over wood panel, 48" x 48". *Photo by Richard Nicol, Courtesy of Greg Kucera Gallery.*

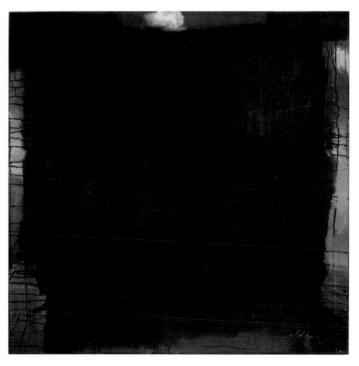

Joseph Goldberg

Tom Gormally Studios

The Dennis Morgan Gallery

I've always been building and making things out of wood, ever since I can remember being able to use tools –from go-carts and forts to weapons and swords. I was taking art classes at the University of Minnesota at the height of the Vietnam War, and ended up enlisting in the Navy. My squadron, along with other government agencies, worked on weapons testing and developed laser guided bombs. I don't feel so good about that. In my twenties, after discharge from the Navy, I traveled around the country aimlessly, and then survived a near fatal car crash. While recuperating, I had an epiphany and realized that art was my life's path. In art school I tried all types of new materials, from poured bronze to polyester resins. I became chemically sensitive to many of these materials, and decided that I would go back to the natural materials of my childhood; wood, stone, and glass.

We live in a period of great change in technology, and we're at risk from many sources. My concerns about the political landscape inform many of my pieces. I combine craftsmanship with a light heart and dark humor to create sculptural commentaries on current issues. My work takes a dark stab at re-inventing the wheel, and our legacy to future generations, with illogical sculptural absurdities.

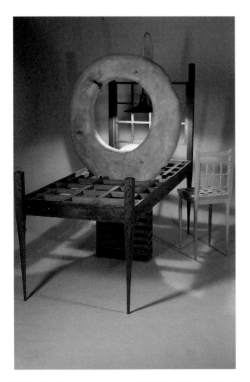

Witness, 2001, Poplar, fir, oak, steel, 90" x 96" x 66". *Photo by Theresa Batty.* The sculptural installation acts as a narrative stage for an encounter with the unknown. From the bed of an unseen figure, a portal opens to provide a platform for visions and dreams.

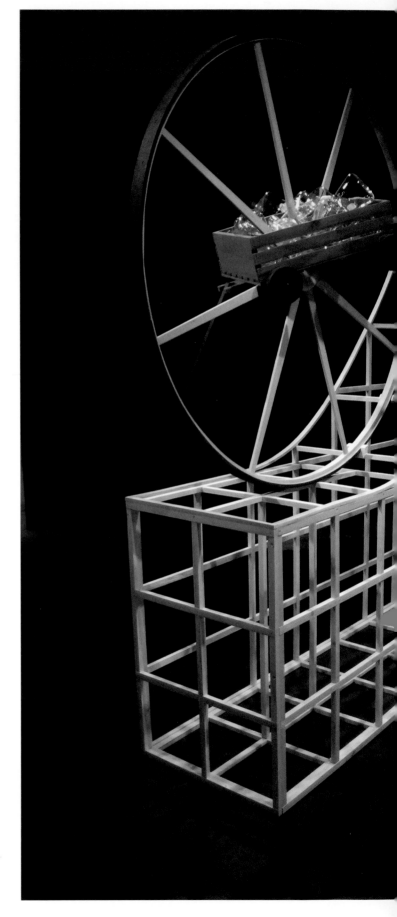

Launch, 2008. Wood (hemlock, oak), glass, stain, 96" x 30"x 96". *Photo by Theresa Batty.* Launch, a five foot high wooden wheel careens down a ski-jump like structure that looks like it was built for an X-Game competition. At the center of the wheel is a child's wagon made of wood, filled with scientific lab beakers.

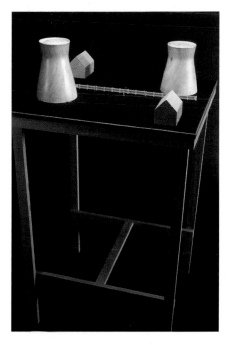

Good Fences Make Good Neighbors, 2004. Wood plastic, flocking, 53" x 24" x 21". *Photo by Theresa Batty.* Good Fences Make Good Neighbors is one of a series of small scale table-top dioramas which allude to an "Our Town" gone haywire. In a "keeping up with the Joneses" tableau, Good Fences is a diorama of neighbors arguing over the proverbial white picket fence.

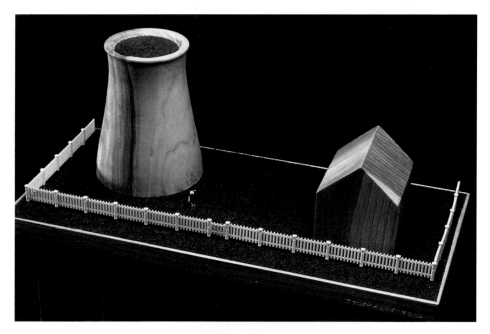

Signs Of Spring, 2004. Cedar, pine, plastic, paint, flocking, 51" x 18" x 12". *Photo by Theresa Batty.* I was focusing on the ambiguity of the figure, whether she is swooning, fainting, or just looking at the cooling tower. What she can't see is what is happening on top of the cooling tower; the cooling tower is making "green" or nature, rather than waste.

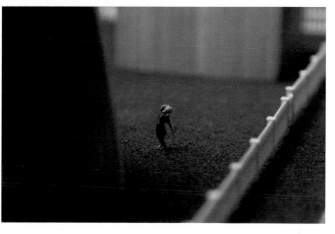

Tom Gormally Studios

Michael Gregory

John Berggruen Gallery

Michael Gregory is best known for his highly realistic oil paintings that favor desolate barns, silos, tents, and remote rural towns as their subject matter. Although appearing to be lifted directly from real locations, the images in Gregory's paintings exist solely as fabrications produced from the artist's imagination. Alternating between the bucolic and the eerie, these works offer a unique glimpse into the mercurial temperament that patterns human imagination. There exists a distance between the viewer and the viewed, but also a distance that separates the reality of genuine life from the atmospheric intangibility of the mythological American landscape as Gregory meticulously paints it.

Michael Gregory was born in Los Angeles in 1955. He received his BFA from the San Francisco Art Institute in 1980, and currently lives and works in the Bay Area. Aside from exhibiting on a regular basis at John Berggruen Gallery, Nancy Hoffman Gallery in New York, and Gail Severn in Idaho, Gregory's work is included in many private and public collections including the Delaware Art Museum, the Denver Art Museum, Microsoft Corporation, General Mills Corporation, Bank of America, and most recently, the San Jose Museum of Art.

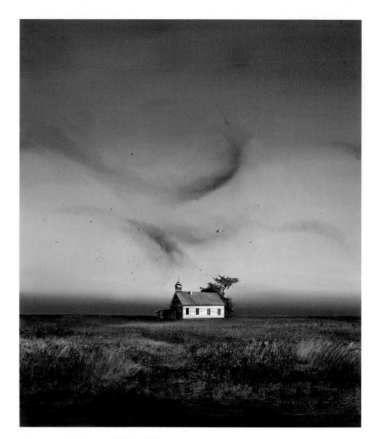

Crows and Crows, 2007. Oil on canvas mounted on panel, 72" x 60". *Courtesy of John Berggruen Gallery.*

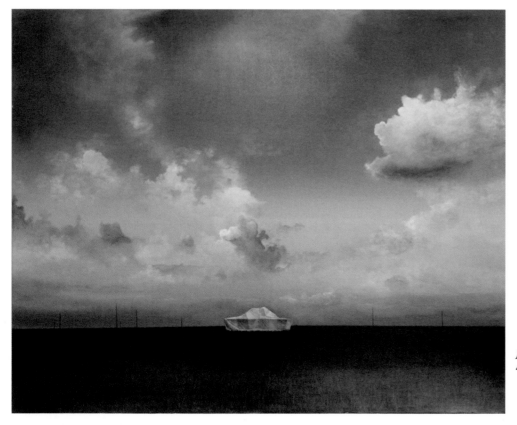

Blue Revival, 2005. Oil on panel, 45.5" x 45.5". *Courtesy of John Berggruen Gallery.*

Newbern, 2005. Oil on panel, 38.5" x 45.5". *Courtesy of John Berggruen Gallery.*

Belle Plaine, 2004. Oil on panel, 41.5" x 35.5". *Courtesy of John Berggruen Gallery.*

Singing Lessons, 2008. Oil on canvas mounted on panel, 72" x 80". *Courtesy of John Berggruen Gallery.*

Michael Gregory

Michael Hall

Swarm Gallery

Michael Hall is an Oakland-based artist. He received his BFA from California College of the Arts, Oakland, CA and in 2008, received his MFA from Mills Collage, Oakland, CA. West Coast gallery representation: Swarm Gallery, Oakland, California.

My work begins with an observation of history. I am particularly interested in historical narratives found in discarded photographs. By careful observation of an abandoned image, I find myself forming narratives about the people depicted, the time in which they lived, my own relation to that period, as well as to the physical photographs and the lost or dying process used to make them. Though photography plays a key role in my work as both a reference and subject, it is ultimately my love of painting that keeps me working. Its visceral encouragement to linger and look is essential to my work.

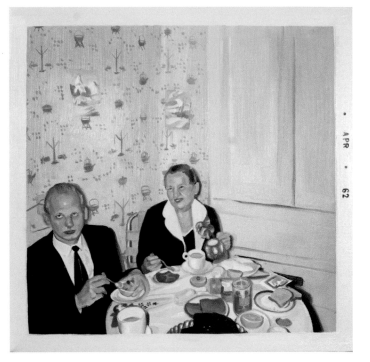

APR 62, 2008. Oil on canvas, 12" x 12". *Courtesy of Swarm Gallery, Oakland, California.*

Group 1, 2008. Oil on canvas, 20" x 24". *Courtesy of Swarm Gallery, Oakland, California.*

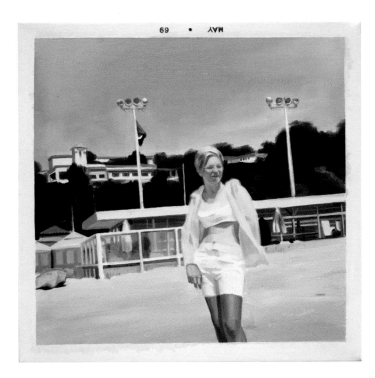

MAY 69, 2008. Oil on canvas, 12" x 12".
Courtesy of Swarm Gallery, Oakland, California.

Scatter 4, 2008. Oil on canvas, 18" x 18". *Courtesy of Swarm Gallery, Oakland, California.*

Michael Hall

Robin Hall

Art Expressions Gallery / Rogers Gardens Fine Art Gallery / Villas & Verandas Fine Art Gallery

Besides her formal education at Orange Coast College in Costa Mesa, California, and University of California, Irvine, Robin Hall has tutored under Doug Higgins of Santa Fe, Kevin MacPherson, of L.A., Sebastian Capella, of La Jolla, and others. Both her mother and her great grandmother painted professionally. Surrounded with the sights and smells of the artist's studio while she was growing up, Hall says she was lucky to have that influence as a child. "I think early exposure to art is important. You develop an appreciation that follows you for life."

Light and the absence of light make up the compositions, while color, edges and brushwork are the elements that project the vision for my paintings. The focus of my work has changed from the early paintings I created in the '90s portraying the natural untouched landscapes of California, to today's paintings, which are all about saturated light and the drama it creates on surfaces and architecture, specifically how color and edges are affected by it."

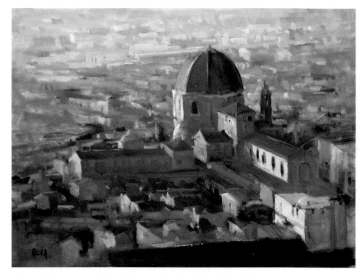

Above Florence, 2005. Oil on linen, 16" x 20". Florence, Italy is the backdrop for this painting. From atop the towering Duomo, there is a spectacular view, where light and shadow contribute to the composition of many rooftops.

Fortificado, 2009. Oil on linen, 30" x 40". The aged fortress-like wall and gate of Mission San Miguel Archangel inspired me to paint it. The hills beyond the gate are covered in an early bloom of Spring's grasses.

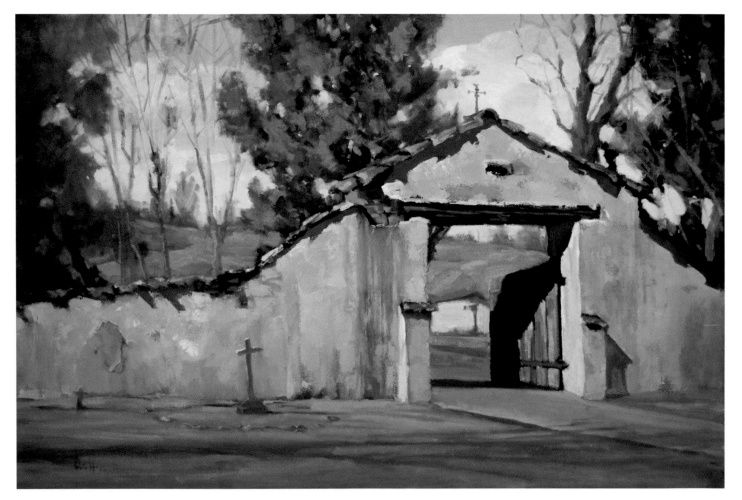

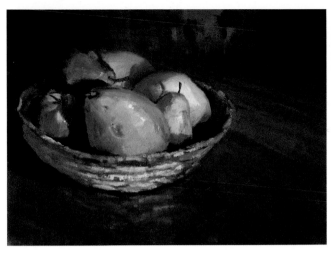

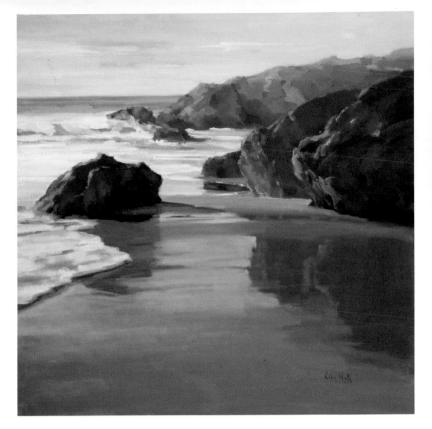

Pears & Apples, 2009. Oil on linen, 9" x 12". This painting was inspired when afternoon sunlight streamed through a window and cast bold light on a simple basket filled with pears and apples.

Summer Day, 2007. Oil on linen. 16" x 20". On a hot summer day, the open courtyard of the Mission San Juan Capistrano sizzles, while the covered hallways stay cool in the shade.

High Tide, 2008. Oil on linen, 24" x 30". High Tide is a painting from El Matador State Beach coastline of Malibu, California. Large boulders are scattered along the sand, and when high tide occurs, the reflections are dramatic.

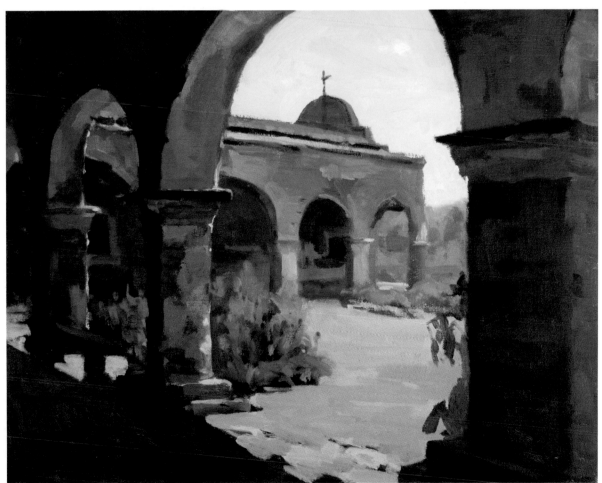

Robin Hall

Robin Harlow

Gallery 110

Robin Harlow was born in Los Angeles California in 1957 to two artists who encouraged her to begin painting at an early age. By the age of six, she had developed an uncanny talent for portrait painting. She received her bachelor's degree from Evergreen State College, where her studies included painting, printmaking, sculpture, and photography.

My work has an ambiguity that combines 19th century Victorian imagery with contemporary surrealism. When I work, I am unencumbered by social restrictions, I allow myself to paint freely what I want, the way I feel it. While blending a sense of the absurd I ponder such issues as emotional isolation, longing, and the psychological vividness of childhood. I explore the density and despair of a nightmare as I expose the vulnerability of my own childhood as well as the nightmares and dreams of my youth.

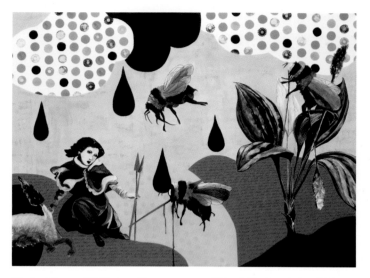

Cache Chaser, 2007. Acrylic on canvas, 48" x 36". A quick rabbit shows a girl an escape route via the rabbit hole. They are being pursued by giant bees in a surreal cloudy garden setting.

Go Ask Alice, 2007. Acrylic on canvas, 48" x 36". Subtle tones portray a lonely child curled up in a sparse surreal landscape crawling with snails.

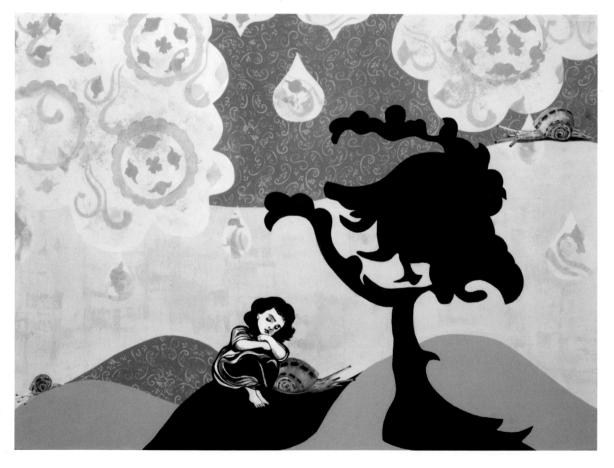

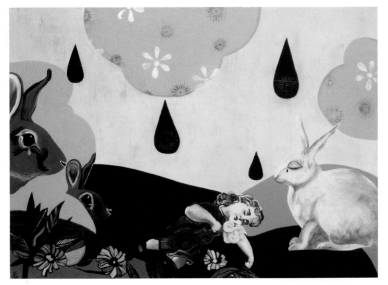

Lys Blanc, 2008. Acrylic on canvas, 48" x 36". A fantasy-scape with pink patterned clouds and giant rabbits tearfully watching over a child gripping lilies as if in a death link trance or sleep.

Turvey Wise, 2008. Acrylic on canvas, 48" x 36". A watchful owl sees a child on a swing held by tentacles of a giant squid overlooking a body of water infested with creatures. Her parents watch from afar.

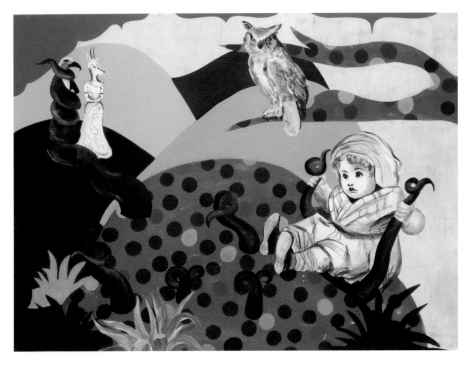

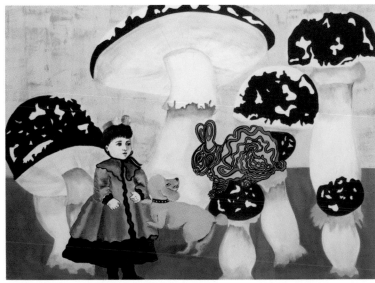

Widdershins, 2007. Acrylic on canvas, 48" x 36". A surreal setting of giant mushrooms surrounds a small girl walking her pink poodle, who is avoiding an encounter with a large rabbit.

Robin Harlow

Victoria Haven

Greg Kucera Gallery / PDX Contemporary Art

Victoria Haven was born in 1964 in Seattle, where she currently lives and works. She received her BFA from the University of Washington and her MFA from Goldsmiths College/University of London. She has won numerous awards, fellowships, and grants, and her work has been exhibited at the Frye Art Museum, Seattle; Austin Museum of Art, Texas; the Drawing Center, New York; and RMIT Gallery, Melbourne, Australia, among many others.

She recently completed a large, site-specific commission for King County Libraries in Black Diamond, Washington. Her work is included in the permanent collections of City of Seattle; 4Culture, King County, Seattle; Amgen, Seattle; SAFECO Collection, Seattle, and the Henry Art Gallery, University of Washington, Seattle.

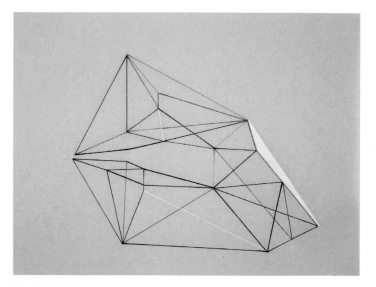

Untitled Fifth (Levitation Series), 2009. Ink on gampi paper, 18.75" x 23". *Collection of Tara Wefers.*

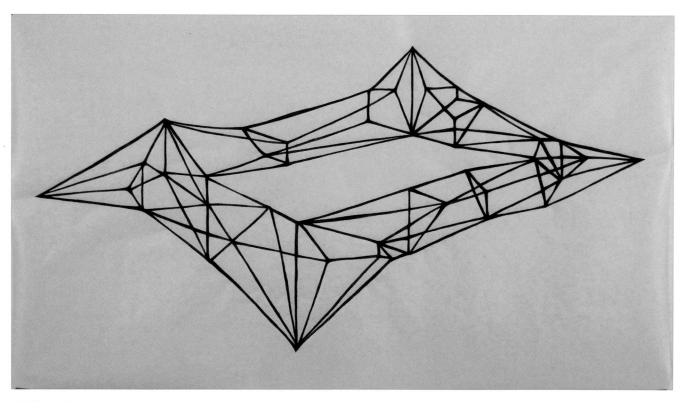

If All In All Is True, 2009. Watercolor on gampi paper, 32.25" x 57". *Courtesy of the Greg Kucera Gallery.*

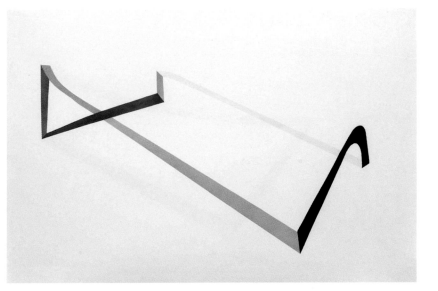

Double Sided "L" Series, (Rabbit Hole Study 2), 2004. Ink on tape on paper, 25.5" x 37". *Courtesy of Greg Kucera Gallery.*

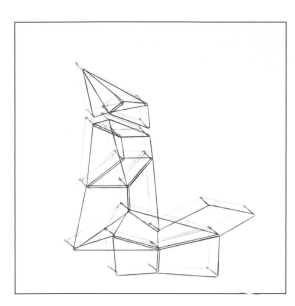

Oracle 2, 2009. Selenium toned silver gelatin print, 19" x 15.75". *Courtesy of Greg Kucera Gallery.*

Double Or Nothing (White), 2008. Cut steel with white powder coating and fasteners, 27" x 25" x 1.75". *Courtesy of Greg Kucera Gallery.* Victoria originally began studying landscape and its abstraction by pinning cut Mylar installations to the walls of rooms. The cut steel forms are a continuation of this meditative abstraction of landscape and other natural forms.

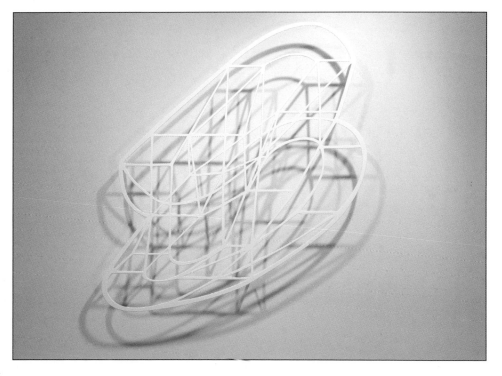

Victoria Haven

Terry Hoff

Michael Rosenthal Gallery

Terry Hoff was born in Prescott, AZ. He attended school at San Joaquin Delta College in Stockton, CA, and the Academy of Art in San Francisco, CA, where he currently teaches. Terry lives seaside in Pacifica, California, with his two children. His paintings evoke a sci-fi fantasy world reminiscent of Doctor Who's time travels. His work questions suburban American 'ideals' and the desire to get beyond the ties of gravity, to places that separate us from what is above and what is below.

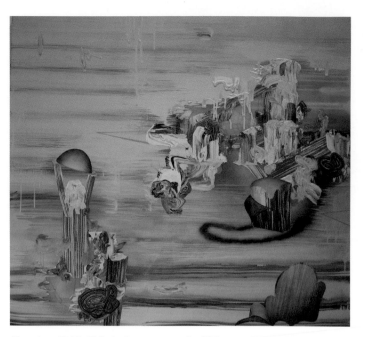

Coasting, 2009. Fabric, latex enamels, UV treated epoxy resin on panel, 44" x 48".

Drive By, 2009. Fabric, latex enamels, UV treated epoxy resin on panel, 44" x 48".

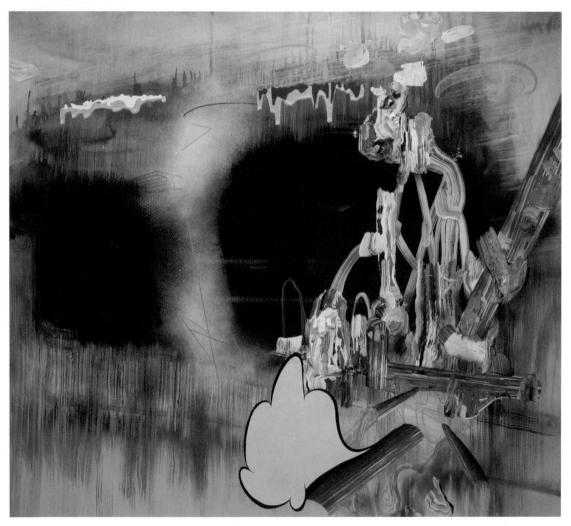

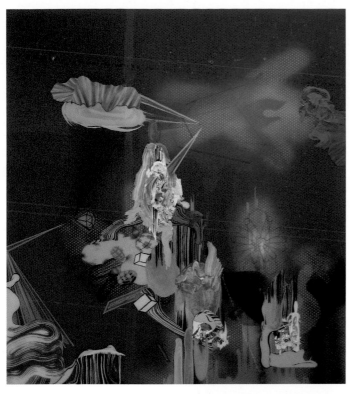

In The Pink, 2008. Fabric, latex enamels, UV treated epoxy resin on panel, 40" x 36". *Courtesy of artists collection.*

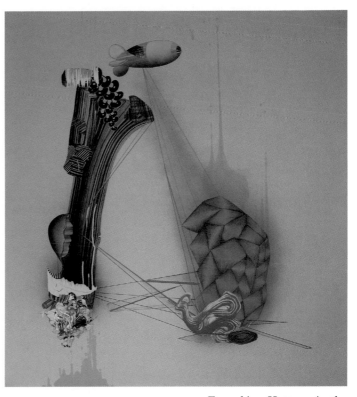

Everything Happens in the Sky, 2009. Fabric, latex enamels, UV treated, on panel, 44" x 48".

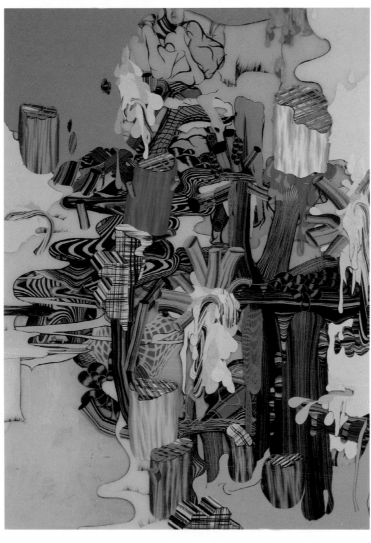

Sweet State, 2008. Fabric, latex enamels, UV treated epoxy resin on panel, 30" x 18".

Terry Hoff

Katina Huston

Anne Reed Gallery / Dolby Chadwick Gallery

Katina Huston received her MFA in fine arts practice from Mills Collage in Oakland.

Bicycle shadows became my primary subject over the past six years and in that time a whole range of abstract compositions and unexpected meaning has been revealed. Individual bikes become figurative. In groups they convey motion. Lined up like inventory, bikes become Utopian. Piled they turn into an ominous heap. Lately the meanings and their connections to formal qualities have come to seem arbitrary and malleable. To make these drawings I use twenty shades of ink on Mylar focusing on elements repeated from several angles to create a complex and mysterious whole. Thus, six-foot drawings of shadows of bicycles made from ink pooled, poured, and drawn into familiar yet elusive forms also speak of geological experience.

Double Dynamo, 2008. Ink on Mylar, 36" x 72". Photo by Richard Morgenstein, Courtesy of Anne Reed Gallery.

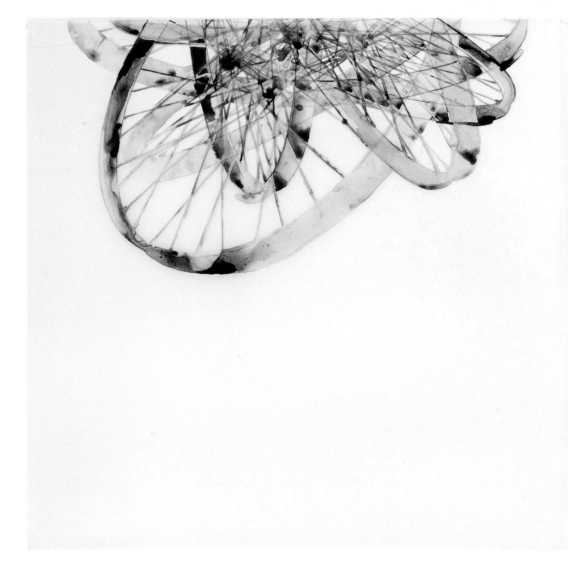

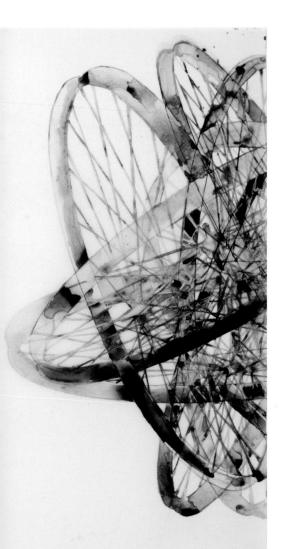

Chaos, 2004. Ink on Mylar, 36" x 24". *Photo by Richard Morgenstein, Courtesy of Anne Reed Gallery.*

Katina Huston

Richard Hutter

Lisa Harris Gallery / Circa Gallery

The intersection of organic and synthetic matrices has been the subject of my work for the past two decades, expressed chiefly by an evolving exploration of floral still life and landscape as viewed through an abstracted and "architectonic" prism. Formal concerns predominate over symbolic or emotional ones, and are informed by Minimalism and Pop, with a nod to Dada. Found elements from old technical books, magazines, and postcards are combined with imagery drawn using architects' tools and collaged in alternating layers with paint and ink on substrates such as paper, canvas, and found wood. Concern for tactility and heft are evident: for example, encaustic-like acrylic paint passages on found-wood constructions and sticky-looking mottled passages on billowing lithographic monotypes in overbuilt shadow-box frames.

My methods of applying paint borrow heavily from my training as a printmaker. Notable influences on my work are my memories of happy days spent in a succession of backyard gardens during childhood, my love of architecture and the built environment, and my appreciation of ephemera and anything old and printed.

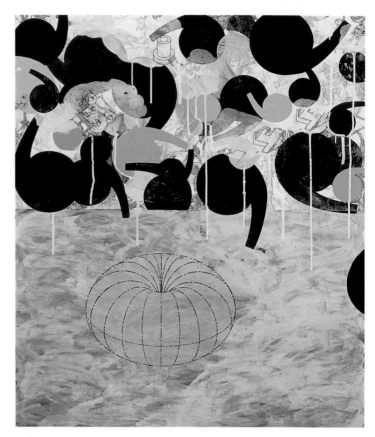

Fortunato, 2004. Collage, acrylic and charcoal on birch panel, 57" x 48". *Photo by Spike Mafford, Collection of Lucy Mohl.*

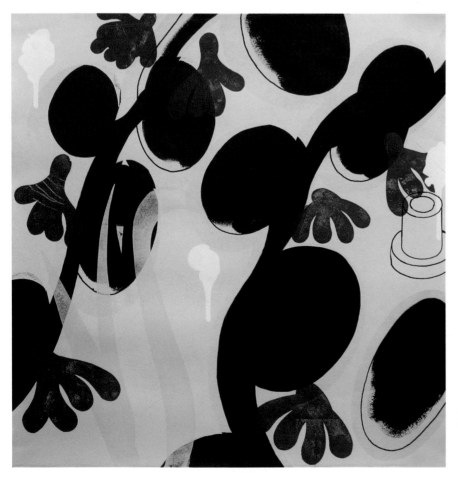

Bunda, 2008. Acrylic and ink on paper, 22.5" x 21.5". *Courtesy of the Lisa Harris Gallery.*

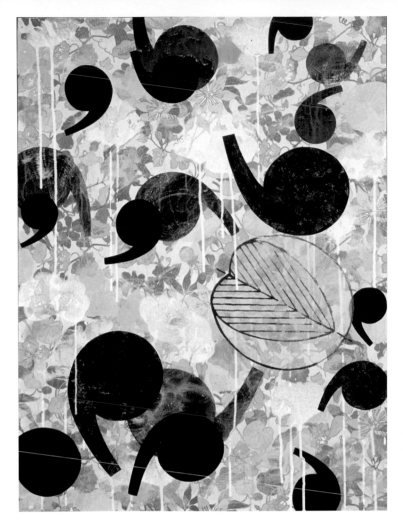

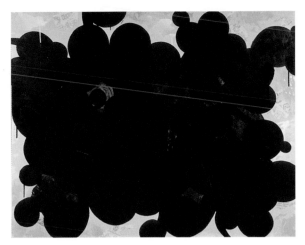

Pitch, 2005. Collage, acrylic and ink on canvas, 48" x 60". *Photo by Craig Sherburne, Courtesy of the Lisa Harris Gallery.*

Whelp, 2004. Collage, acrylic and charcoal on birch panel, 48" x 36". *Photo by Craig Sherburne. Collection of Julie Lindell.*

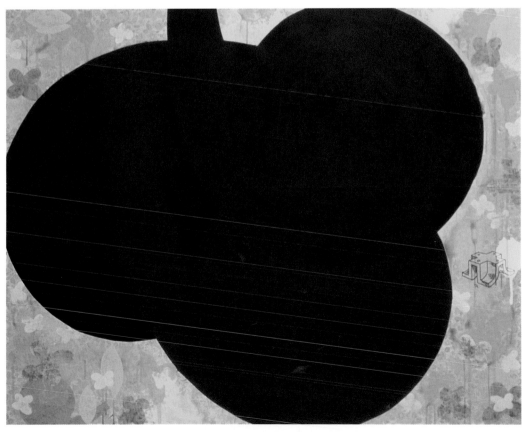

Vitrine, 2004. Collage, acrylic and charcoal on birch panel, 48" x 60". *Photo by Spike Mafford.*

Richard Hutter

Eva Isaksen

Foster White Gallery / Sardella Fine Art

Eva Isaksen has an MFA in painting from Montana State University and her BFA from the University of South Dakota. Previous studies included the Nordland School of Arts & Crafts in Norway and Jaruplund Folkehoyskole in Germany. She has won numerous awards and staged numerous solo exhibitions.

My work is an exploration of complex color schemes and contrasts. I seek ways to bring my work to new levels of my personal interpretation of nature. My work is about color, line, material, form, space, and about art as process that always changes and grows.

Where to stop? How far to push? How little? How much? In this body of work I started with a focus on color. Color is intense. It overpowers me. After working with it for weeks on end, I step back, peel the color away. What is underneath? Something new. Somewhere to grow from again. The thin papers, which I print on, draw on, cut up, mix, are layered endlessly on the canvas. No "found" papers are used. I print them all, using yarns, fabric, seeds, pressed plants and other organic material.

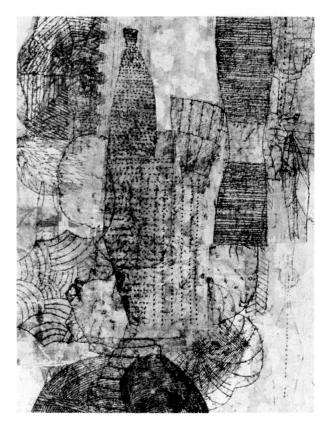

Fission II, 2007. Collage on canvas, 48" x 36". Photo by Nancy Hines.

Shore Lines I, 2007. Collage on canvas, 24" x 36". *Photo by Nancy Hines.*

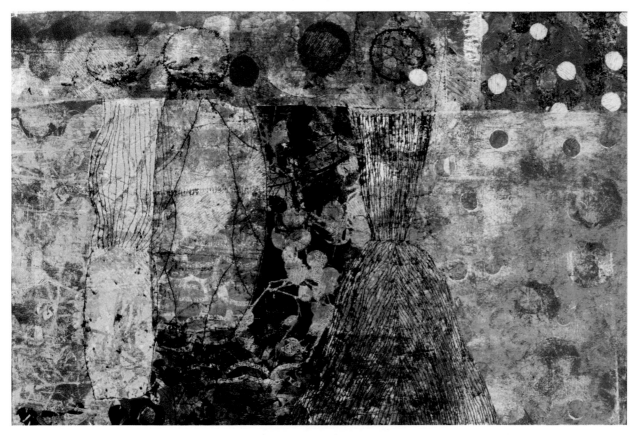

Tilt, 2007. Collage on canvas, 40" x 30".
Photo by Nancy Hines.

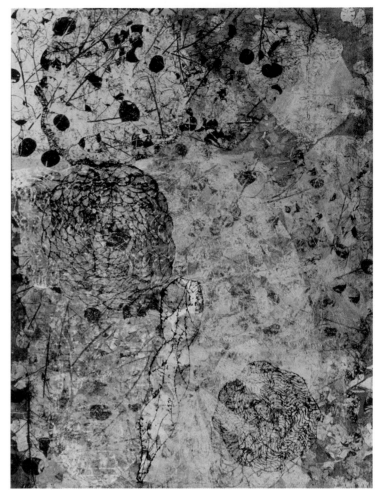

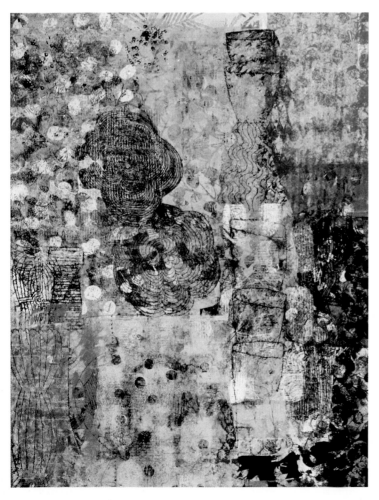

Pulse, 2007. Collage, 48" x 36".
Photo by Nancy Hines.

Eva Isaksen

Craig Kauffman

Frank Lloyd Gallery

Craig Kauffman's work has been exhibited in his native Los Angeles, the United States, and abroad since 1951. Kauffman remains an active and enthusiastically received painter who is equally well recognized for his history of adventurous engagement with new materials. Kauffman is one of the most prominent and influential artists to have come out of the Los Angeles art scene of the 1960s, having shown with Felix Landau Gallery and later at Ferus.

Kauffman's work with vacuum-formed acrylics has achieved iconic status for its sensuous rendering of an experimental medium. In addition to his work with plastics, which continue to appear in survey exhibitions, Kauffman is an accomplished draftsman and colorist. Kauffman's paintings range from the abstract canvases of the 1950s to the silk paintings of the 1980s and 1990s.

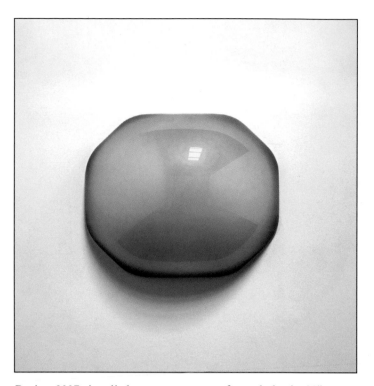

Durian, 2007. Acrylic lacquer on vacuum formed plastic, 32" x 42" x 12". *Photo by Vicki Phung, Courtesy of the Frank Lloyd Gallery.* This work, made from acrylic plastic and spray-painted in subtle, luscious colors, continues the artist's investigation of the medium. Kauffman began his work with vacuum-formed acrylic plastic in the mid-1960s and has periodically returned to the medium as he invents new forms.

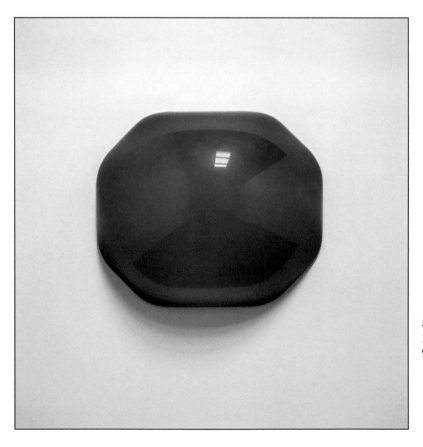

Seresa, 2007. Acrylic lacquer on vacuum formed plastic, 32" x 42" x 12". *Photo by Vicki Phung, Courtesy of the Frank Lloyd Gallery.*

Untitled Dish (Pink) 1, 1994-2002. Drape-formed plastic with acrylic lacquer & glitter, 51.25" x 36" x 7". *Photo by Vicki Phung, Courtesy of the Frank Lloyd Gallery.*

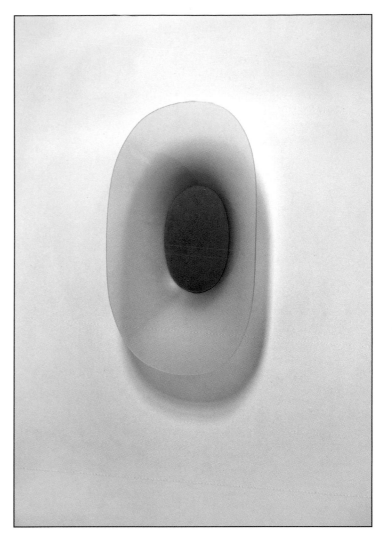

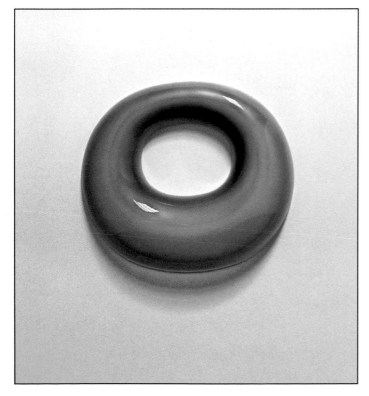

Untitled (Donut), 2001. Acrylic lacquer on vacuum formed plastic, 35.5" x 32" x 5.5". *Photo by Vicki Phung, Courtesy of the Frank Lloyd Gallery.*

Craig Kauffman

Katherine Kean

Tag Gallery / Four Star Gallery

Raised in the Massachusetts area, Katherine Kean graduated from the Rhode Island School of Design before moving to California, where she worked as a motion picture visual effects designer, animator, and producer, before eventually turning entirely to painting. Her work has been shown in numerous solo and group shows, in galleries and museums, locally and across the country. Her work is included in corporate as well as numerous private collections. She is affiliated with the Southern California Women's Caucus for Art, Coach Art, and the California Art Club.

I paint atmospheric landscapes in oils to give shape to the invisible forces of life. Like the point between dream and waking, subtle edges of earth and water, tree and sky, dissolve and reappear, caught at that moment when boundaries are undetermined and reality is malleable.

Beginning with under painting, I modulate the intensity of light that spreads from the center of the canvas. Lines and shapes are defined and then partially obscured. Layer is painted over layer, resulting in unexpected graduations and tones. Elusive shapes are muted by fog or shadow. Imagination's alchemy transforms the recognizable into delicately nuanced layers of color and tone, to gently invoke mystery, sensation, and mood.

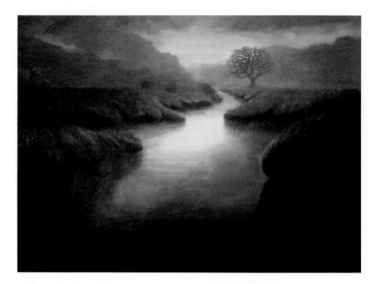

Where the Water Goes, 2008. Oil on linen, 18" x 24". I am intrigued by the unpredictable nature of the waterways in Los Angeles, sometimes disappearing underground for months at a time.

Autumn's Veil, 2006. Oil on linen on panel, 24" x 36". A visual portrayal of a breaking free-a farewell to an illusion, acknowledging the accompanying poignancy of letting go together with the exhilaration of transformation and the mystery of the unknown.

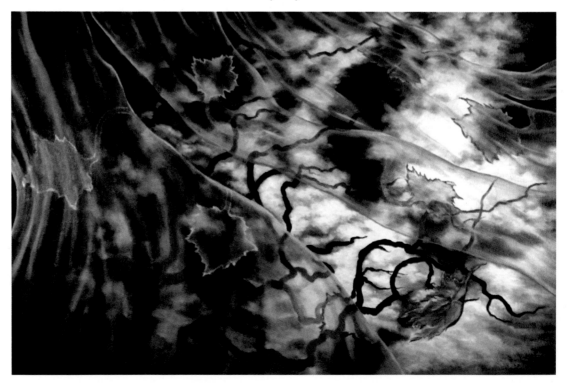

Shades of Winter, 2005. Oil on canvas, 40" x 30". Painted from a remembered dreamscape, an entrance to a world both inviting and daunting.

Thought and Memory, 2007. Oil on linen on panel, 36" x 24". An imaginary journey to Tuscan sunflower fields named after the two ravens of myth.

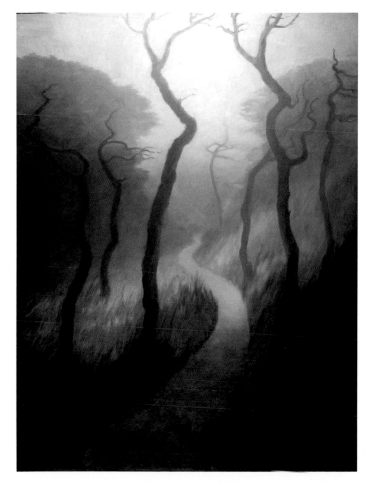

Mist Shrouded, 2008. Oil on linen on panel, 40" x 30". Inspired by the Cypress trees of Point Lobos that seem to mirror the forces of nature and time – their branches like calligraphy from another language, keeping secrets that we can't understand.

Katherine Kean

Lee Kelly

Elizabeth Leach Gallery

Lee Kelly is one of the most recognized artists in the Northwest. His modernist sculptures are a central focus at regional institutions such as Reed College, Maryhurst University, Oregon State University, Catlin Gabel School, the Oregon Health and Sciences University, and the Washington Park Rose Garden. In 2008 the Elizabeth Leach Gallery presented *Doubtful Sound*, an exhibition that included some of Kelly's paintings from the 1950s and '60s. When Kelly switched his emphasis to sculpture in the early '60s the resulting three-dimensional work demonstrates a definite relationship to his paintings from that same period. The sculptures are powerful and organic, much like the paintings. Some display an application of paint on their surface demonstrating the connection between Kelly's two-dimensional and three-dimensional work during these formative years.

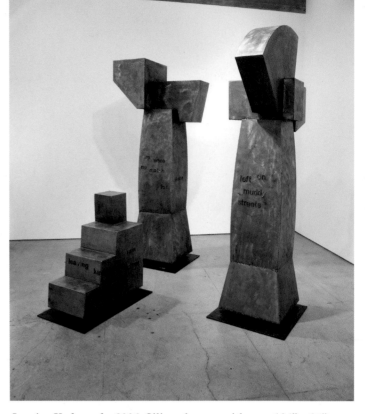

Leaving Kathmandu, 2006. Silicon bronze with text, 104" x 36" x 24", 104" x 48"x 24", 42" x 18" x 35". *Courtesy of the artist and the Elizabeth Leach Gallery.*

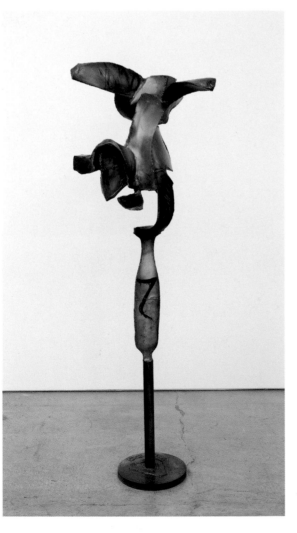

Bird Series I, 2003. Painted welded steel, 78" x 30" x 24". *Photo by Dan Kvitka, Courtesy of the artist and the Elizabeth Leach Gallery.*

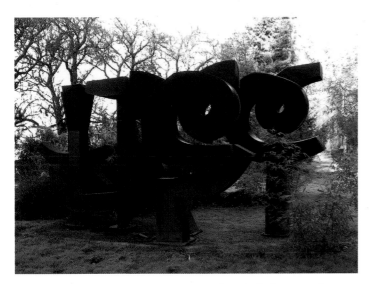

Mughal Garden, 2005. Stainless steel with color, 87" x 76". *Courtesy of the artist and the Elizabeth Leach Gallery.*

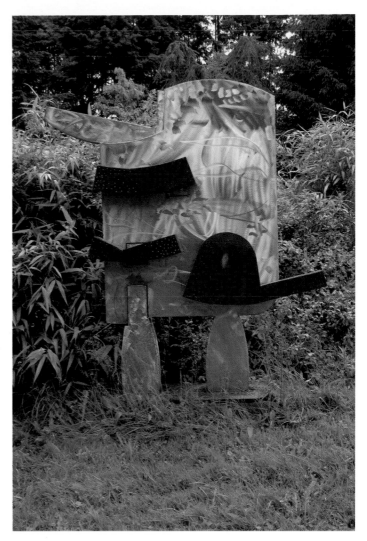

Memory 99, 1999. Cor-Ten steel, 11" x 23" x 6' 3". *Courtesy of the artist and the Elizabeth Leach Gallery.*

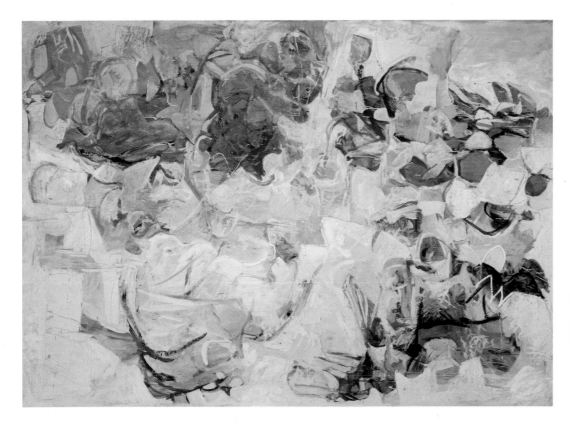

Untitled, 1959. Oil on canvas, 70" x 97". *Photo by Dan Kvitka, Courtesy of the artist and the Elizabeth Leach Gallery.*

Lee Kelly

Michihiro Kosuge

Laura Russo Gallery

Born and raised in Tokyo, Japan, Michihiro Kosuge first studied architecture at the Tokyo Sumida Technical School of Architecture and then went on to receive his MFA in sculpture from the San Francisco Art Institute in 1970. He began teaching art at Portland State University in 1978, becoming a full professor in 1989, and after serving three years as the Chair of the Art Department, retired in 2003. Exhibitions of his work include the Oakland Art Museum, the Portland Art Museum, the San Francisco Museum of Art, and the Seattle Art Museum. Major commissions include Kaiser Permanente Foundation, Vancouver, WA; the Little Tokyo Mall, Los Angeles; River Point Education Center, Spokane; and the Washington County Justice Center, Hillsboro, OR. Most recently, Kosuge completed an extensive five-piece commission for the Portland TriMet Transit Mall.

The interaction of humans with nature and a profound respect for environment have long been issues that inform my work. My interest in combining the natural qualities of stone with hand-made manipulation allows my sculptures to maintain an organic presence as they reflect and integrate with the places they inhabit and, at the same time, establish human connections.

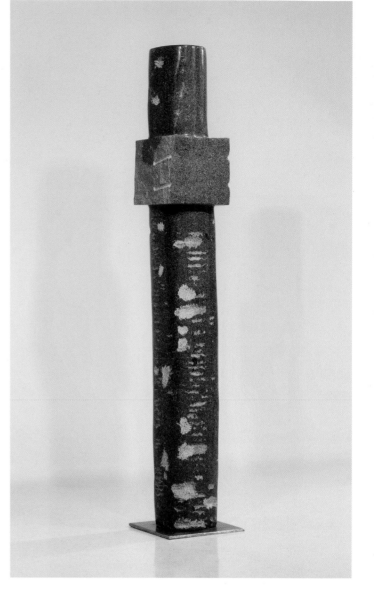

Arbor Series #2, 2008. Granite, 84" x 12" x 13". *Courtesy of Laura Russo Gallery.*

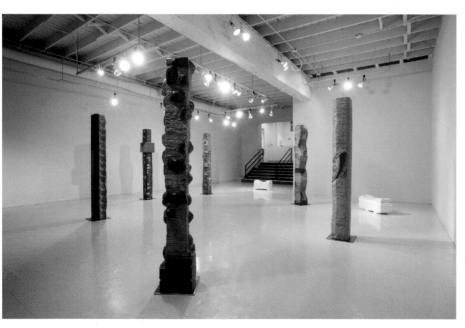

Arbor Series, Installation View, 2008. Granite, size variable. *Courtesy of Laura Russo Gallery.*

Arbor Series #6, 2008. Granite, 84" x 12" x 13". *Courtesy of Laura Russo Gallery.*

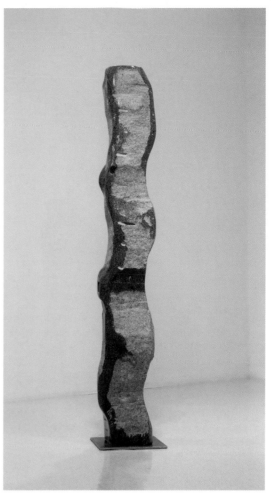

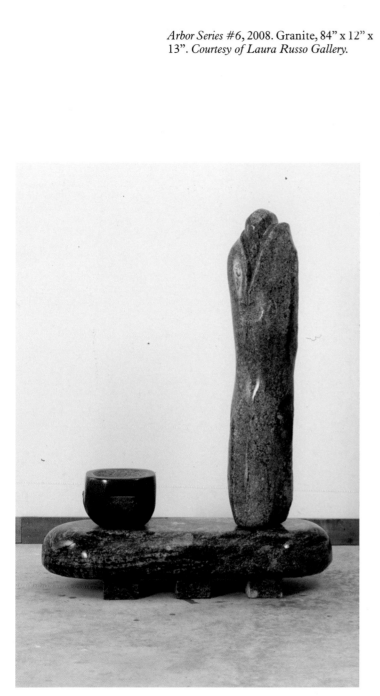

Offer, 2006. Pink granite, black granite, 43.5" x 33" x 14".

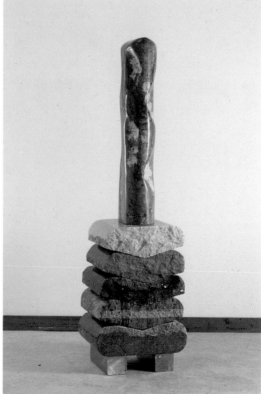

Shari-Den, 2005. Stainless steel, granite, 66" x 16" x 17".

Michihiro Kosuge

Gyöngy Laky

Braunstein/Quay Gallery

My studies at the University of California, Berkeley in the late 1960s and early 1970s (as well as a year-long postgraduate UCB program in India) in visual art, cultural anthropology, and architecture, provided the confluence of interests and encouraged the activism underlying my artworks today. As an environmentalist, my work often employs materials harvested from nature and agricultural sources, with some recycled elements incorporated. I am attracted to humble materials and simple, direct methods of hand construction that I associate with a basic grassroots and human propensity toward crafting things. A fascination with improvised constructions such as scaffolding and fences, has led me to experiment with hand-built structures and materials emphasizing linear arrangements. In both my sculptures and temporary site-specific outdoor constructions, I work in what I consider to be part of the architectural spectrum.

Certain political themes developing over the years have increasingly moved me to express my worries about and discontent with the world around me. In using language and symbols as sculpture, I associate my art with issues beyond just my concern for the rising threats to our environment. The juxtaposition of toothpicks and branches or nails and charcoal, help me to depict the fragile and tense relationships between nature and the flux and folly of human interaction.

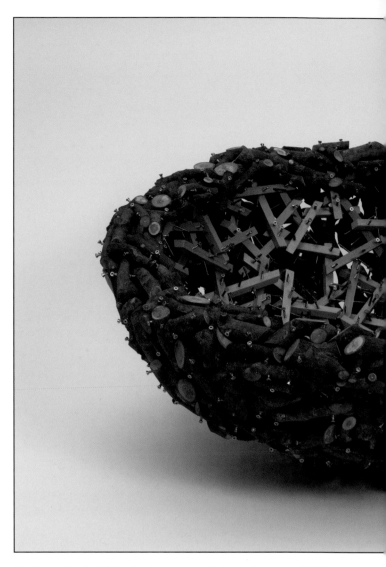

Cradle to Cradle, 2007. Apple, commercial wood, screws, 15.5" x 30". *Photo by Ben Blackwell, Courtesy of Braunstein/Quay Gallery.* Title borrowed from William McDonough and Michael Braungart's 2002 book.

Dada, 2007. Plastic babies, clear construction sealant, 36" x 32" x 1.5". *Photo by Ben Blackwell, Courtesy of Braunstein/ Quay Gallery.*

GO and.., 2007. Ash branches, paint, screws, 40" x 46" x 4". *Photo by Ben Blackwell, Courtesy of Braunstein/Quay Gallery.* Ampersand… end of the alphabet?…27th character?…as when reciting "xyz and" (the Latin *per se*, meaning by or in itself) becoming slurred into *ampersand*.

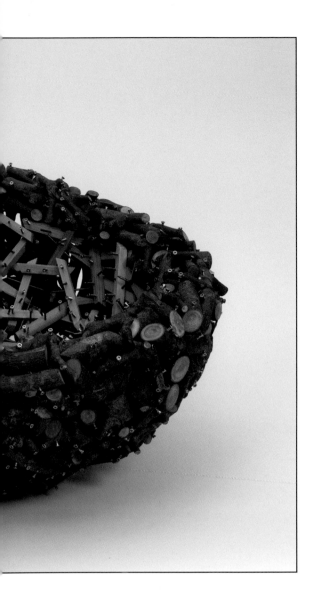

Big Question, 2007. Manzanita, blue ink, bullets for building, 68" x 78" x 5". *Photo by Ben Blackwell, Courtesy of Braunstein/Quay Gallery.*

Globalization IV Collateral Damage, 2006. Ash branches, commercial wood, paint, bullets for building, 32" x 97" x 4". *Photo by Ben Blackwell, Courtesy of Braunstein/Quay Gallery.*

Gyöngy Laky

Carolyn Lord

Nancy Dodds Gallery / Knowlton Gallery / Fairmont Gallery / Bingham Gallery

Carolyn Lord's paintings are a reflection of her surroundings. Since she lives in California, she is able to paint on location throughout the year, responding to the changing seasons' quality of light and color. Carolyn is attracted to design elements in a scene that could be the basis for painting: shadows, sculptural forms, silhouette, perspective, pattern, and color. Her personal interest in plants and gardening shows through in her interpretation of species-specific details of the plants' stems, leaves, and flowers. Architecture and mans' interaction with nature are reoccurring themes as well.

Carolyn Lord is a graduate of Principia College and has attended workshops with California Regionalists such as Millard Sheets and Robert E. Wood. In addition to numerous solo and group shows in galleries, she participates in plein air events and juried shows. She is a member of the California Art Club and the National Watercolor Society.

Summer Hay, 2007. Watercolor on paper, 22" x 30". *Photo by Jim Ferreira.* Summer Hay is a based on a small *plein air* painting that I enjoyed painting. I liked the monolithic massing of the stacked hay bales enveloped in diffused light.

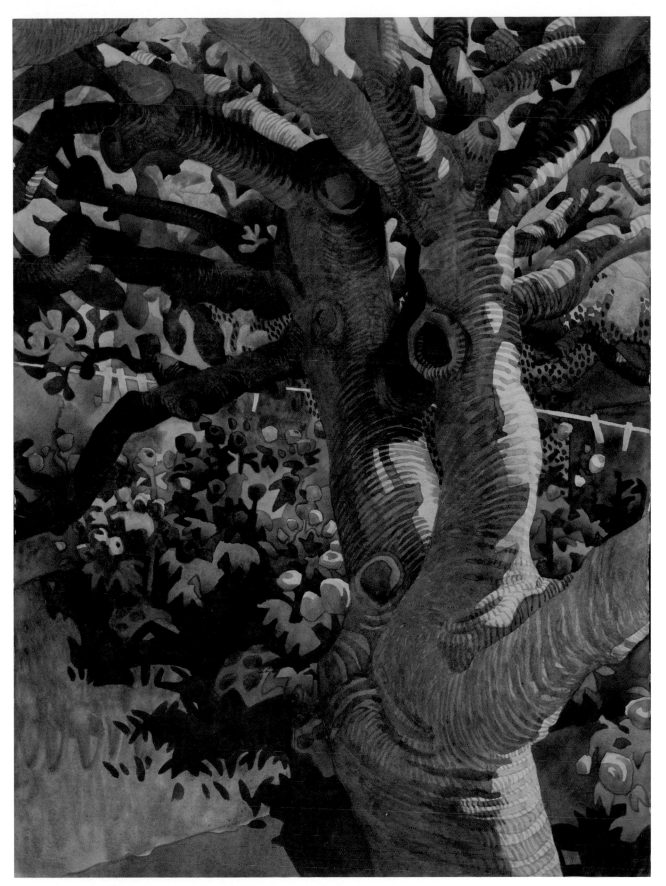

Holly's Fig, 2008. Watercolor on paper, 30" x 22". *Photo by Jim Ferreira.* I painted this the week before Thanksgiving in a fellow gardener's backyard. "Holly's Fig" has been her daughter Holly's playground for swinging and climbing.

Carolyn Lord

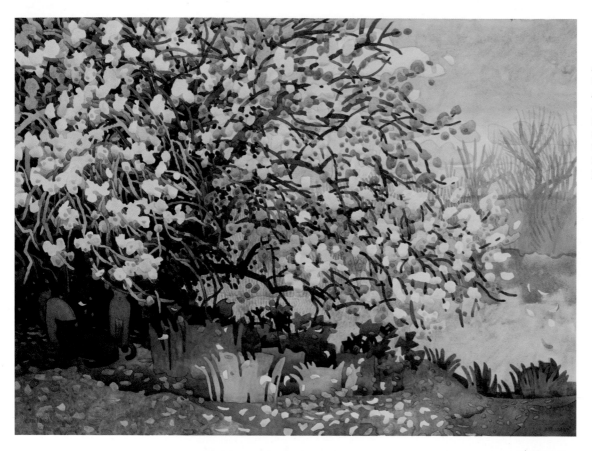

Feral Almond, 2009. Watercolor on paper, 22" x 30". *Photo by Jim Ferreira.* Feral Almond is a scene of the feral cat colony in the wild almond trees at the edge of town. On this overcast February day the subtler colors predominate.

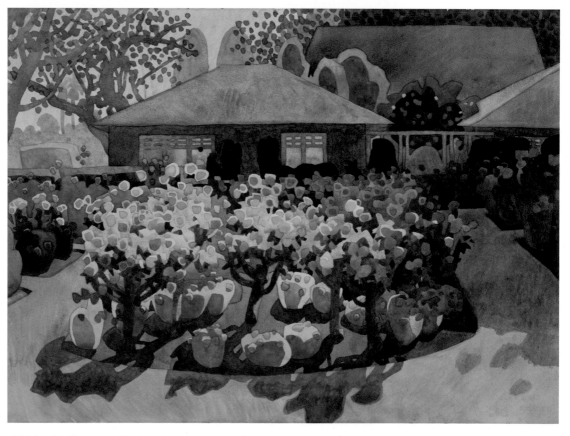

Wrigley Garden, 2008. Watercolor on paper, 22" x 30". *Photo by Jim Ferreira.* The orderly garden of Pasadena's "Wrigley Garden" provided a profusion of juicy-fruit colors. Fortunately, this stately garden had a shady pergola to sit under in the +100° heat!

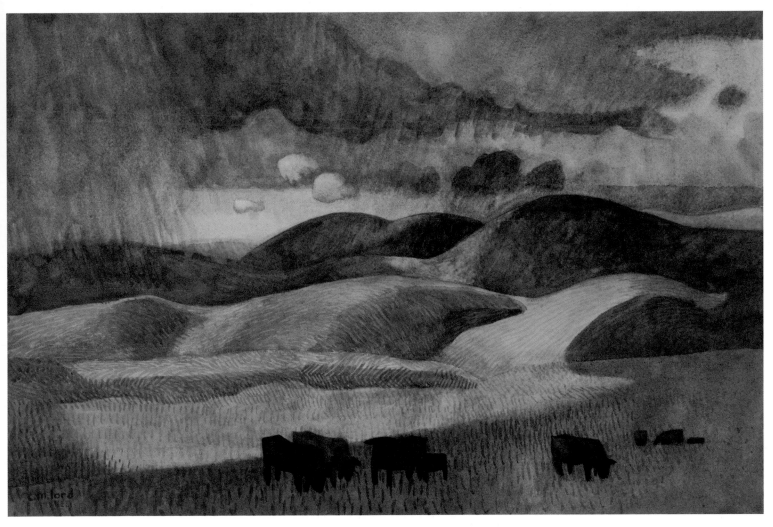

Grazing Fields and Hills, 2009. Watercolor on paper, 15" x 22". *Photo by Jim Ferreira.*
Conceived in the studio, merging two on-locations paintings that weren't successful,
this painting expresses the sculptural landscape and shifting light I had wanted.

Carolyn Lord

Rae Mahaffey

Laura Russo Gallery

Rae Mahaffey studied at the University of Copenhagen, Denmark, and the University of Washington. She moved from Seattle to Los Angeles in 1988 where she worked as a curator for Gemini G.E.L. and as a consultant for David Hockney's studio. She moved to Portland in 1992 to start Mahaffey Fine Art print studio with her husband Mark. Exhibitions include regular shows at the Laura Russo Gallery, as well as exhibits at the Portland Art Museum, Oregon, The Art Gym, Marylhurst University, Oregon, Maryhill Museum, Washington, and the Schomburg Gallery in Santa Monica. Her 2008 commissions include a Washington State Arts Commission for Gray Middle School, in Tacoma and the Pacific First Center, Harsch Investment Properties, in Portland, Oregon.

I am concerned with how various visual experiences affect us emotionally. To investigate this, I use color, pattern, and perspective to describe what surrounds us in the world, often without our conscious awareness. I am interested in how we perceive color and space, and in how we incorporate them into our subconscious. I endeavor to create images that feel surprisingly familiar, but are unlike anything seen before. I want the images I make in paint or prints or glass to be beautiful and engaging, yet reveal another way of perceiving the familiar.

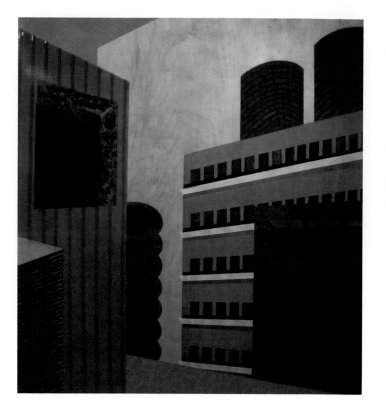

4th & Alder, 2008. Oil on wood panel, 60" x 54". *Photo by Bill Bachhuber, Courtesy of Laura Russo Gallery.*

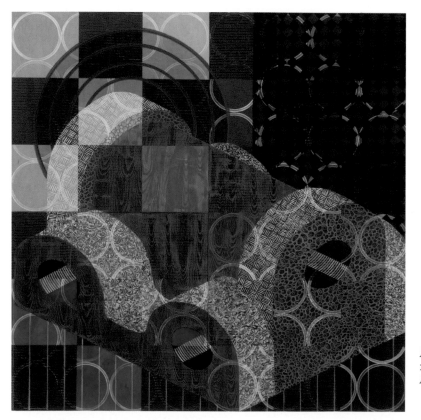

Figure 659, 2008. Oil on wood panel, 48" x 48". *Photo by Bill Bachhuber, Courtesy of Laura Russo Gallery.*

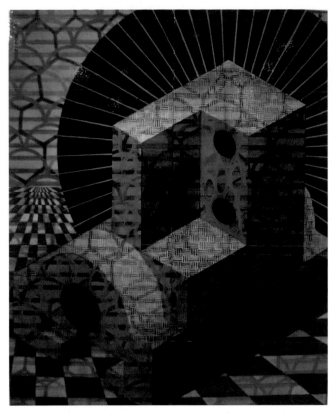

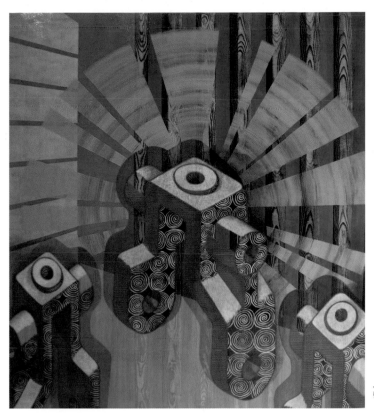

Figure 717 Centering, 2008. Oil on wood panel, 45" x 36". Photo by Bill Bachhuber, Courtesy of Laura Russo Gallery.

Figure 704 Brackets, 2008. Oil on wood panel, 60" x 54". *Photo by Bill Bachhuber, Courtesy of Laura Russo Gallery.*

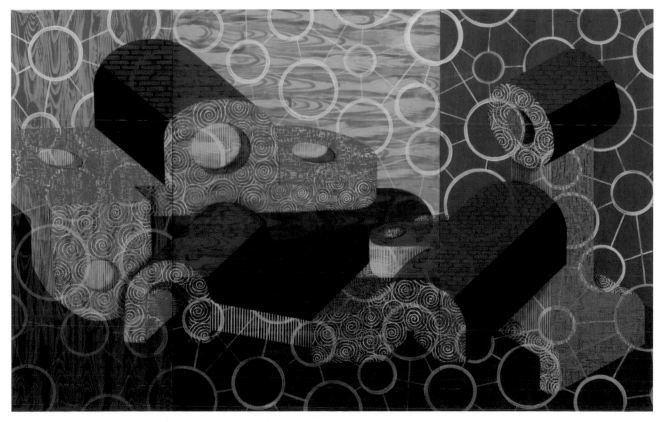

Figures 700, 690 & 671, 2008. Oil on wood panel, 45" x 72". *Photo by Bill Bachhuber, Courtesy of Laura Russo Gallery.*

Rae Mahaffey

Ann Maki

Gallery 110

Ms. Maki has worked with fabrics, threads, and yarns most of her life. Her grandmother taught her the basics of sewing and knitting at an early age and she has constructed clothing for herself since her teen years. With a fashion merchandising and design degree from Washington State University, she modified and altered clothing for people with physical disabilities in the early 1980s, quilted in the mid-1990s, and has turned her focus to fiber art and wearable art in 1997. Her line of framed pieces began in early 2004. Her art pieces have been shown in a number of venues, including the Nordic Heritage Museum, Gallery 110, Artfx Studio and Gallery, Kingston Art Gallery, and Sixth Street Gallery in Vancouver, WA.

My works are two-dimensional abstract assemblages of manipulated hand-dyed cotton fabrics that are embellished with colorful threads, yarns, and machine stitch. High contrast color relationships and textured surfaces are expressive on multiple levels. Application of a torn fabric and opening it up to an embellished fabric beneath, adds a depth and texture that reveals the richness of the healing experience. Elements of the underlying thread sketch flow over the torn layer, softening the harshness of the tear, and bearing witness to new found strength.

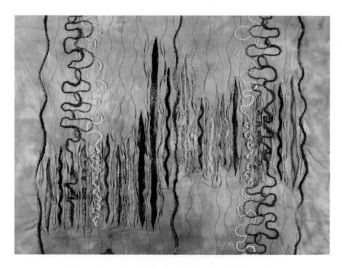

Autumn With A Promise of Spring IV, 2008. Fiber, image, 17.25" x 18.5".

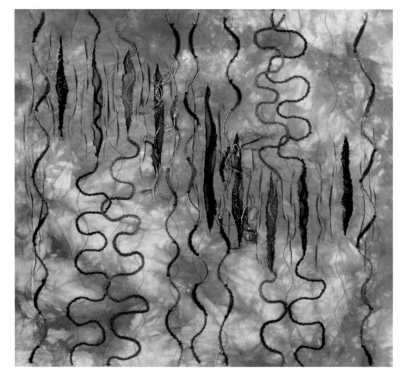

Pretty in Pink, 2007. Fiber, image, 15.25" x 19.5".
Photo by Mark Fey.

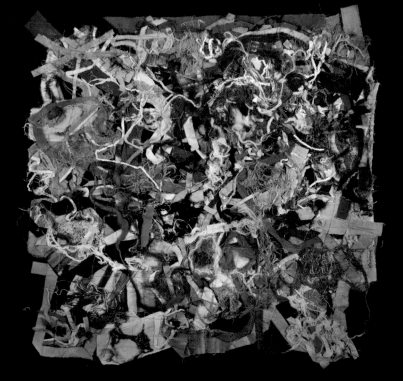

All The Bits Get Used, 2008. Fiber, image. 19" x 19". *Photo by Mark Fey.*

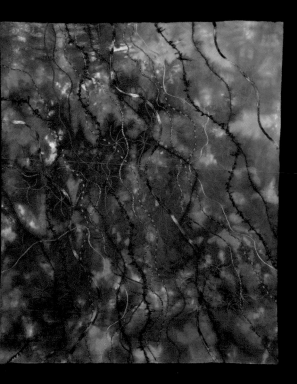

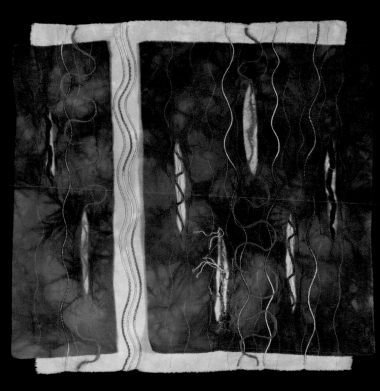

Rusty Purple Thread Sketch, 2008. Fiber, image, 38" x 32.5". *Photo by Mark Fey.*

Split, 2008. Fiber, image, 16.5" x 21". *Photo by Mark Fey.*

Ann Maki

Sharon Maley

Anne Reed Gallery

Sharon Maley paints with energetic spontaneity, interspersing moments of scraping, layering and fusing as she seeks to discover the elusive control over the encaustic medium. She builds up the subtlety textured surface by applying multiple layers of semi-translucent wax, each fused to each other with a delicate heat process ultimately resulting in a rich luminosity. Objects, designs, and pigments are sometimes imbedded into the depths of the wax giving the impression of mystery lying beneath the surface of the painting. Sharon earned a degree in Business Economics from the University of Santa Barbara, CA, then later studied graphic design at the College of Santa Barbara. Her work is held in private collections throughout the United States and has been exhibited in many galleries and private showings.

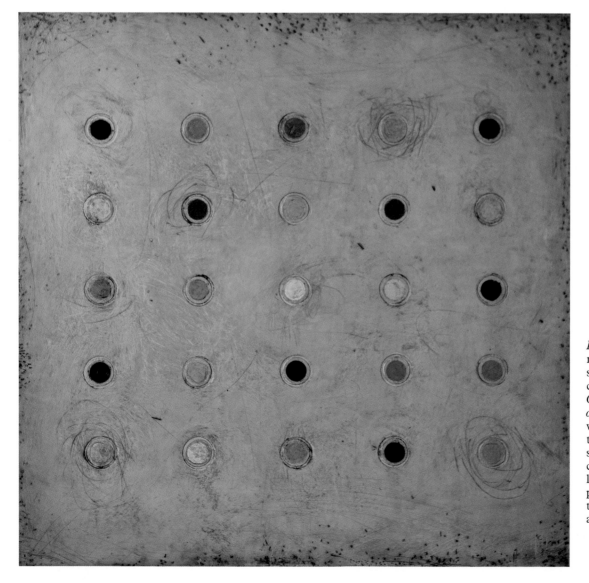

Five by Five, 2008. Pigmented encaustic, pigment sticks, oil, charcoal on canvas, 24" x 24". *Photo by Caroline Woodham, Courtesy of Anne Reed Gallery.* This work is a re-discovery of the concepts of order and simplicity. Relevant to current times where we are learning to scale back, this piece echoes a movement toward less complication and organization.

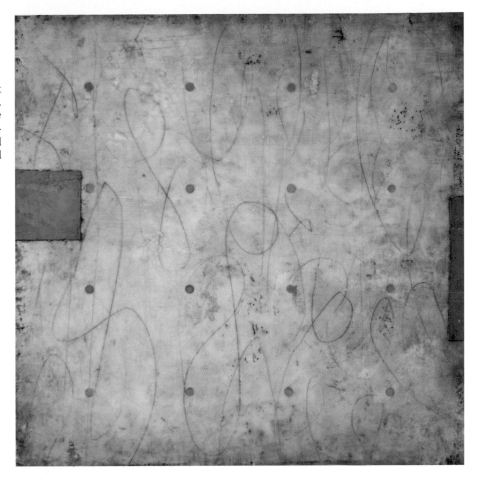

Caress, 2008. Pigmented encaustic, pigment sticks, oil, charcoal on canvas, 18" x 18". *Photo by Caroline Woodham, Courtesy of Anne Reed Gallery.* This work explores the coexistence of order and chaos. It is a multi-layered piece, which involves scribing, carving and scraping to discover the layers below.

Energy, 2008. Pigmented encaustic, pigment sticks, oil, charcoal on canvas, 12" x 12". *Photo by Caroline Woodham, Courtesy of Anne Reed Gallery.* Energy is part of a series dedicated to symbols and writing as a form of communication. These works juxtapose the hard edge ribbon like symbols against the more muted characters that are embedded below the wax surface.

Sharon Maley

Alden Mason

Foster White Gallery / Laura Russo Gallery

Born in Everett, Washington in 1919, Alden Mason earned his MFA from the University of Washington in 1947 and taught painting there from 1949 to 1981. His work can be found in the collections of the Henry Art Gallery, Seattle Art Museum, Tacoma Art Museum, Museum of Northwest Art, San Francisco Museum of Modern Art, Portland Art Museum, Milwaukee Art Museum, and many private and corporate collections. He was selected by the Seattle Art Dealers Association (SADA) to be a part of the Century 21 exhibit at the Wright Exhibition Space in Seattle.

My paintings are a private world of improvisation, sponta-neity, humor, pathos, exaggeration, and abandon. The images and shapes are often figurative, organic, personal totems, which in closer view become highly abstract. They reflect my travels and interest in tribal art and children's art. Old-fashioned emotional involvement is still my main priority in painting.

Rigamarole, 2007. Mixed media on paper, 26" x 35".

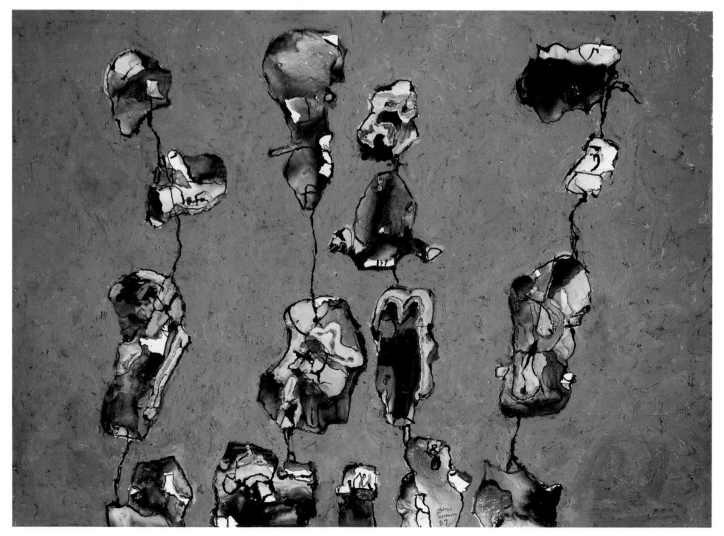

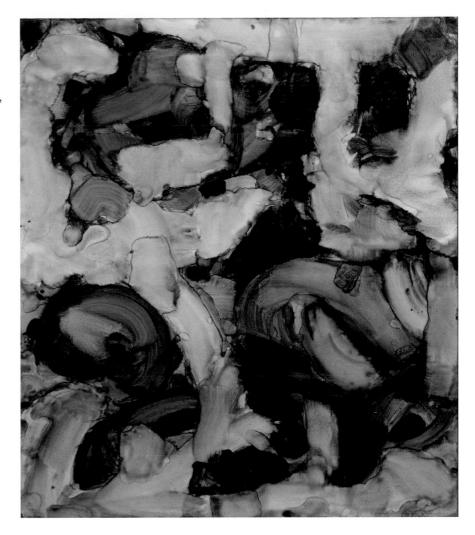

Burpee Red Surprise, 1973. Oil on canvas, 81" x 71". *Photo by Sarah Gilbert.*

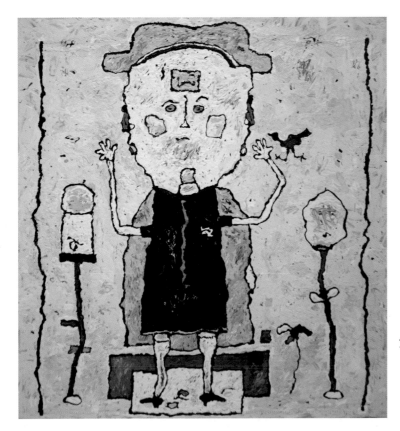

The Last Shaman, 2002. Acrylic on canvas, 60" x 53".

Alden Mason

John Mason

Frank Lloyd Gallery

John Mason works in Los Angeles today, where he has maintained a major presence in the art world since the late 1950s, when he exhibited at the legendary Ferus Gallery. Mason has had one-man shows at the Pasadena Museum of Art (1960 and 1974), the Los Angeles County Museum (1966), the San Francisco Museum of Modern Art (1978), and the Hudson River Museum (1978), among others. In an article published by *Art News*, Suzanne Muchnic wrote, "A major figure in ceramic sculpture, Mason emerged in the mid-1950s as one of the leaders of a revolution that transformed clay from a craft to a fine art medium. His vertical sculptures of the early 1960s have been associated with trends in Abstract Expressionism."

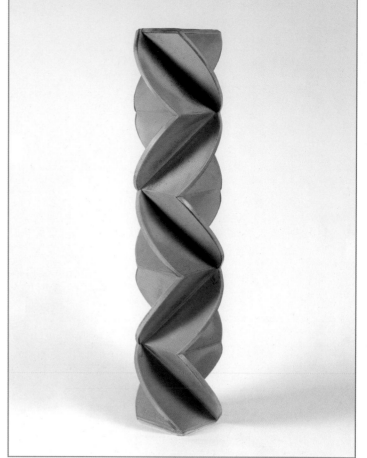

Golden Mystery, 2007-08. Ceramic, 47.5" x 13" x 11". *Photo by Roxanne E. Hall, Courtesy of the Frank Lloyd Gallery.* Throughout his long career Mason has maintained a consistent sensibility and focus. His work in abstract sculpture explores the notions of translation, inversion, reflection and symmetry. These towering, twisting vertical sculptures composed of modular forms continue that exploration. The work incorporates twists, torques, and rotations with surface patterns based on symmetry.

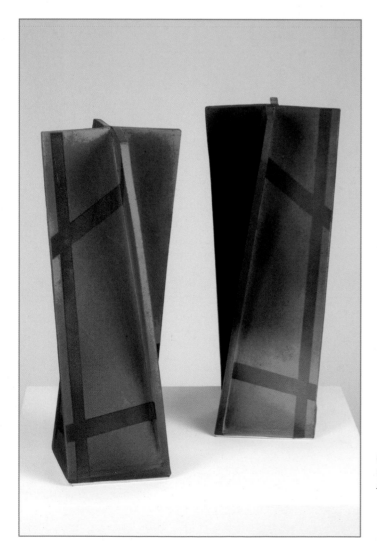

One Pair-Vertical Wraps with Tracers, 2008. Ceramic with dark ember glaze, 28" x 11.5" x 11.5". *Photo by Roxanne E. Hall, Courtesy of the Frank Lloyd Gallery.*

The Gate, 2008. Ceramic, 22.5" x 16" x 16". *Photo by Roxanne E. Hall, Courtesy of the Frank Lloyd Gallery.*

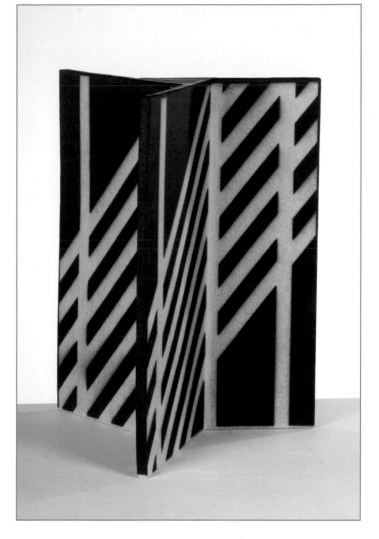

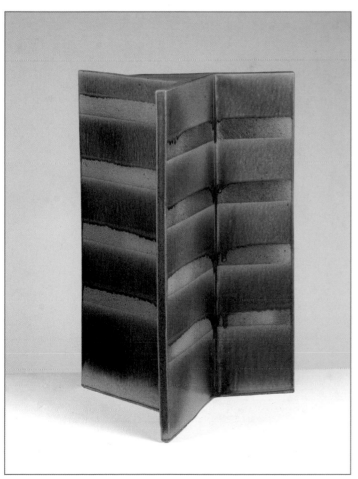

The Storm, 2007-08. Ceramic, 22.5" x 15" x 15". *Photo by Roxanne E. Hall, Courtesy of the Frank Lloyd Gallery.*

John Mason

Michael McConnell

Braunstein/Quay Gallery / Gallery 16

Educated at Columbus College of Art and Design, Michael McConnell has had numerous solo and group exhibitions.

I fear I have no voice. I am awkward and anxious. I don't remember the details of growing up, but long to tell my story. Making art has become my refuge in which to make sense of the world and my forgotten childhood. Inspired by stories that examine loneliness, responsibility, and choice, I am able to explore the tension between youth and maturity.

My drawings, reminiscent of old photographs, blur the line between the observed and the imagined. While the sculptural work, composed of discarded stuffed animals, suggests the uneasy feeling of lost childhood. At first glance the work reads like a fairytale, the playful images of children and animals seduce the viewer into the work. Closer observation strips away the innocent appearance and the viewer is confronted with darker stories of skepticism and failure. I combine these peculiar specific images with phrases, which often become titles, to create work that is layered with narrative possibility.

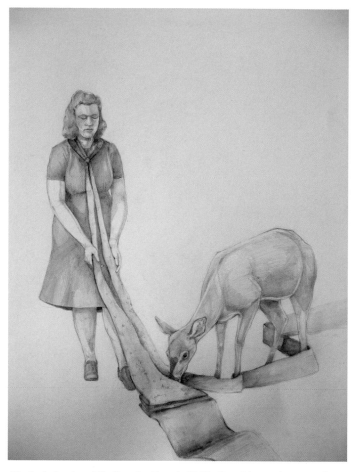

Motherly Instinct (Feeding the Fawn), 2008. Graphite and watercolor on paper, 30" x 22". *Courtesy of Braunstein/Quay Gallery.* The young woman cares and feeds the fawn, an act of her sense of responsibility, which allows a connection in an otherwise life of solitude.

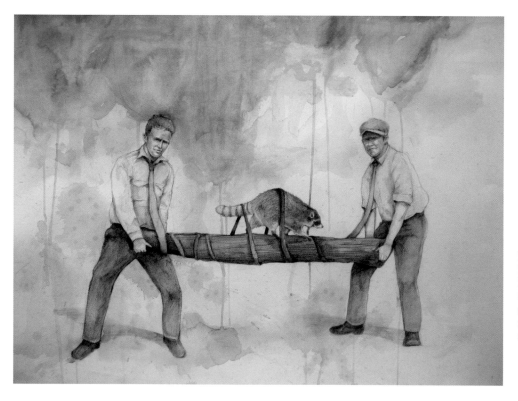

Tree Trappings (Caught in the Middle), 2008. Graphite and watercolor on paper, 22" x 30". *Courtesy of Braunstein/Quay Gallery.* The complexities of relationships and ownership are represented as two men and a raccoon struggle with the ties that bind us together.

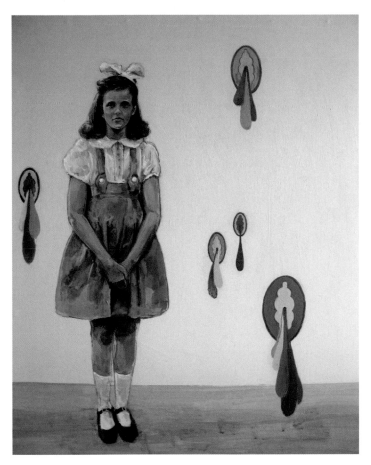

Some Things Remain Hidden, 2008. Acrylic on wood panel, 20" x 16". *Courtesy of Braunstein/Quay Gallery.* A young girl is not ready to expose herself like those surrounding her.

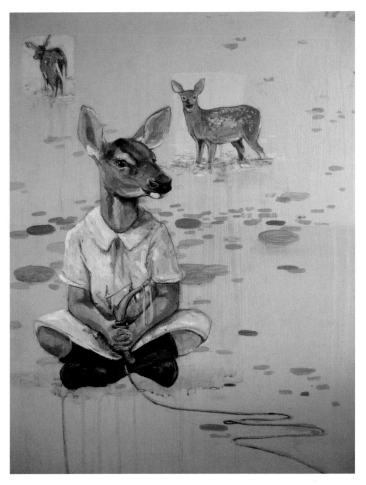

Fragments of Family Loss and Decay, 2008. Acrylic and latex on wood panel, 24" x 18". *Courtesy of Braunstein/Quay Gallery.* Out cast by family, she is left to discover the artifacts of her family past.

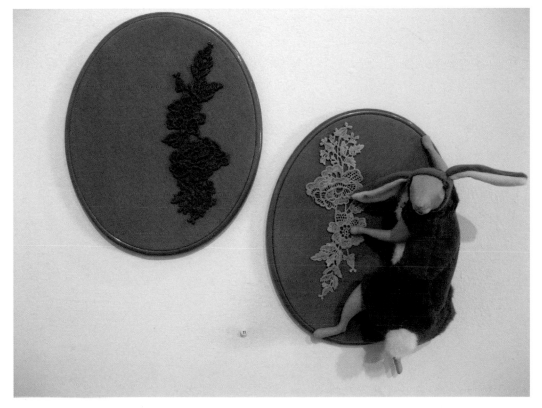

New Growth, 2008. Taxidermy form, fabric, lace, embroidery hoops, latex, and deconstructed stuffed animals, 15" x 19" x 6". *Courtesy of Braunstein/Quay Gallery.* Clinging onto the patterns of our past.

Michael McConnell

Mery Lynn McCorkle

Jancar Gallery

Everything exists on the continuum between energy and matter. Nothing is lost, just shifted along the continuum and redefined. Stars are a dramatic example of the continuum, generating massive amounts of both energy and matter, seemingly creating and destroying simultaneously.

Until recently, stars were considered fixed and permanent. Stars were named after famous people to grant the dead a kind of immortality. We now know about stellar drift. We now know even the stars will die and the universe itself will continue expanding until it unravels into nothingness.

What we see in the night sky has long ceased to exist. The stars we see are memory in the form of light hurled through space. Cicero said that the life of the dead is placed in the memory of the living. Those memories in the living are mere fragments of what was much like the stars we admire at night. The violence of creation and destruction is so beautiful from a distance. These days I find myself longing for beauty.

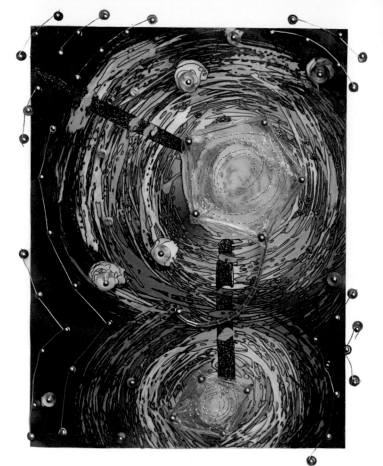

Star Chart 5, 2007. Mixed media: synthetic vellum with acrylic, spray paint, pencil and glitter for lower layer; escutcheon pins, brass wire, beads, rayon, acrylic, auto body pigment for upper layer, 7.25" x 5.5". *Courtesy of Jancar Gallery.* Everything exists on the continuum between energy and matter. Nothing is lost, just shifted along the continuum and redefined.

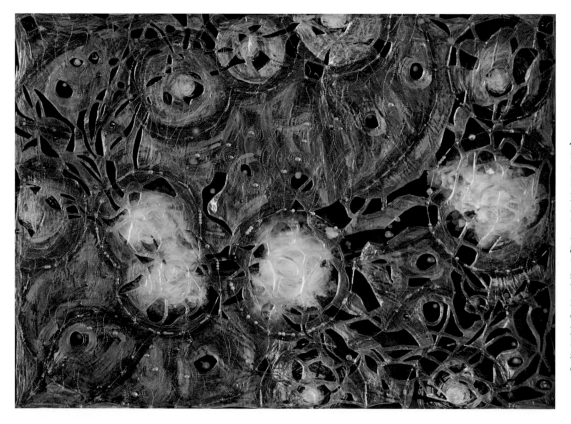

Aries 2, 2008. Mixed media: synthetic vellum with acrylic, spray paint, pencil and glitter for lower layer; escutcheon pins, brass wire, beads, rayon, acrylic, auto body pigment for upper layer (the beads are in Morse Code) 22" x 30". *Courtesy of Jancar Gallery.* Each of the specific star clusters in this series is the astrological symbol of a family member. Until recently, stars were considered eternal. Naming a star after a person was a way of granting immortality, just as painting a portrait was a method of extending a life span.

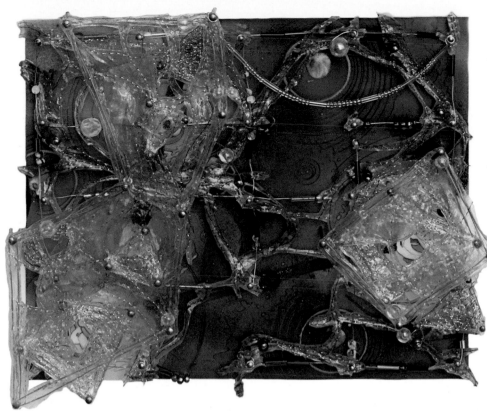

Point of Pisces, 2008. Mixed media: synthetic vellum with acrylic, spray paint, pencil and glitter for lower layer; escutcheon pins, brass wire, beads, rayon, acrylic, mylar thread, auto body pigment for upper layer (the beads are in Morse Code), 6.5" x 7.5". *Courtesy of Jancar Gallery.* Stars embody creation and destruction. From great enough distances, both processes are beautiful, even playful.

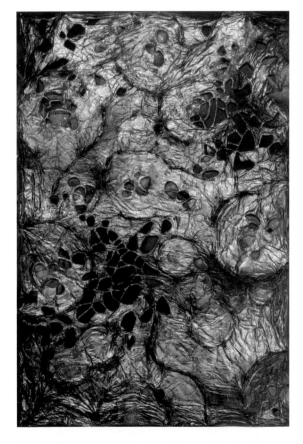

Winter Sky 2, 2008. Mixed media: synthetic vellum with acrylic, spray paint, pencil and glitter for lower layer; escutcheon pins, brass wire, beads, rayon, acrylic, mylar thread, auto body pigment for upper layer (the beads are in Morse Code), 30" x 20". *Courtesy of Jancar Gallery.* Under the top layer in each of these are obsessive amounts of drawing. Even though mostly hidden, the information is not lost.

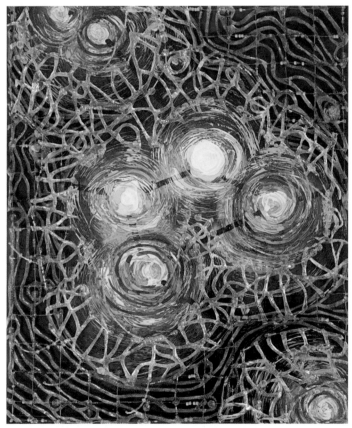

Heart of Sagittarius 2, 2008. Mixed media: synthetic vellum with acrylic, spray paint, pencil and glitter for lower layer; escutcheon pins, brass wire, beads, rayon, acrylic, auto body pigment for upper layer (the beads are in Morse Code), 17.75" x 14.5". *Courtesy of Jancar Gallery.* The bead work in this series is in Morse code. This particular piece reads: You are my sunshine, My only sunshine, Even the stars will die.

Mery Lynn McCorkle

Tom McKinley

John Berggruen Gallery

Tom McKinley's work is meticulously composed in the photorealist style and invite viewers into a series of eerie yet alluring architectural landscapes and interiors. Although predominantly devoid of people, his canvases are often occupied by objects of material culture that suggest human interaction – paintings, books, and beds that are juxtaposed with the clean, spare interiors to hint at lived-in spaces. Tom McKinley was born in Bay City, Michigan, and was educated in England at the Brighton Polytechnic, Ravensbourne College of Art, and the Falmouth School of Art, and Goddard College in the United States. He lives and works in the San Francisco area.

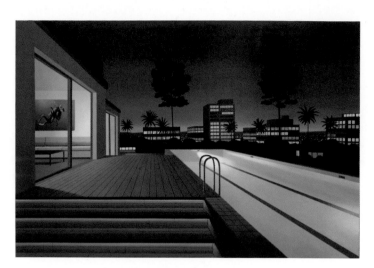

Swimming Towards the Pool, 2007. Oil on panel, 34" x 49". *Courtesy of John Berggruen Gallery.*

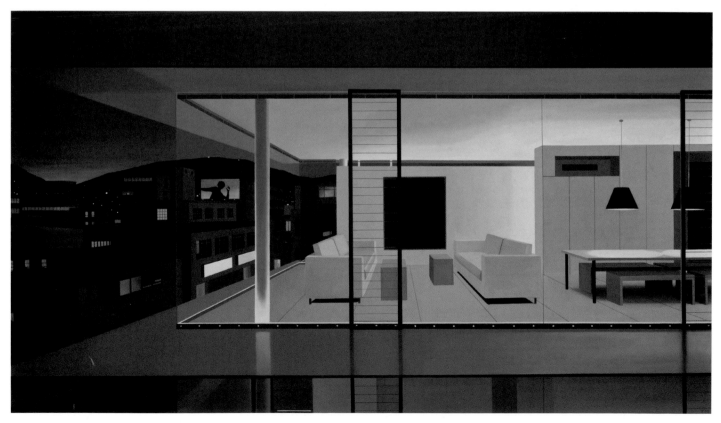

Turn It Up, 2007. Oil on panel, 29.5" x 50.25". *Courtesy of John Berggruen Gallery.*

800 Square Feet, 2007. Oil on panel, 28.5" x 49.75". *Courtesy of John Berggruen Gallery.*

Dark Coast, 2008. Oil on panel, 36" x 50". *Courtesy of John Berggruen Gallery.*

Office Life, 2008. Oil on panel, 24.25" x 47.5". *Courtesy of John Berggruen Gallery.*

Tom McKinley

Cheryl Medow

Tag Gallery

Cheryl Medow graduated from UCLA with a degree in the arts and has worked in a variety of artistic disciplines to reveal "nature's strong song." She worked with pastels, charcoals, printmaking, ceramics, and, for the last decade, photography, aided by a variety of lenses, settings, and 21st century computer and darkroom techniques.

Born and raised in Southern California, I am fortunate to remember it as a very different place than it is now – far less congested and far more rural. My love of nature took root here as a child. My passion to observe wondrous creatures, whether in my backyard, Europe, Africa or Central America continues to educate and delight me. Photographing birds in their native habitat is a powerful reminder to me of the interconnection we have to all creatures. Powerful (and heavy!) lenses have enabled me to visually get closer to the color, light, reflections, and patterns.

Hornbill, 2007. Digital pigment print, 17" x 13". This ground hornbill was preening himself on a gnarly stump in the middle of the Masai Mara in Kenya.

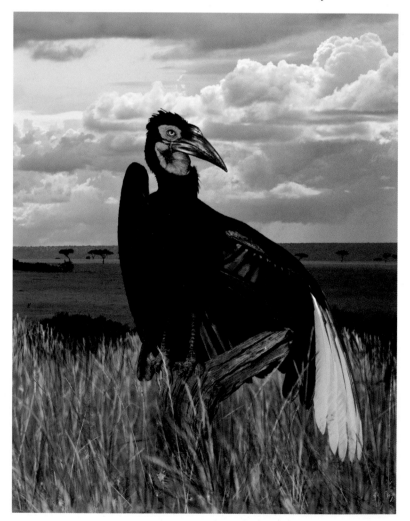

Galapagos Greater Flamingo, 2008. Digital pigment print, 13.5" x 10.5". The colors and the reflection of the flamingo in the water made it impossible not to take this picture.

Cheryl Medow

Secretarybird, 2007. Digital pigment print,
20" x 23". This majestic snake eater is one
of the largest birds in Kenya. I didn't notice
the caterpillars in the tree until I returned
to my studio in Santa Monica.

Desert Green Heron, 2008. Digital
pigment print, 10" x 10.5". I was at-
tracted to the heron's green eye and
observed him for quite a while.

Cheryl Medow

Snowy Egret, 2007 Digital pigment print, 24.5" x 14". This elegant bird was perched on a long branch hanging over one of the meandering canals in Tortegucro, Costa Rica.

Cheryl Medow

Aiko Morioka

Desert Art Collection / The Churchill Gallery

A secret door to hidden potential opened the first time I touched clay. I work intuitively and rarely have a plan, but rather let my hands release the image concealed in the clay or stone. Nature, the human form and themes based in ancient wisdom are a recurring inspiration and presence in my sculptures.

I often use the substructures method of sculpting in clay My first teacher was an Italian stone carver and it was natural for me to approach clay in the same manner. I start with a block of clay and often spend hours twirling the clay around watching for the moment when the form will appear. I am intrigued by the surprise of evolving shapes and how a simple shadow becomes a story. The clay is symbolic of the self; malleable, constantly changing, locked within…a potential awaiting manifestation. It is the metamorphosis. The caterpillar becoming the butterfly.

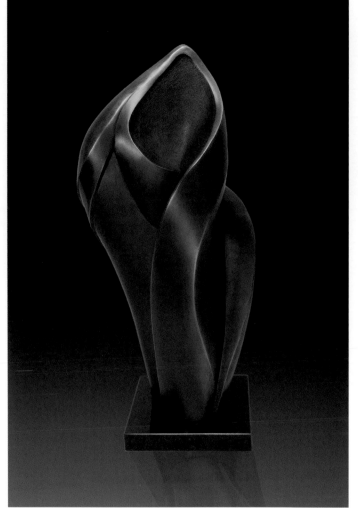

Balanced Vision, 2006. Bronze, 28" x 14" x 10". *Photo by Jemgraphics.* This work was designed to sooth the polarized nature of our world and the friction it causes when forces work against each other rather than in tandem. This piece is about the need to understand both sides; about hindsight and foresight; about listening before rushing to judgment. As with many of the other works in this series, the veiled figure appears to be facing in both directions; there is no back side, but rather an indication that we must look both ways for balance and in that process an inner calm shall prevail and peace can begin to grow.

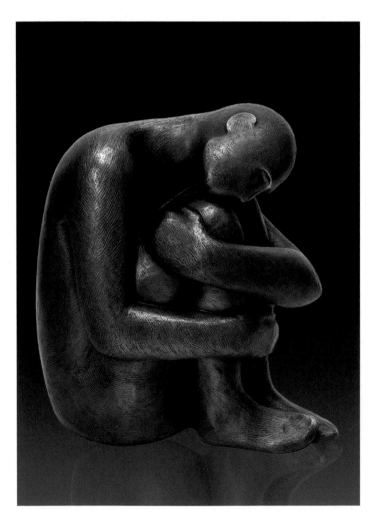

Solace, 2006. Bronze, 20" x 17" x 8". *Photo by Jemgraphics.* There comes a time when we realize we cannot look to the outside for those things we must find within ourselves.

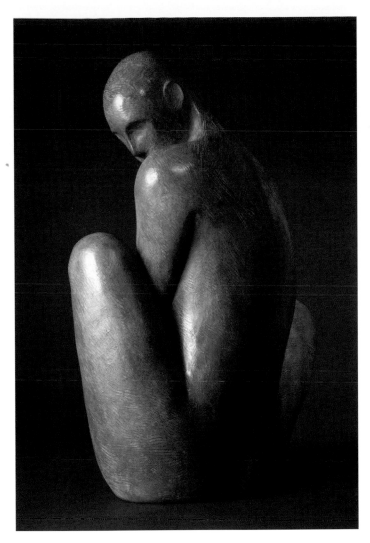

Within, 2006. Bronze, 20" x 17" x 5". *Photo by A. Quintero.* Truth is within us when we still ourselves and listen. The answers lay in the question. All we need do is ask.

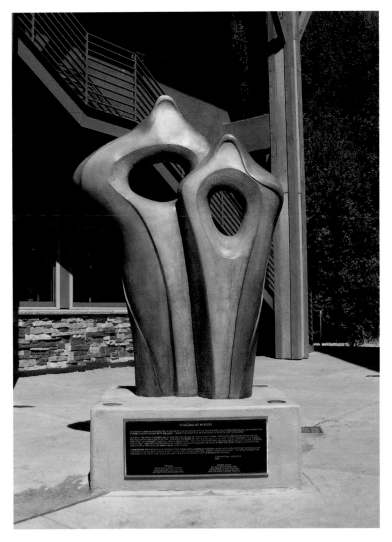

Windows of Wisdom, 2006. Bronze, 6" x 4" x 2". *Courtesy of Creekside Professional Center.* Two veiled figures symbolizing the spirit act as guardians of the land. The opening in the chest area represents an open heart, which creates a portal to the past and that of understanding and wisdom. The figures face forward toward the future, but they also appear to face in the opposite direction, which acknowledges their heritage. A reminder that the future will be far richer when built upon the wisdom of the past.

129 Aiko Morioka

Ann Morris

Lisa Harris Gallery / Lucia Douglas Gallery

Ann Morris's education includes a *cum laude* bachelor's degree in Philosophy from Pomona College, and numerous studies under prominent artists. She has been featured in many solo and group exhibitions.

These pieces come from the forested land of mist and rain, where ravens rule and bones wash up on beaches. I have always been fascinated with bones. They are forms, which grow. Bones are given form by the forces of each individual life and support it, but their beauty is invisible until after death. They are the synthesis of life's function and form, death's architectural remains.

Vessels or boats are expressive of journey. Their forms are pod like, suggesting nature's verdant growth. They float. They shape and are shaped by water, life's principal ingredient.

Plants are one of life's most abundant forms and provide us with the nourishment to continue life. Combining bones and vessels becomes for me a Bone Journey, a symbol of our own journey through Nature and Time. Each of our journeys is one of life and death. These vessels are its echo.

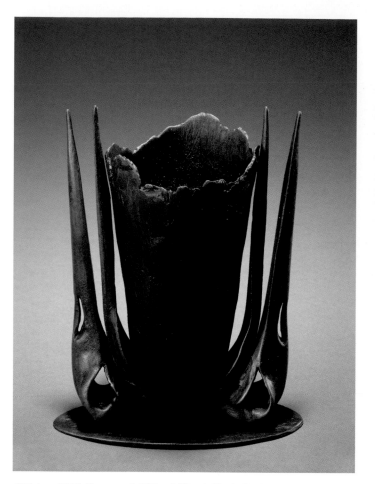

Offering, 2005. Bronze, 8.75" x 6.5" x 4.5". *Collection of Ann Wilson.*

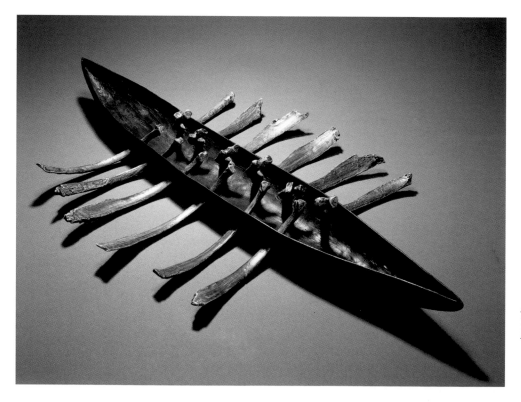

Rib Canoe Bronze, 2003. Bronze, 2.5" x 15.5" x 29.5". *Courtesy of Lisa Harris Galley.*

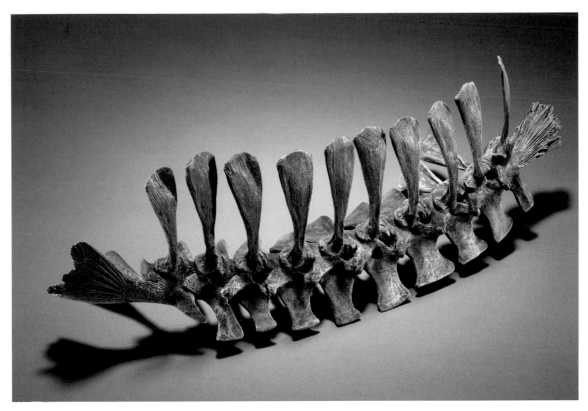

Beached, 2006. Bronze, 5" x 5.5" x 17". *Courtesy of Lisa Harris Galley.*

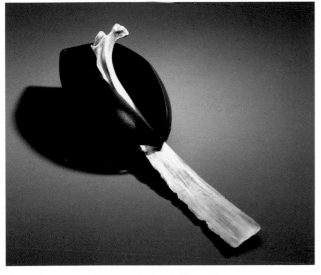

Bone Stem, 2003. Bronze, 6.5" x 5.5" x 18".
Courtesy of Lisa Harris Galley.

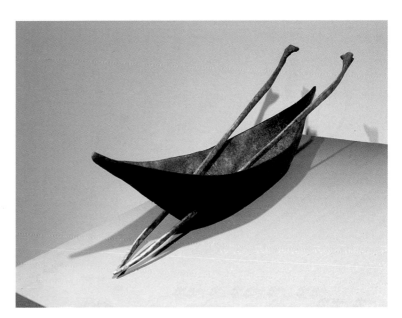

Dive, 2007. Bronze, 10.25" x 34" x 8.25". *Courtesy of Lisa Harris Galley.*

Ann Morris

Ed Moses

Frank Lloyd Gallery

Moses (born 1926 in Long Beach, California), has an extensive history with painting, and his lyrical abstractions of the 1950s and 1960s form a major and self-sustaining body of work. He first exhibited in 1949, and was part of the original group of artists from the Ferus Gallery in 1957. Moses' career was the subject of a major retrospective at the Museum of Contemporary Art in 1996, and his art was featured in the Pompidou Center's recent survey exhibition *"Los Angeles: Birth of an Artistic Capital, 1955-1985."*

His recent work in large-scale paintings creates an open and lyrical sense of pictorial space with swirling and looping abstractions. At over 80 years old, he remains a prolific fixture of the Los Angeles art scene, and is respected for his inventiveness as an artist and his attentiveness to new developments in contemporary art.

The artwork of Ed Moses has appeared in exhibitions around the world, and his pieces are included in the collections of the Los Angeles County Museum of Art, the Art Institute of Chicago, the Menil Foundation, the Museum of Modern Art, the Corcoran Gallery of Art, the Philadelphia Museum of Art and the Whitney Museum of American Art, among others.

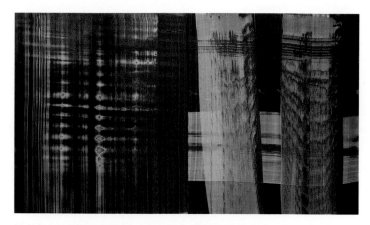

LA Cross, 2008. Acrylic on canvas, 78" x 132" (diptych). *Photo by Vicki Phung, Courtesy of the Frank Lloyd Gallery.* I've been tracking paint on a wet surface for many years. The surface is slurpy and wet and moist. There is no pre-imaging or pictorial ambitions. The tracking is very physical – pushing, shoving, looping, etc. I am not trying to express myself or any image, except when the fool steps in. There are physical obsessions and procedures. The fallout can be apparitional imagery.

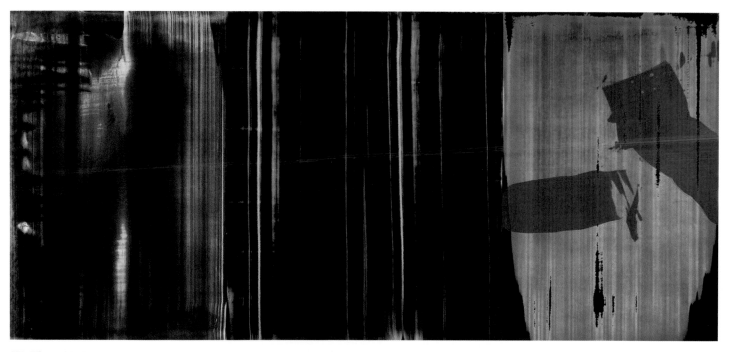

We-Three, 2008. Acrylic on canvas, 72" x 156" (triptych). *Photo by Vicki Phung. Courtesy of the Frank Lloyd Gallery.*

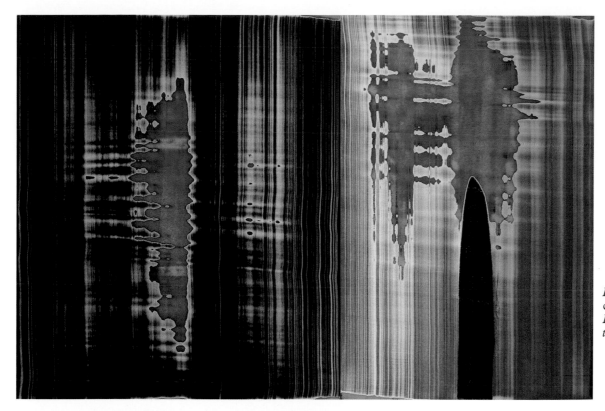

Diamond-Jim, 2008. Acrylic on canvas, 72" x 108" (diptych). *Photo by Vicki Phung. Courtesy the Frank Lloyd Gallery.*

Woo, 1976/2008. Charcoal, India ink, and masking tape on Strathmore board, 39.5" x 29.5". *Photo by Vicki Phung. Courtesy of the Frank Lloyd Gallery.*

Ed Moses

Pamela Mower-Conner

Orlando Gallery

Pamela Mower-Conner received bachelor and masters degrees from California State University, and has pursued further studies at the Otis Art Institute.

The landscape mysterious and intriguing, is always the central theme in my work. My artworks are populated by humans and other creatures, who are always in relationship to this natural element. The scenes I depict are an intertwining of real landscapes with those of the mind. Landforms seem to retain the imprint of past events, this combines with our own personal projections and mankind's long history of nature myths. The resulting landscape is as much about the strata of the mind as it is layers of rock.

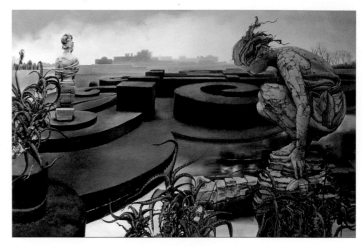

Simulacra, 2003. Acrylic on canvas, 36" x 60".
Courtesy of collection of Charles Seawell.

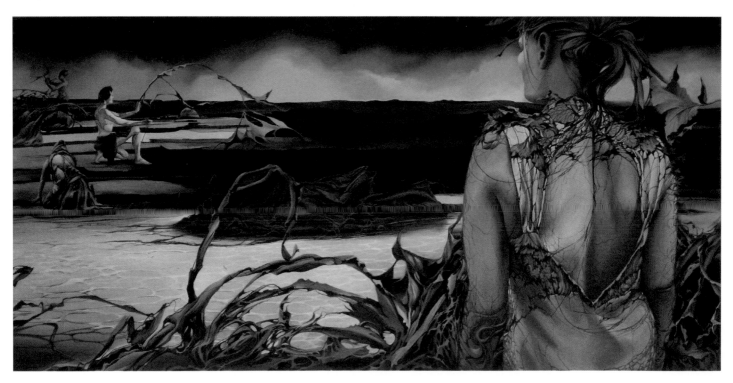

Black Sea, 2003. Acrylic on canvas, 24" x 48".

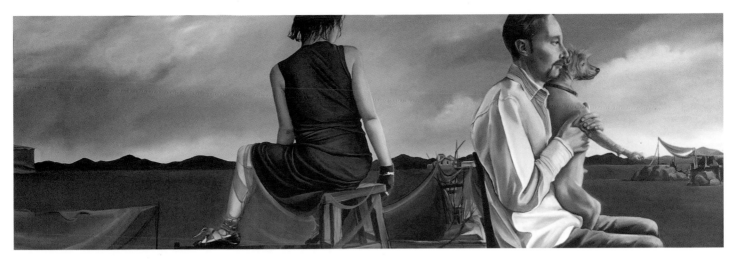

The Haunted Terrain 2, 2007. Acrylic on canvas, 20" x 60".

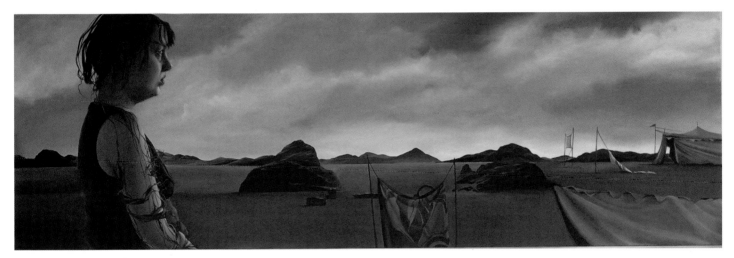

The Haunted Terrain 1, 2007. Acrylic on canvas, 20" x 60".

Interior, 2002. Acrylic on canvas, 6" x 20". *Courtesy of collection of Pamela Gray Tweena.*

Pamela Mower-Conner

Grace Munakata

Braunstein/Quay Gallery / b. sakato garo

Grace Munakata received her MFA from the University of California, Davis, and is a full professor of painting and drawing at California State University, East Bay.

I currently work with acrylic paint, mixed media (colored pencil, charcoal, oil crayon), and bits of collage. I use different kinds of pictorial language so associations can diverge and intersect. Line drawings can lie on patterned backgrounds; a bird may be rendered in paint or represented by a blue and yellow graph of its song. Color, gesture, and tactile surfaces are constants, and literature, nature, and childhood memories are continual sources of subject matter.

In much of my work, domesticity jostles with departure and migration. Traditional Japanese poetry uses puns, double-meanings and innuendo; similarly I want my work to serve as visual metaphors allowing viewers to quilt their own connections.

Moshi Moshi, 2008. Acrylic, mixed media, collage on gatorboard, 31" x 23.25". *Courtesy of Braunstein/Quay Gallery.* Like a nursery wall, flat colored flowers swirl around a diagram of a dress pattern. A drawing of a wooden toy is overlaid; the Japanese rabbit on the moon.

Traveling Entertainers, 2007. Irregular format acrylic and mixed media on museum mount 31" x 23.25". *Courtesy of Braunstein/Quay Gallery.* Traveling entertainers move from place to place. The Indian animal actors leave a forest with branches draped with colored saris, a trick once played on bathers by young Vishnu.

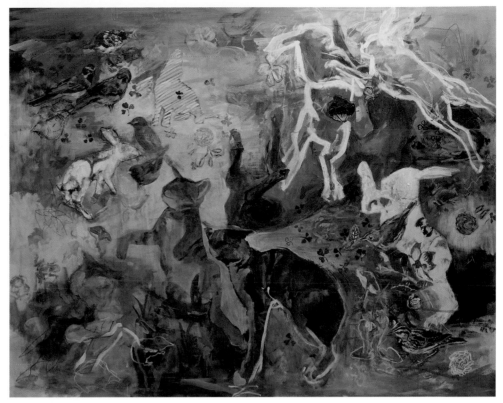

Bestiary, 2008. Acrylic, mixed media and collage on gatorboard. 48" x 60". *Courtesy of Braunstein/Quay Gallery.* Bestiaries were illustrated books which indexed animals with attached moral lessons. Here animals float, box, sleep, and perch with bits of painted embroidery to invoke symbol-laden medieval tapestries.

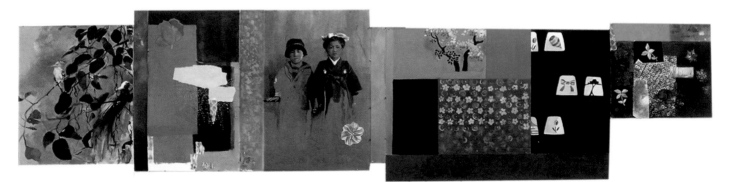

Birds of Paradise, 2007. Irregular format acrylic, mixed media and collage on museum mount, 38" x 72.5". *Courtesy of Braunstein/Quay Gallery.* A photograph of my mother and her brother before they were sent to live in Toyama is central to this piece. Japanese patterns and exotic birds flank their imminent migration.

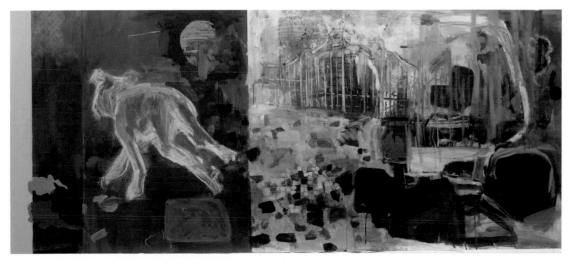

Return Road, 2008. Acrylic and mixed media on gatorboard, 28" x 64.25". *Courtesy of Braunstein/Quay Gallery.* A dog moves through junctures of dusk to night. Leaves scatter in a field. Old tiles and a gate suggest human presence, but open only to outside spaces.

Grace Munakata

Gordon Nealy

Gallery 110

My intent is to capture a purity of thought mimicking states of reverie. I wish to accomplish this by generating less "image," using only one medium, and by sculpting the creamy canvas surface. The medium runs along the surface, collects and slowly dries displaying its submission to gravity. The result evokes a potential kinetic state. As if at any time it will begin moving down the canvas again.

I chose to use the commonplace, liquid Polyurethane, because its utilitarian nature reflects an ordinary connection to commerce and the world. It's clear, tight, glassy surfaces declare the synthetic agent.

Poured onto the rough canvas, pools and blisters of this viscous liquid develop their own unique contrast in textures. It reminds me of something abstract, like energy being trapped in the thick reservoirs. Closer examination of the surface reveals intricate arabesques and cellular elements. This visually suggests human rhythms of systems, tissues, and fluids.

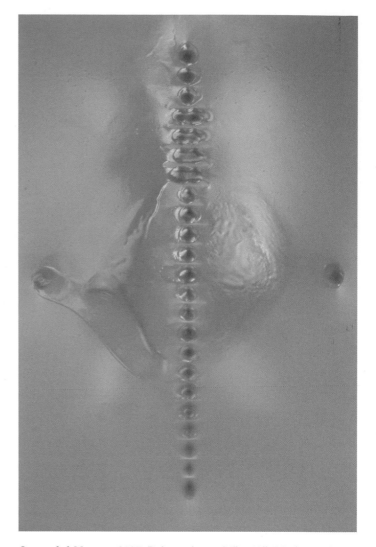

Suspended Memory, 2007. Polyurethane, 36" x 48". My intent is to capture a purity of thought mimicking to states of reverie. I attempt to accomplish this by generating less "image", using only one medium, and by sculpting the creamy canvas surface.

Thought Reservoir No.2, 2007. Polyurethane. 22" x 28".

Across Thought, 2007. Polyurethane, 36" x 48".

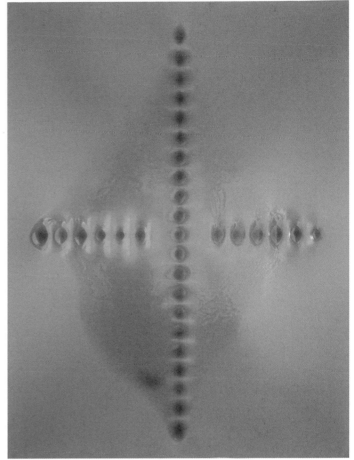

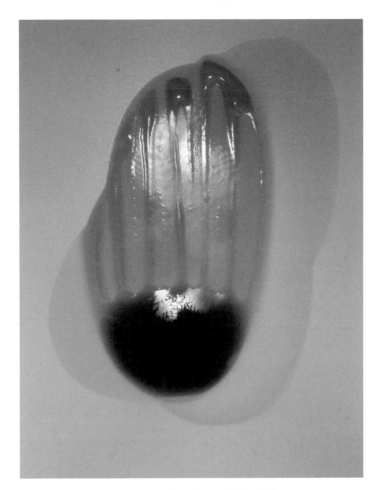

Channeled Thoughts, 2007. Polyurethane, 28" x 36".

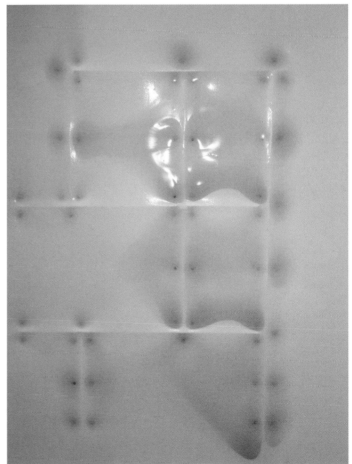

Linear Boundaries, 2008. Polyurethane, 30" x 40".

Gordon Nealy

Royal Nebeker

Lisa Harris Gallery / Augen Gallery

In these paintings I explore existential drama. I am interested in that space existing between the players on stage. My intention is to apprehend the conciliation of form and substance. Only a synthesis of the signified and the signifier can stand. Alone, neither achieves expressive significance. Without question, art can establish values that no other form of expression can reveal. The qualities of those values reside in the space between. Much as the unique content of poetry is often said to be manifest between the lines, so in art that which is visual is often only visible when you know where or rather how to look.

Recognition pre-supposes ethnological cognition. For either the maker or the viewer the déjà vu of self-knowledge comes only in the moment of occupying the space between. The wandering eye, once fixed on that moment falls upon a one-way path to the essence of existence. I am the humble servant of that possibility.

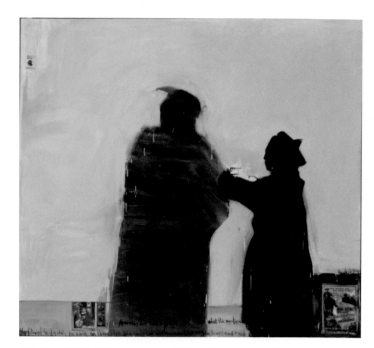

War Cry, 2009. Oil on canvas, 60" x 64". *Courtesy of Lisa Harris Gallery, Seattle.*

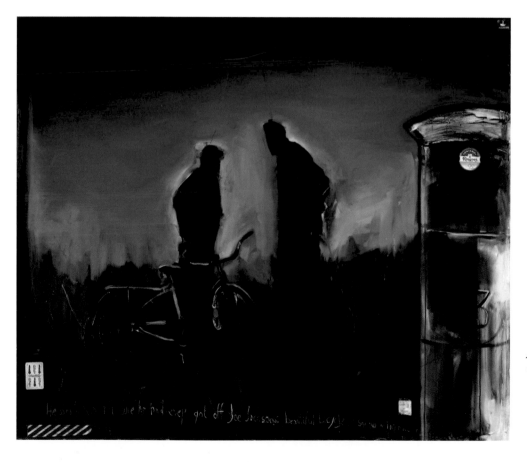

Aside, From Father, 2006. Oil on canvas, 58.25" x 68.25". *Collection of Valerie and Greg Gorder.*

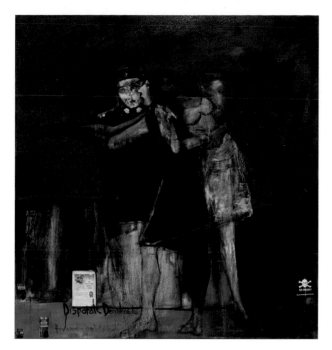

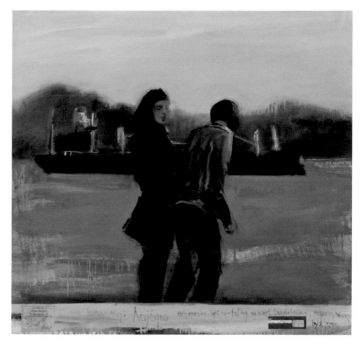

Disparate Desordenado, 2007. Oil on canvas, 68" x 64".
Courtesy of Lisa Harris Gallery.

Adjegas (Moment in Time), 2009. Oil on canvas, 38" x 40".
Courtesy of Lisa Harris Gallery, Seattle.

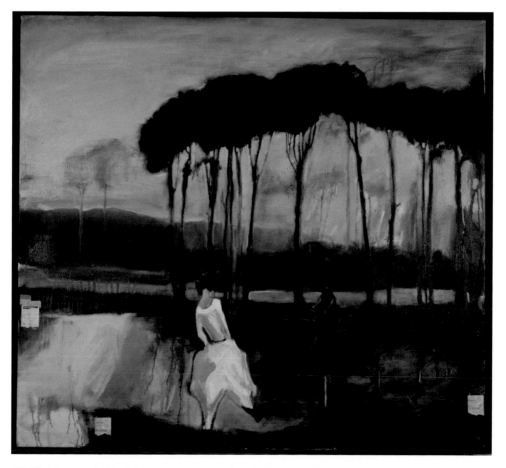

Waking Dream, 2008. Oil on canvas, 48" x 52". *Collection of Kipp and Danette Carroll.*

Royal Nebeker

Glenn Ness

Sue Greenwood Fine Art / Hespe Gallery / George Billis Gallery

I explore city scenes, interiors of restaurants, and places we may frequent, or even rural backyard pools to set a stage for a narrative that explores this quandary. Our lives are full of places and people that come, or who have gone or those we may long to know. My paintings give the viewer the permission to superimpose and examine their own feelings pertaining to the narrative given in each image; i.e. the ubiquitous empty chair implies a presence, or absence that may trigger memory or hope, the story everyone has but many hold secret. Or the empty quiet room that imbues isolation without loneliness, allowing us the freedom to follow thought.

My work is a visual commentary on my perceptions of a psychological and spiritual need to connect; to our surroundings and to each other. I love realism for its ability to express the abstract. I love the process of oil painting for its ability to translate my own need to confess, to connect, to tell a story we may all read ourselves into.

Holiday, 2006. Oil on canvas, 18" x 24". The basic idea behind my paintings is to isolate images that are common, but may have a profound ability to visually stimulate psychological or even emotional triggers; images that connect to our own thoughts or beliefs, to our past, and to each other. A ubiquitous doorway, painted in a certain light might completely change its context from universal to personal.

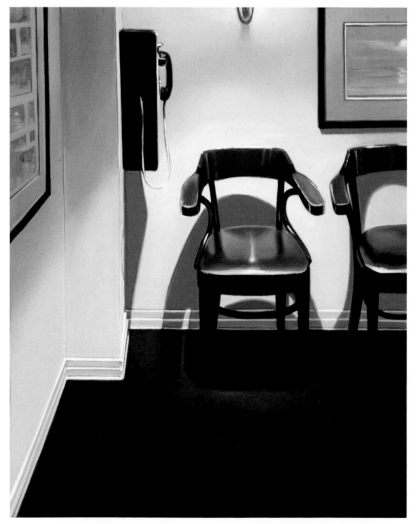

Fifty Cent Call, 2007. Oil on canvas, 14" x 11". The sight of any common object – a chair, a drinking fountain, an empty café, an escalator – may create a context that elicits a powerful response in the viewer when his own experience or memory is added to the act of looking.

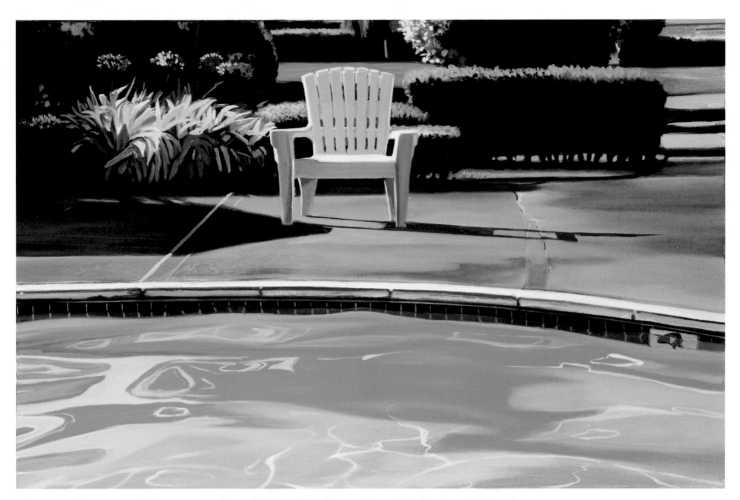

45 Minutes Alone, 2007. Oil on canvas 12" x 18". Glenn Ness lives and works in Southern California. He attended Northwest Nazarene University in Nampa, Idaho and Boise State University in Boise, Idaho. Glenn Ness has exhibited in numerous galleries throughout Southern California and most recently New York.

After the Lie, 2006. Oil on canvas, 12" x 18".

Revolving Door, 2005. Oil on canvas, 36" x 48".

Glenn Ness

Enzo Palagyi

Orlando Gallery

Enzo Palagyi earned his BFA from the Art Center College of Design. He has been featured in numerous group and solo exhibitions in California and New York.

Look up, Look Down, Look Around, That's what it's all about.

Library, 2008. Mix. 36" x 32" x 1.5".

U.R.V (Unmanned Racing Vehicle),
2008. Mixed medium, 25" x 46" x 1.5".

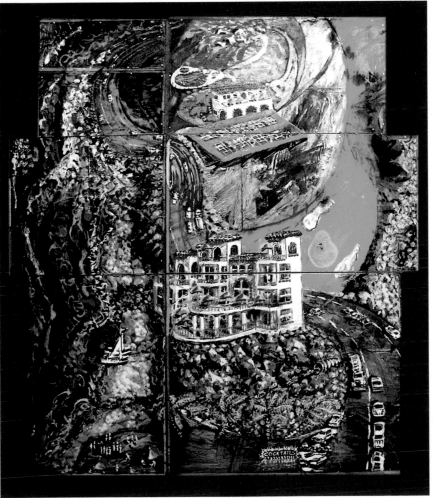

Rehab, 2008. Mix, 36" x 27" x 1.5".

Enzo Palagyi

Lucinda Parker

Laura Russo Gallery

Originally from Boston, Lucinda Parker received a BA jointly from Reed College and the Pacific Northwest College of Art, and an MFA from Pratt Institute, New York in 1968. Her work has been exhibited at numerous one-person shows throughout the West as well as in several exhibitions nationally, including the Corcoran Gallery in Washington, D.C., the Seattle Art Museum, the David Findlay Gallery and the Sue Ellen Haber Gallery, both in New York. The Portland Art Museum honored her with a mid-career retrospective in 1995, and the Boise Art Museum gave her a one-person exhibition in 2002. Parker's work in major public collections include the Boise Art Museum, the Portland Art Museum and the Seattle Art Museum. Public projects include the Lower Columbia College, Longview WA; the Oregon Convention Center, Portland; Midland Library, Gresham, City Hall, Portland; and Southern Oregon University, Ashland.

My paintings are a collision between gesture and geometry. I start out flailing like a windmill and end up in a state of electric cubism with a painting constructed out of frozen urges. I've often wondered where my desire for order wrestled out of chaos comes from. Since I love fat paint, these warring forces finally come to an uneasy truce with heaving layers of color abruptly cut off by contrasting slabs of thick paint. I love black and yellow, so deliciously ugly, the strongest contradiction possible between color and value (which dirties both sides and accosts the eye). Bumblebees and highway warning signs are black and yellow. I hope the end result resonates with natural forms in a bold, lumbering rhythm. My heroes are Stravinsky, Prokofiev, exposed basalt, big clouds, moving water, everything wild.

Where Water Comes Together With Other Water, 2007. Acrylic on canvas, 14' x 44'. *Photo by Jim Lommasson, Courtesy of Lower Columbia College, Longview, Washington.* This painting was commissioned by Lower Columbia College, Longview Washington, for a new campus arts center. Its subject matter responds to the natural and historical features of the region.

Evaporation, Condensation, Precipitation, Percolation, 2008. Acrylic on canvas 6' x 15'. *Photo by Jim Lommasson, Courtesy of Bellevue Towers, Bellevue, Washington.* I started the process for this painting by thinking about what I would see from 40 stories up, looking West.

Laterals, 2008. Acrylic on canvas, 43" x 85". *Photo by Jim Lommasson,*
Courtesy of the Dussin Group.

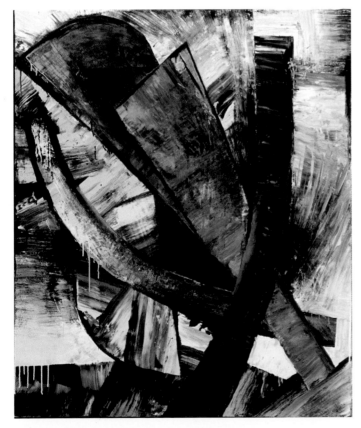

Ikebana, 2008. Acrylic on canvas, 61" x 51".
Photo by Jim Lommasson.

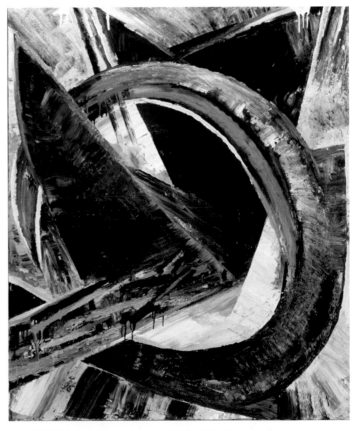

Squill, 2008. Acrylic on canvas, 61" x 51". *Photo by Jim Lommasson.*

Lucinda Parker

Parvin

Susan Woltz Gallery / Gallery 322

Parvin has a BFA from Chouinard Art Institute, and has exhibited work throughout the pacific Northwest and China.

Early picture making experiences taught me to accept, and even welcome the accidental things which happen as I work and to allow my painting materials and painting process to set the program. Only when I'm commissioned to do a painting similar to one I've previously completed, do I have an agenda in my technique or color choices. Most often, I show up in the studio and wonder what image will emerge that day.

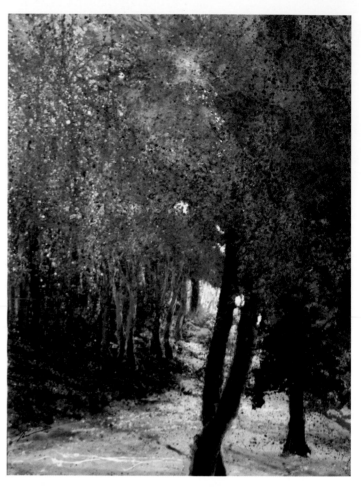

Northwest Woods, 2008. Acrylic on canvas, 40" x 30".

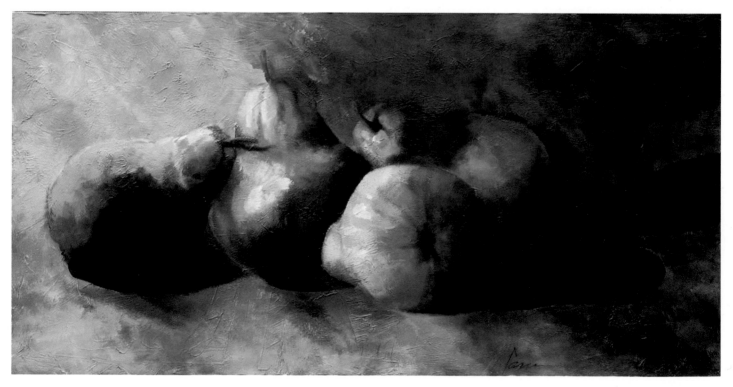

Pears for Carmine, 2008, Acrylic on canvas, 36" x 72".

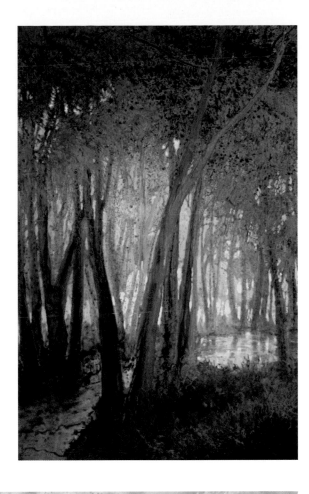

Phototropia, 2008. Acrylic on canvas, 40" x 30".

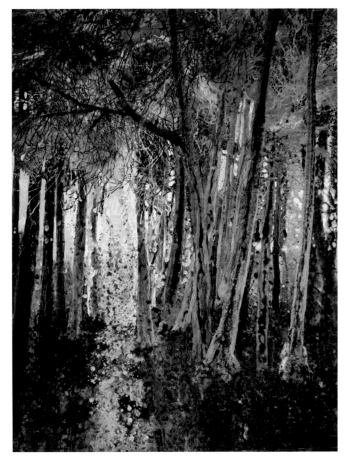

Phototrophia 2, 2008. Acrylic on canvas, 60" x 40".

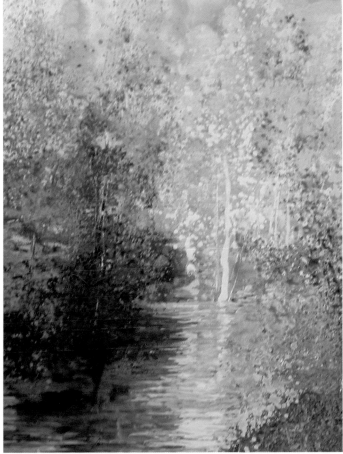

Summer I, 2008. Acrylic on canvas, 48" x 36".

Parvin

Tony Peters

Tony Peters is a Mentor Member of the California Art Club. He draws on his passion for the rich history and architecture of Southern California and, in the tradition of the landscape painter, he combs the city in search of views that inspire a sense of awe. For him, these subjects are tattered street corners, restaurants, train yards, the Los Angeles River, and the vast web of freeways around Los Angeles. Peters was awarded a scholarship to the prestigious Art Center College of Design, and worked as an assistant at the Mendenhall Gallery in Pasadena where he met and later apprenticed painters like Richard Bunkall, Ray Turner, and Mark Ryden. Since graduating in 2000, he has had a prolific career as an artist, with more than twenty gallery exhibitions, feature articles in *Southwest Art Magazine*, and private commissions. Peters continues to travel to Europe and New York, photographing and painting along the way, and finding inspiration in details such as the variety of light cast on the East Coast. But his first love remains the winding metropolis of Los Angeles, where he continues to be moved by the quiet beauty of the screaming city

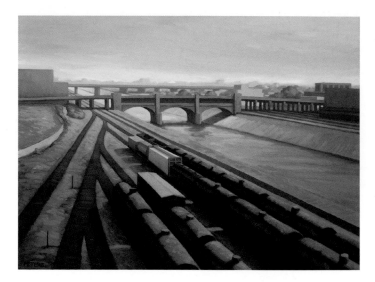

Four LA River Trains, 2008. Oil on canvas, 18" x 24". This area of Los Angeles, just east of downtown, is a world of continuous inspiration for my work. I made an effort to keep the color quiet in this piece, using a limited palette. The foreground trains are rich in darker/warmer contrast to the milky haze of the atmosphere in the receding cooler background. I like the way that those trains are all converging together at this point to make it under the bridge, those tracks they follow help make for a rather interesting composition.

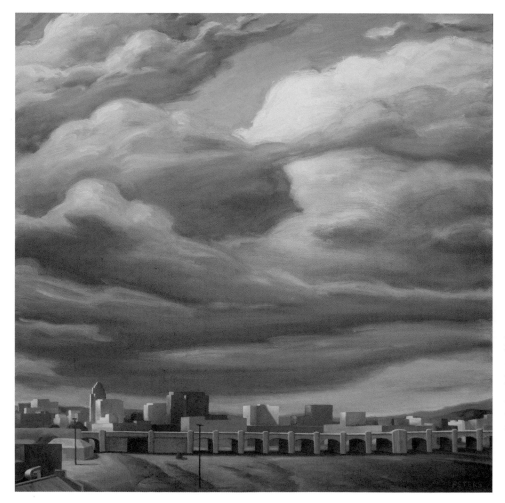

Los Angeles Sky, 2009. Oil on canvas, 20" x 20". This is set in an area just east of downtown by the Los Angeles River, just after the rain. Los Angeles City Hall is the building on the left side of the skyline. I enjoy the juxtaposition of the geometric city buildings below with the organic sky above in this piece.

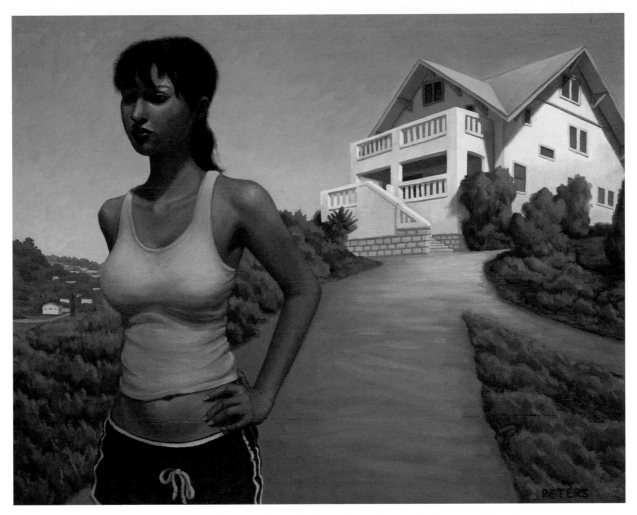

Looking Forward, 2009. Oil on canvas, 16" x 20". There is a kind of mood with this figure and its placement that I was going for, the piece acts as somewhat of a portrait, but with a feeling of anticipation for things to come. In my mind, she wants to move on from this place in order to grow, to start the hero's journey as in mythology. The model is 19 years old, and I remember myself at that age, my greatest desire was to leave the familiarity of home to explore the possibilities that awaited me. Hence the title.

Canters, Fairfax, 2007. Oil on canvas, 36" x 48". Canter's is a really great deli located on Fairfax in Hollywood. I remember going there several evenings when I first moved to L.A. They make a mean Reuben sandwich. I believe that painting a nocturne is a special challenge to an artist, depicting the color of night.

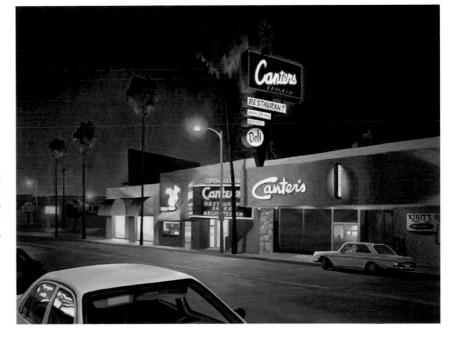

Tony Peters

Aaron Petersen

Braunstein/Quay Gallery / Ruth Bachofner Gallery / Skinner/Howard Contemporary Art

Aaron Peterson has a BFA from California College of the Arts, Oakland/San Francisco. He has participated in numerous group and solo exhibitions since his graduation in 1998.

There is a simple structure upon which I build each painting: control and chaos. I always bring a painting back from the brink of chaos; this balance of looseness and control becomes the foundation I build upon. I am fascinated with the dialogue created as disparate worlds collide. The technological and the natural worlds share an element of ethereal beauty, yet both also wield the duality of comfort and disaster simultaneously. In my work, I attempt to crash a playful sense of color and mark making into something verging on the unsettling. The oozing, dripping, whizzing marks suggest a pending eruption or the steady motion of a churning process indicative of generation and regeneration. A glimpse into an unseen world that surrounds us daily is my aim, and all the while finding myself bewitched by the beauty, lusciousness, and mystery of the paint itself.

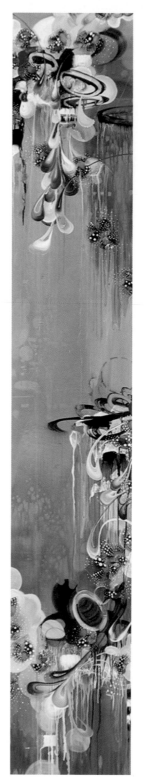

Base Camp, 2008. Oil on aluminum, 72" x 12" x 3". *Courtesy of Braunstein/Quay Gallery.* Technological marks litter the background of a world where it seems the goal is to keep climbing upward, yet it seems a constant stream of characters are in descent as well as ascent.

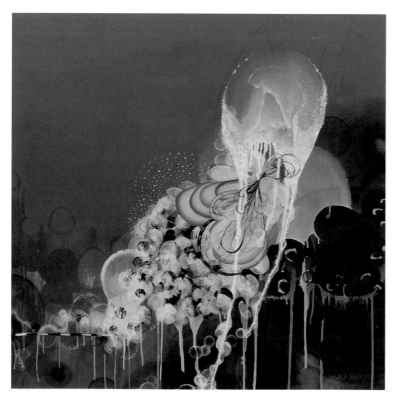

Checkpoint, 2007. Oil on aluminum, 36" x 36" x 3". *Courtesy of Braunstein/Quay Gallery.* A lacy diaphanous character finds itself bottlenecked at a checkpoint. The world behind seems dark and dangerous, yet the lightness on the other side of the gate offers hope.

Aaron Petersen 152

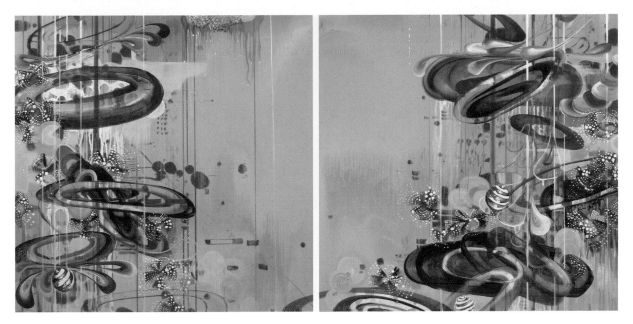

Proving Ground (diptych), 2008. Oil on aluminum, 24" x 48" x 3". *Courtesy of Braunstein/Quay Gallery.* A combination of concrete tones interlaced with bright bursts of color lay the groundwork for a place everyone at one point in their life visits; a place where we must prove ourselves, if even only to ourselves.

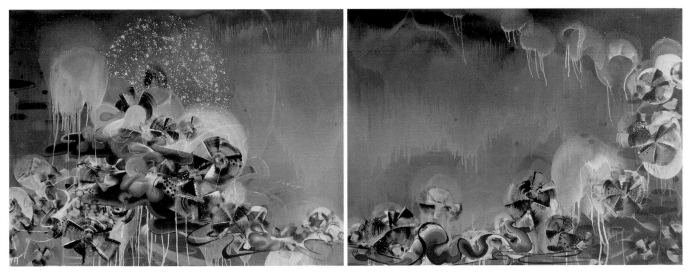

Return (diptych), 2007. Oil on aluminum, 36" x 97" x 3". *Courtesy of Braunstein/Quay Gallery.* A spewing, taffy-like world of spinning gears, wispy ribbon-like paths and pure possibility lead the way out into the ethers. The question is whether a return to this place is the goal or the curse.

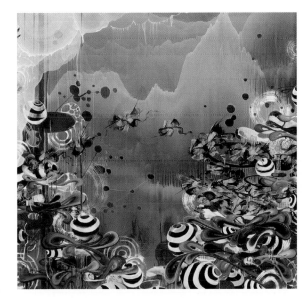

Cradle, 2008. Oil on aluminum. 48" x 48" x 3". *Courtesy of Braunstein/Quay Gallery.* An ominous yet playful nursery is the idea behind cradle. The cradle seems more dangerous and chaotic than the cold, ominously yet serene world beyond.

Aaron Petersen

Andre Petterson

Bau-Xi Gallery / Foster White Gallery / Wallace Galleries

Petterson has exhibited in both private and public galleries in Canada and the United States. He is the recipient of The National Film Board of Canada Award, and has work featured in numerous private and public collections including Canada Council Art Bank, Canadian Airlines, Vancouver General Hospital, and Laxton & Company. Recently, Petterson's focus has been on painting, photo-based works, steel sculpture, and photography. Music has always been a very important facet of the artist's life, whether it be playing, composing, or simply appreciating music. He has explored performance art, film, and kinetic work involving his own music compositions, set design and choreography.

In this series, I combine elements that have long fascinated and haunted me: elements such as the temporal and the absent qualities of light and movement. Being Dutch, I knew Dutch painting from an early age—at least the reproductions on my relatives' walls. Rembrandts everywhere. Cups, pillows, fabrics. What I remember is the light. Rembrandt's use of light was as intriguing, if not more, as his subject. He directs light at the essential elements. Everything else is assumed.

Nightshift, 2008. Mixed media on paper, 24" x 42".
Courtesy of Bau-Xi Gallery.

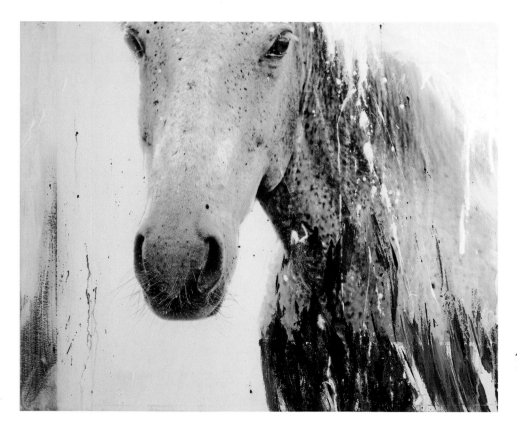

Macula, 2007. Mixed media on paper, 16" x 20".

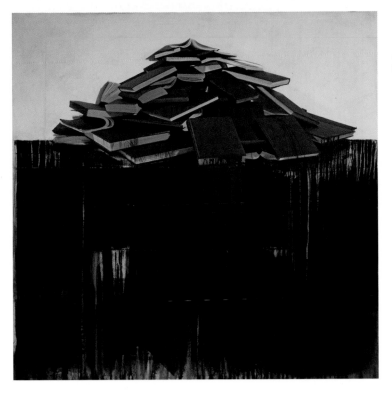

Summit, 2007. Mixed media on paper, 48" x 48". *Courtesy of Bau-Xi Gallery.*

Tumult, 2008. Mixed media on paper. 60" x 48". *Courtesy of Bau-Xi Gallery.*

Upstage, 2007. Mixed media on paper, 24.8" x 23". *Courtesy of Bau-Xi Gallery.*

Andre Petterson

Pamela Powell

Leslie Levy Fine Art

Pamela Powell fell in love with classical art on a trip to Europe as a young woman. She received her first BFA degree in sculpture from the University of New Mexico and later, a second BFA in illustration from the Academy of Art University in San Francisco, joining their faculty in 1995 and teaching painting and composition there for twelve years. Powell has been chosen by jury for The California Art Club's select "artist member" category in 2006. Pam Powell has also been awarded second prize in the 2007 Challenge competition sponsored by International Artist Magazine and the Grand Prize in The Portrait Art Society's annual portrait exhibition in San Francisco in 2002. She is a member of the Oil Painters of America and the Portrait Society of America.

It may sound strange, but I think I have a lot in common with playwrights. I'm concocting scenarios, scouting locations, and directing actors. I edit the material to a single scene, the one I consider to be the most essential moment in the drama, and then I step away without divulging the beginning or the end. The people who respond to my paintings are the ones who can't resist supplying their own storyline.

A Break in the Clouds, 2008. Oil on linen, 36" x 24". *Photo by Owen Kahn.* I love how plate glass windows allow us to see the inside and outside.

A Sure Sign, 2009. Oil on linen, 36" x 24". *Photo by Owen Kahn.* I look for the gesture, the look, the silent communication between the main characters.

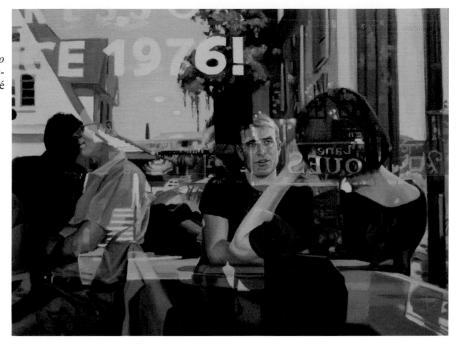

Chemistry, 2008. Oil on linen, 18" x 24". *Photo by Owen Kahn.* I really loved how the reflections of the street and interior of the café combined to make beautiful shapes.

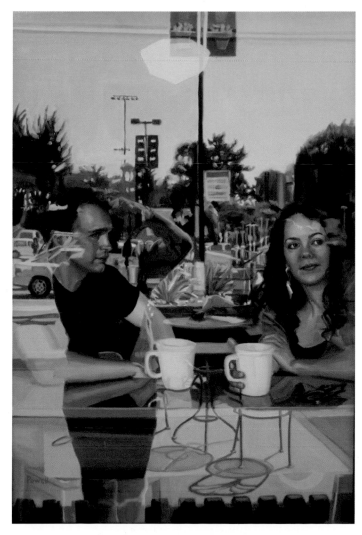

A Lull in the Conversation, 2009. Oil on linen, 24" x 18". *Photo by Owen Kahn.* I am loading more and more layers of visual information into my reflective paintings, I like the abstract qualities that evolve.

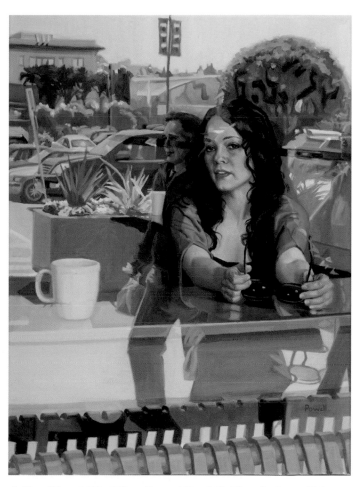

A Clear View, 2009. Oil on linen, 18" x 24". *Photo by Owen Kahn.* This is the first time I used the window's reflection as part of the narrative

Pamela Powell

Paul Pratchenko

Braunstein/Quay Gallery

Paul Pratchenko studied at the Corcoran School of Art, and has his bachelor's and master's degrees from California State University, San Jose. His work is in many collections including the Carnegie Library in Washington, D.C., the Miami Museum of Art, Oakland Museum, and San Francisco Museum of Modern Art.

I have been painting and drawing, as my life's work, for approximately forty five years. During this time, the emphasis of what I do has changed from the more overtly sensational and Surrealistic imagery of the 1960s and 1970s to the more idiosyncratic narratives of today. Much of what I work with revolves around everyday events and the curious nature of ordinary activities.

I have worked extensively in emblematic representations of remembered situations (that is, I've conjured memories and dreams of the "real" world and used resulting images as painting subject matter – I generally work from my imagination). The paintings, acrylic on canvas, are composed of many layers of acrylic resin and paint. While they appear thinly painted, they are the result of a complex layering process. The drawings are most often graphite or charcoal on rag paper with acrylic or watercolor washes and glazes with a final layer of drawing material added to restate the primacy of drawing.

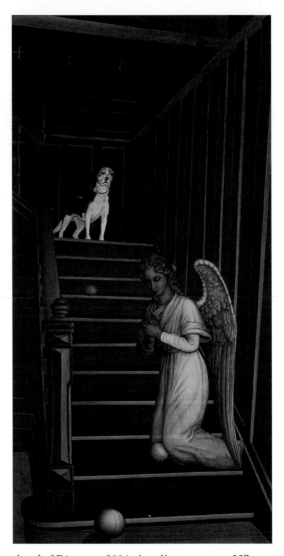

Angel of Pétanque, 2004. Acrylic on canvas, 32" x 61". *Courtesy of Braunstein/Quay Gallery.* Homage to the angel that determines the ultimate placement and trajectory in the game of petanque.

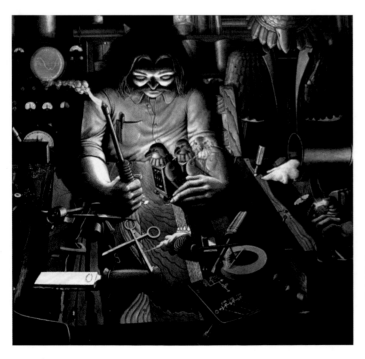

Inventor at the Moment of Invention, 1976. Acrylic on canvas, 54" x 51". *Courtesy of Braunstein/Quay Gallery.* Refers to working for an inventor of flying machines as a mold maker and electronics fabricator.

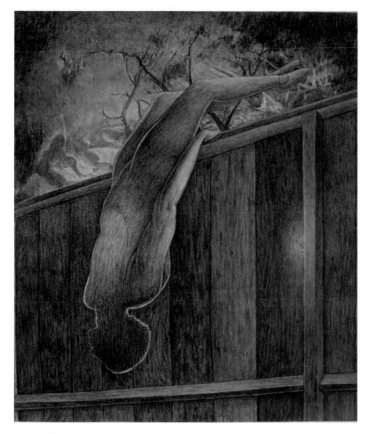

Leap, 2002. Mixed media on paper, 26" x 30". *Courtesy of Braunstein/Quay Gallery.* A clever gymnast avoids the flames at his feet and leaps to safety.

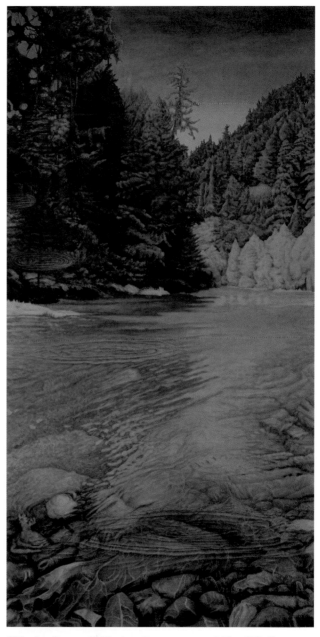

Skipping Stones, 2008. Acrylic on canvas, 31" x 62". *Courtesy of Braunstein/Quay Gallery.* A "takeout" on a trout stream and the similarity of a flat picture plane and the surface of the water.

Possibility of Expulsion from the School for Pirates, 1982. Mixed media on paper, 30" x 22". *Courtesy of Braunstein/Quay Gallery.* An imaginary school of piracy where there exist real consequences for unproductive actions by students.

159 Paul Pratchenko

Barry John Raybould

Lyons Head Gallery / Carmel Art Association

Barry John Raybould, MA. is an award-winning *plein air* artist on the central coast of California. Originally from England, Raybould divides his time between his studios in Pacific Grove California, Venice Italy, and Tuscany Italy. He is an artist member of the prestigious California Art Club, the Carmel Art Association, Laguna Plein Air Painters Association, the Oil Painters of America, and the American Impressionist Society. His work has been exhibited in the Monterey Museum of Art and in the California Art Club's Gold Medal Exhibition in the Pasadena Museum of California Art (PMCA), and is held in many private collections worldwide. In recent years he has won a total of four awards in the prestigious Carmel Art Festival Plein Air competition, including two medal awards for second and third place overall in the competition. More recently he won the top award in the Telluride plein air competition in Colorado. Raybould is also the Educational Director and Chairman of the Virtual Art Academy®, a publisher of online self study art tutorials for both artists and collectors.

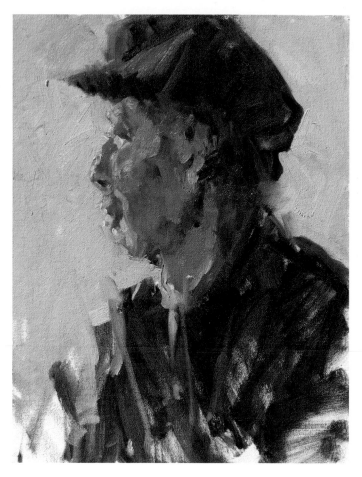

The Farmer, 2006. Oil, 14" x 11". I painted this farmer's portrait on an expedition to northern China in 2005. (Second Prize, Portrait, Seaside Art Competition 2006).

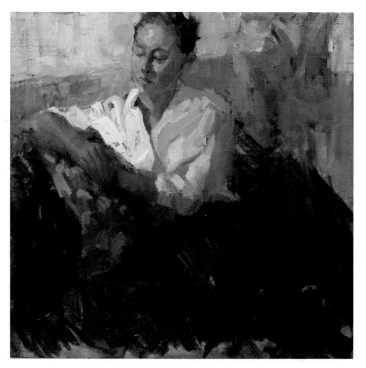

Maya, 2006. Oil, 16" x 16". This painting captured a quiet moment of contemplation, yet the pose was dynamic, enhanced by the vibrant contrast between the red and neutral grays. (96th Annual Gold Medal Exhibition, California Art Club)

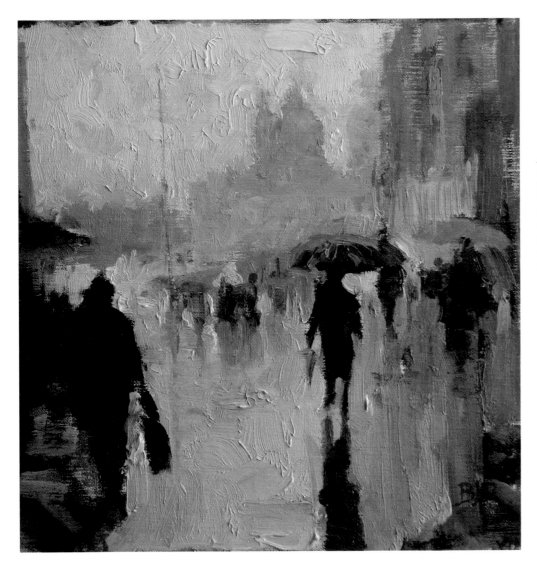

A Rainy Day in Venice, 2007. Oil, 9" x 9". Painted during an extended stay in the Castello district of Venice, one of the few areas where traditional Venetian life still goes on. Rainy weather here brings on a delight for the artists eye with a colorful array of umbrellas contrasting with the gray landscape.

Venetian Lemons, 2007. Oil, 6" x 8". This still life was painted during my stay in the Castello district of Venice. It was a study of the beautiful effects of light on yellow objects.

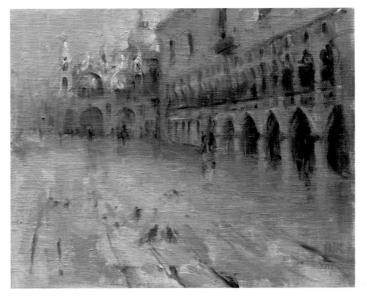

First Light Over St Marks, Venice, 2008. Oil, 20" x 7.8". When the sun first rises over St. Mark's Cathedral in Venice, it creates a beautiful warm glow on the facade. Dawn was my favorite time to paint this magnificent building.

Barry John Raybould

Chris Reilly

Scott White Contemporary Art / Meyer Gallery / Gail Severn Gallery

Chris Reilly was educated at the School of Visual Arts in New York City, and has been exhibiting on the west coast regularly since the early 1990s.

My work speaks of transcendence, often drawing upon nature to depict a sense of universal spirituality. The encaustic wax is a perfect medium to convey my ideas, materializing the various layers of being, from the physical to the metaphysical. Be it an orchid, a dragonfly, a butterfly, a tree limb, or an image of the Buddha himself, I paint these forms set against a luminous and atmospheric background, as a meditative practice to convey a larger dialogue with myself.

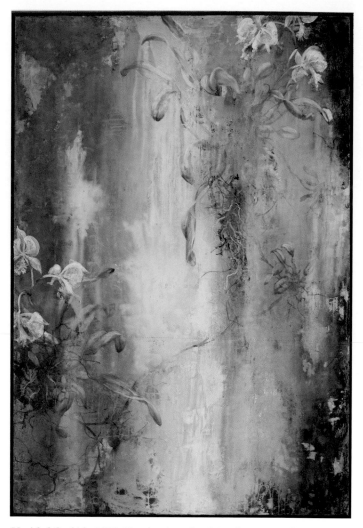

Untitled Orchids, 2008. Encaustic, mixed media on panel/canvas, 72" x 48". *Photo by Chris Reilly Courtesy of Scott White Contemporary Art, San Diego, California.*

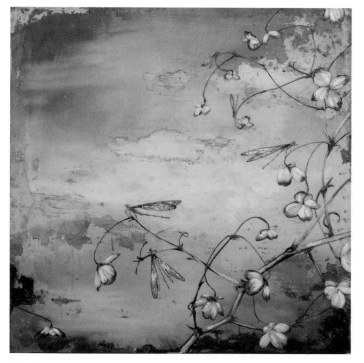

Untitled Damselfly, 2008. Encaustic, mixed media on panel/canvas, 30"x 30". *Photo by Chris Reilly Courtesy of Scott White Contemporary Art, San Diego, California.*

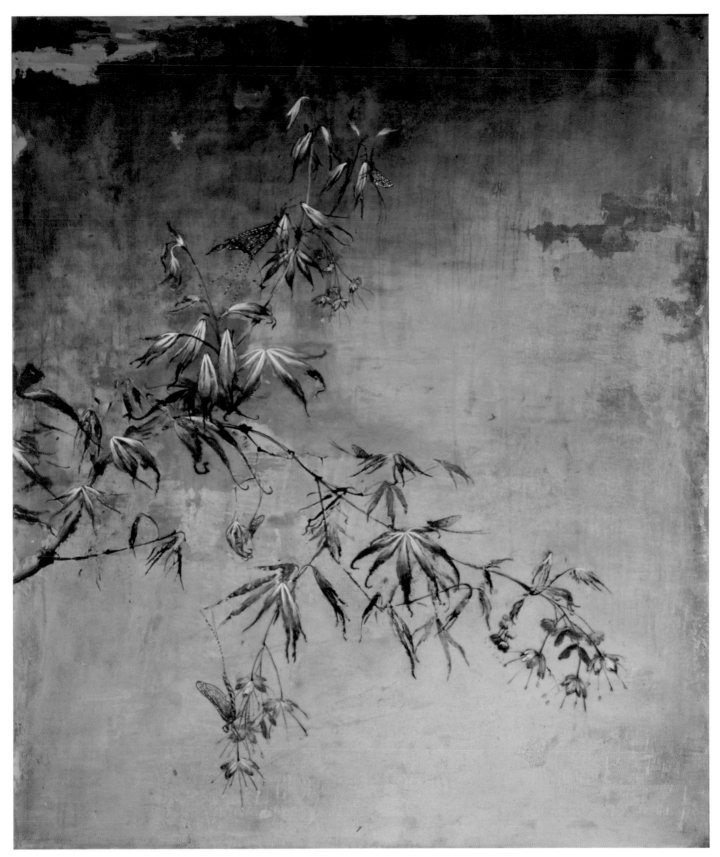

Untitled Mayfly, 2008. Encaustic, mixed media on panel/canvas, 48" x 40".
Photo by Chris Reilly, Courtesy of Ms. Blayne Harvey, Encinitas, California.

Chris Reilly

Will Robinson

Foster White Gallery / Bau-Xi Gallery / Susan Street Fine Art Gallery

Will Robinson's stone sculptures are part of public collections throughout the United States, including the Bellevue Botanical Garden, the Arts Commission in Bellevue, Washington, and many private collections.

My work has always originated from a personal need to create, to bring a vision from the ephemeral to the physical. I have always favored stone as a primary medium with its enduring solidity and resistance to the ravages of time. My inspiration is drawn from the sum of my life experiences, then amplified or muted to fit my emotional state at the moment when I am actually creating, designing, or working. I have an appreciation for the irregular over the straight line, the natural over the manufactured. While I seek to achieve visual impact with my work, equally important is the experience of actually touching the work, as to involve the viewer more personally.

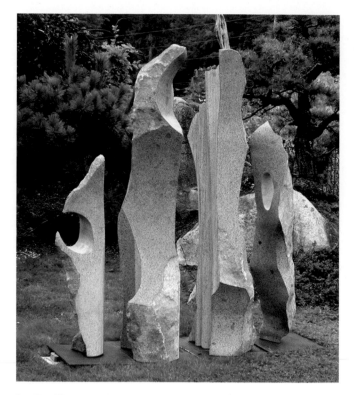

La Famille, 2006. Granite, 84" x 60" x 24". *Photo by Steve Sauer.*

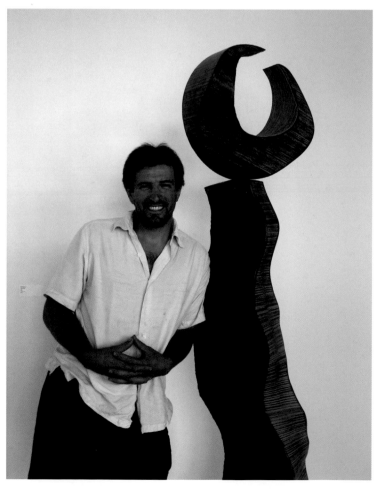

Proud Titania, 2006. Basalt, 83" x 20" x 18".

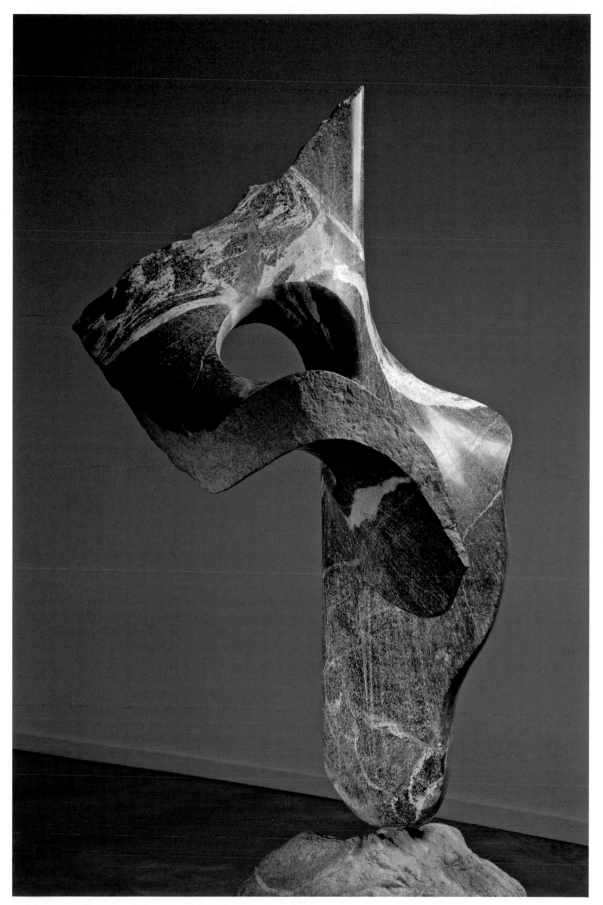

Zephyr, 2008. Granite, 77" x 42" x 29". *Photo by Sarah Gilbert.*

Will Robinson

Gayle Garner Roski

Tirage Gallery / Edenhurst Gallery

Gayle Garner Roski is a native of Los Angeles, and studied Fine Arts at the University of Southern California. Her vibrant watercolors have been exhibited extensively in museums and galleries from Southern California to Scotland. She is a Commissioner of Cultural Affairs for the City of Los Angeles and has headed Public Art projects throughout the city, including the LA Angel project. Roski is also Chairman of Art for the Cathedral of Los Angeles, serves on the Executive Board of the California Art Club and the University of Southern California, School of Fine Arts which bears her name. A Plein air watercolorist and avid world traveler, Roski has explored some of the most remote parts of the globe, always with paints and sketchbook in hand. She dives the unchartered waters off New Guinea and has climbed the summit of Mt. Kilimanjaro.

One of the great joys of travel is seeing how creativity is expressed throughout the world; connecting to the Art and Artisans of different cultures is a profound inspiration.

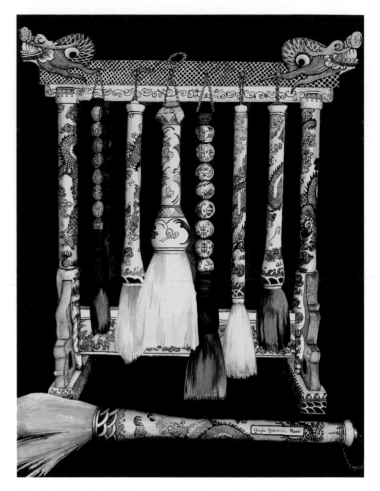

Gentle, A Brush with History, 2007. Watercolor, 29" x 41". *Courtesy of Art Works, Los Angeles.* Antique Chinese calligraphy brushes are the inspiration for this series of paintings.

"*Wise, A Brush with History*, 2006. Watercolor. 30" x 22". *Courtesy of Art Works, Los Angeles.* I went to the best flea market in the world, the Beijing Flea Market, and found several dealers selling antique calligraphy brushes. I purchased all that I could carry home. When I hung them in my studio I knew I had to paint them. These paintings are a true blend of east and west.

Tibetan Door, 2009. Watercolor, 24" x 24". *Courtesy of Art Works, Los Angeles.* The doorways in Tibet are wonderful. Many meaningful items are hung on them. I found this door-hanging souvenir on my travels in Tibet.

A Day at Leo Cabrillo Beach, 2009. Watercolor, 26" x 24". *Courtesy of Art Works, Los Angeles.* A wonderful day of painting with the "California Art Club" at Leo Cabrillo Beach.

Japanese Netsuke Musicians, 2009. Watercolor, 24" x 24". *Courtesy of Art Works, Los Angeles.* From "Travel Treasures" inspired from souvenirs collected around the world.

Gayle Garner Roski

Gary Ruddell

Sue Greenwood Fine Art / Dolby Chadwick Gallery / Gallery Henoch

Born in San Mateo, Gary Ruddell has his BFA from the California College of Arts and Crafts.

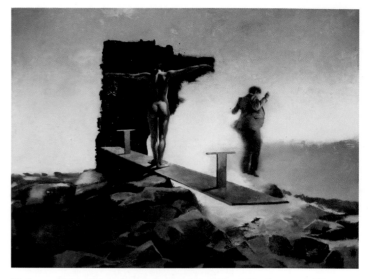

Growing up in Northern California, I spent all my time drawing and painting. Bay Area figurative painting made a major impact on my work, heightening my attraction to surface and materials, as well as the sensuality of objects, and ultimately leading me to paint things that interested me because of genuineness. For me, the act of painting is a way of knowing a process, of seeing. I like to think of my paintings as stills in a film, suspended moments, a private glimpse into the human condition. I paint figures as I see myself interacting with objects, almost as if it is a play in progress.

Balance, 2008. Oil on canvas on panel, 48" x 36". *Courtesy of Sue Greenwood Fine Art.* Looking at Gary Ruddell's paintings is like watching a story unfold. Filling his compositions with symbols, the artist supplies narratives that engage the viewers' imagination. He suggests, for example, that boats symbolize communication and learning, horses are visual metaphors for the passage of time and circular forms, articulated fully or in part, stand for a desire for self fulfillment or, at times, detrimental self absorption.

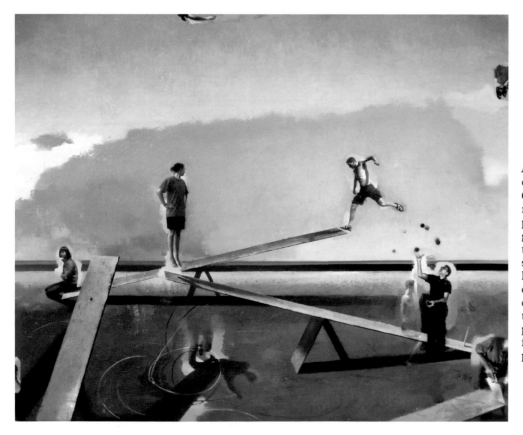

Learning To Trust, 2008. Oil on canvas on panel, 72" x 60". *Courtesy of Sue Greenwood Fine Art.* Images of young men command center stage while performing tasks that, eccentric at first glance, are open to myriad interpretations. Ruddell likens his work to film stills, small vignettes taken from a larger script and suspended in time. He often bifurcates the picture plane into opposing, yet complimentary, elements to illustrate the intricacies of life's passages. Fully or partially articulated, figures speak of a quest for identity, a place in the larger scheme of life.

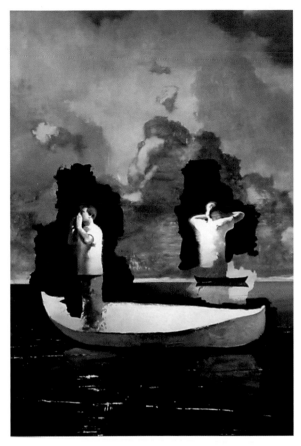

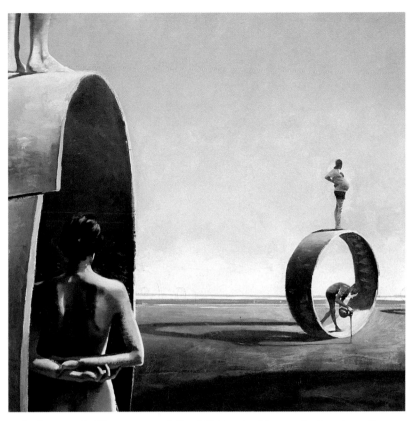

Itchy Feet, 2005. Oil on canvas, 54" x 54". Inspired in part by Bay Area figurative painters, Ruddell's multi-layered, surreal compositions are, for the most part, focused on relationships, on the inner workings of families or the convoluted process of growing from adolescence into adulthood.

1st Study For Voice, 2006. Oil on panel, 37.5" x 25.5". *Courtesy of Sue Greenwood Fine Art.* Rundell says that he does not sentimentalize the human condition but exposes its stark realities by placing his subjects into ritualized settings that will stimulate dialogue among his audience.

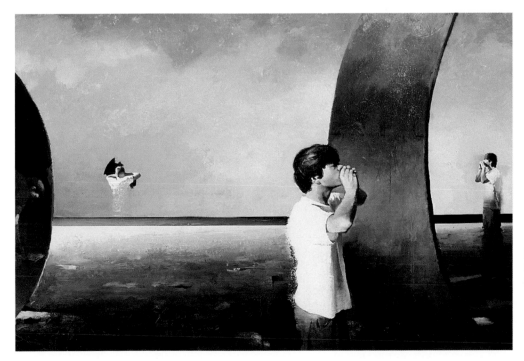

2nd Study for Searching for Voice, 2005. Oil on canvas on panel, 42" x 58". *Courtesy of Sue Greenwood Fine Art.*

Gary Ruddell

Adrian Saxe

Frank Lloyd Gallery

Christopher Knight, art critic of the *Los Angeles Times*, called Adrian Saxe "the most significant ceramic artist of his generation." Saxe has made pottery since the early 1970s, and has been a featured artist at museums across the country and in Europe. His work was the subject of a major mid-career survey organized by the Los Angeles County Museum of Art in 1993-94, and the exhibition traveled to the Museum of Contemporary Art in Shigaraki, Japan, and to the Newark Museum of Art, with a published catalog, *The Clay Art of Adriane Saxe*.

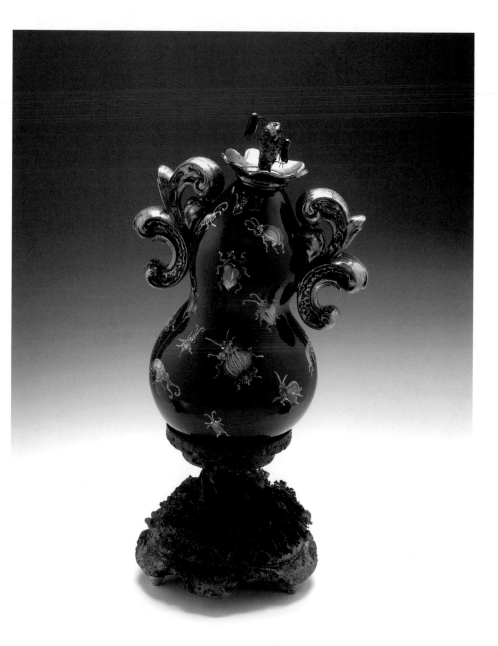

Les Rois du Monde Futur, 2004. Porcelain, stoneware, overglaze, lusters, mixed media, 26.25" x 13.25" x 10". *Photo by Anthony Cuñha, Courtesy of the Frank Lloyd Gallery.* Saxe's works revisit the artist's concerns from the previous thirty years, namely the ornate rococo. As always with Saxe's polymorphous pieces, there is a simultaneous reference to contemporary culture, ceramic history, and word play. As an accomplished ceramicist, Saxe has sought to reinvent the role of ceramic art into a medium that employs decorative art conventions to mirror, comment upon, and redirect social and cultural expectations.

Sweet Dreams, 2004. Porcelain, stoneware, overglaze enamel, lusters, mixed media, 31.25" x 14" x 8.25". *Photo by Anthony Cuñha, Courtesy of the Frank Lloyd Gallery.*

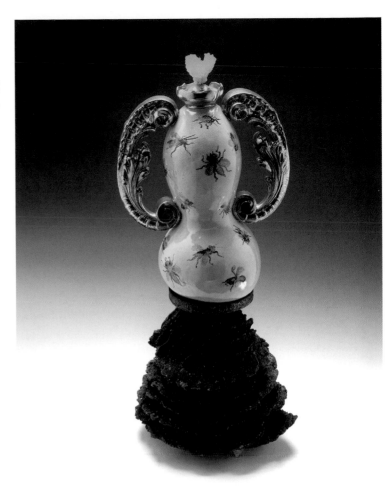

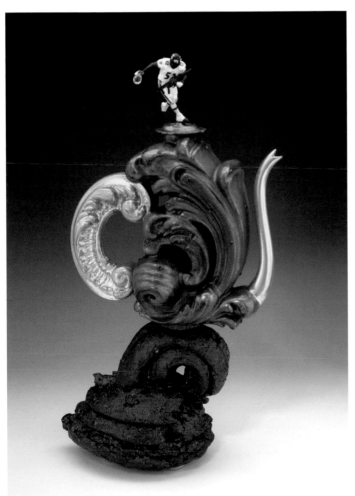

Untitled Ewer Home Team Advantage, 2004-2005. Porcelain, stoneware, mixed media, 16.25" x 9.5" x 6". *Photo by Anthony Cuñha, Courtesy of the Frank Lloyd Gallery.*

Adrian Saxe

Peter Shire

Frank Lloyd Gallery

Since the 1970s, Peter Shire has been working at an intersection where craft, fine art, and industrial design collide, with forays into architecture, furniture, fashion, and ceramics. His early works attracted the eye of Ettore Sottsass, one of the founders of Memphis Group, an international design movement that came out of Italy during the 1980s. The group sought to revitalize design, rejecting conventional standards in favor of a bold, colorful, novel approach to product design, and Sottsass invited Shire to Milan to work with them. This lead to a series of projects that toyed with the intersections of industrial design and fine art, and gave Shire the opportunity to work in glass, metal, and other new mediums.

Shire's most recent work is a series of colorful, bold, and playful chairs that mix art, architecture, and design. His sculptural chairs make wide ranging connections to popular culture, early aerospace and classic modernism. Drawing inspiration from his neighborhood in Echo Park and the ever-changing city of Los Angeles, Shire continues to make painted steel sculpture, ceramic sculpture, works on paper, and painting. In addition, he has done various commissions for public places and private buildings throughout Los Angeles.

Guy Noir, 2007. Steel and enamel, 41.75" x 16" x 26.5". *Photo by Alan Shaffer, Courtesy of the Frank Lloyd Gallery.* Part artist, part architect, and part designer, Shire continues the inventive work of the avant-garde designer, outside the mainstream of industry. His sculptural chairs, often fanciful flights of the mind, make wide ranging connections to popular culture, early aerospace and classic modernism.

Improbable History, 2007. Steel and enamel, 42" x 18" x 33.5". *Photo by Alan Shaffer, Courtesy of the Frank Lloyd Gallery.*

Plane Air I, 2007. Steel and enamel, 47" x 16" x 35". *Photo by Alan Shaffer, Courtesy of the Frank Lloyd Gallery.*

West Hollywood Installation, 2008. Steel and enamel, varying dimensions. *Photo by Richard E. Settle (c) 2008.*

Peter Shire

Barry Simons

Ames Gallery

Southern California artist Barry Simons' provocative images have generated an amazing response. Not only has his work sold out at the Outsider Art Fairs in New York since being introduced in 1995, but it has been accepted into the permanent collections of the Oakland Museum of California, the Milwaukee Art Museum, and the Museum of International Folk Art in Santa Fe, New Mexico.

While some of his pieces are single color ink-on-paper works, Simons usually applies vivid colors with pen or brush, and often uses collage, which adds another dimension of texture and depth. Simons also includes text in some pieces, ranging from a word or thought to a poem. His poems and short stories were published in small press books in the 1970s. He has been painting since 1976, on a *"quest to release the visionary artist I felt living inside me. So far the journey has lead me through many rented rooms and coffee shops in East Hollywood and the San Fernando Valley and I'm still looking for that one free refill of coffee with a picture of Rembrandt on the napkin."*

I Woke Up To See I Was Broke, 1996. Ink & watercolor on paper, 12" x 18". *Photo by Sherry Bloom, Courtesy of the Ames Gallery.*

If There Was A Straight Job, 1996. Ink & watercolor on paper, 12" x 18".
Photo by Sherry Bloom, Courtesy of the Ames Gallery.

I Woke Up in the Mines, No Date. Ink/paint collage on paper, 15" x 22".
Photo by Sherry Bloom, Courtesy of the Ames Gallery.

Barry Simons

Mark R. Smith

Elizabeth Leach Gallery

Mark R. Smith's current body of work presents a narrative of a sacred journey using found fabric and mixed media in two-dimensional and three-dimensional formats, Smith explores the journey and its potential rewards, as well as the complications and obstacles presented by the accompanying travel. The story is told by symbols from the vernacular – cut out human figures, airports, and city plans – that are universal and immediately understandable. Smith's figures experience a familiar sense of paranoia and loss of control throughout their travels. From the moment they set off they are controlled, forced to queue, and travel through labyrinthine airports. Even the destinations, the sacred spots in the natural world, are gated off and monitored.

Exit Flow, 2008. Acrylic and printed fabric on canvas 64" x 48" *Photo by Aaron Johnson, Courtesy of the artist and the Elizabeth Leach Gallery.*

Queue At The Witness Tree, 2008. Printed fabric and acrylic on canvas, 59.75" x 48". *Photo by Aaron Johnson, Courtesy of the artist and the Elizabeth Leach Gallery.*

Sanctuary, 2008. Acrylic and printed fabric on canvas, 58" x 42". *Photo by Aaron Johnson, Courtesy of the artist and the Elizabeth Leach Gallery.*

Terminal, 2008. Acrylic and printed fabric on canvas, 47.75" x 72". *Photo by Dan Kvitka, Courtesy of the artist and the Elizabeth Leach Gallery.*

Mark R. Smith

Phyllis Solcyk

Watercolor artist Phyllis Solcyk is noted for powerful land and seascape paintings and has been featured in many respected art publications. She received her formal training at Chouinard Art Institute, and spent her early career in the Walt Disney Studio. Her work is in public and private collections in both Europe and the United States; including the Smithsonian Institution and the Library of Congress.

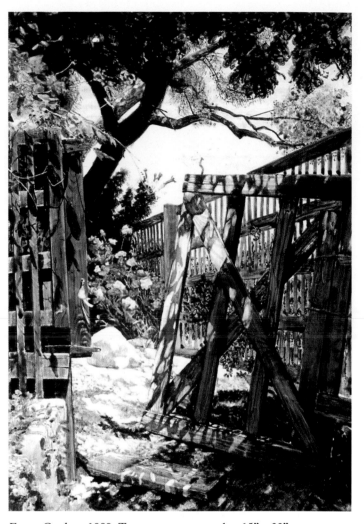

Empty Gardens, 1989. Transparent watercolor, 15" x 22". *Courtesy of the O'Grady Collection, Ireland.*

Old Mill, 1990. Transparent watercolor, 22" x 15".

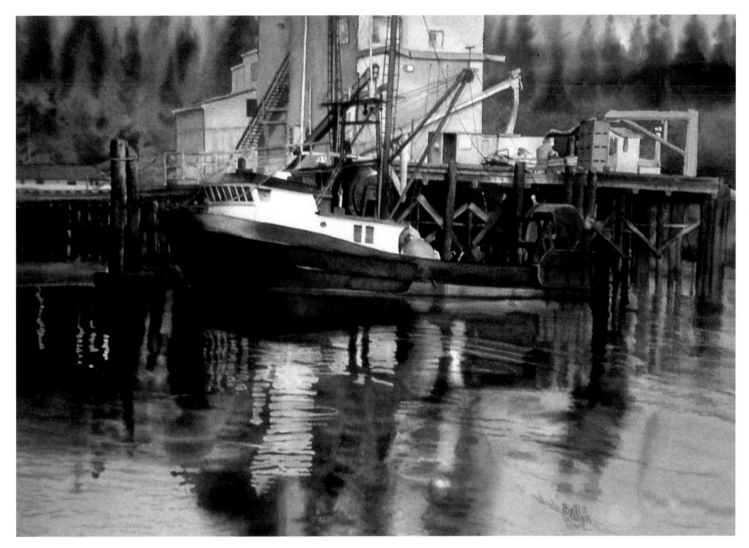

Coos Bay, 2006. Transparent watercolor, 31" x 33".

Phyllis Solcyk

Alice Wanke Stephens

Rental Sales Gallery of the Portland Art Museum

Alice Wanke Stephens' theme for her landscapes is Art for Land's Sake. Her mission is to promote awareness of the beauty that surrounds us, and to inspire conservation of our planet. She works on stretched linen or masonite with acrylic paint and palette knives. The World Forestry Center Museum in Portland, Oregon has exhibited several of her landscape series including "The Columbia River Gorge", "The Filbert Farm", and "Forest Park". Her paintings are available at the Rental Sales Gallery of the Portland Art Museum, the Oregon Society of Artists, and in her studio. She is represented in collections throughout the United States.

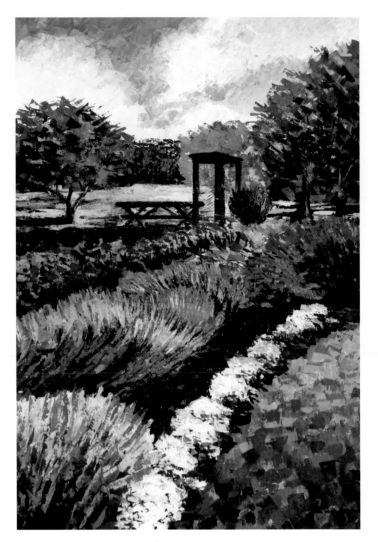

Picnic Area at World Steward, 2004. Acrylic on linen, 40" x 30".

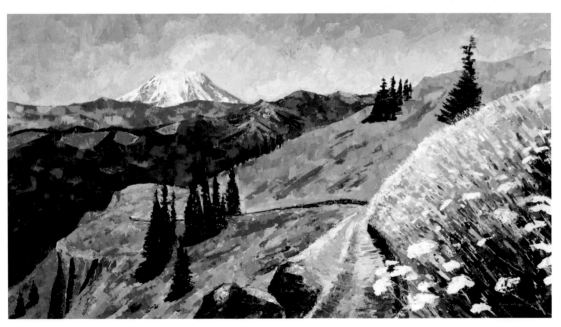

Silver Star to Mt. St. Helens, 2005. Acrylic on linen, 26" x 46".

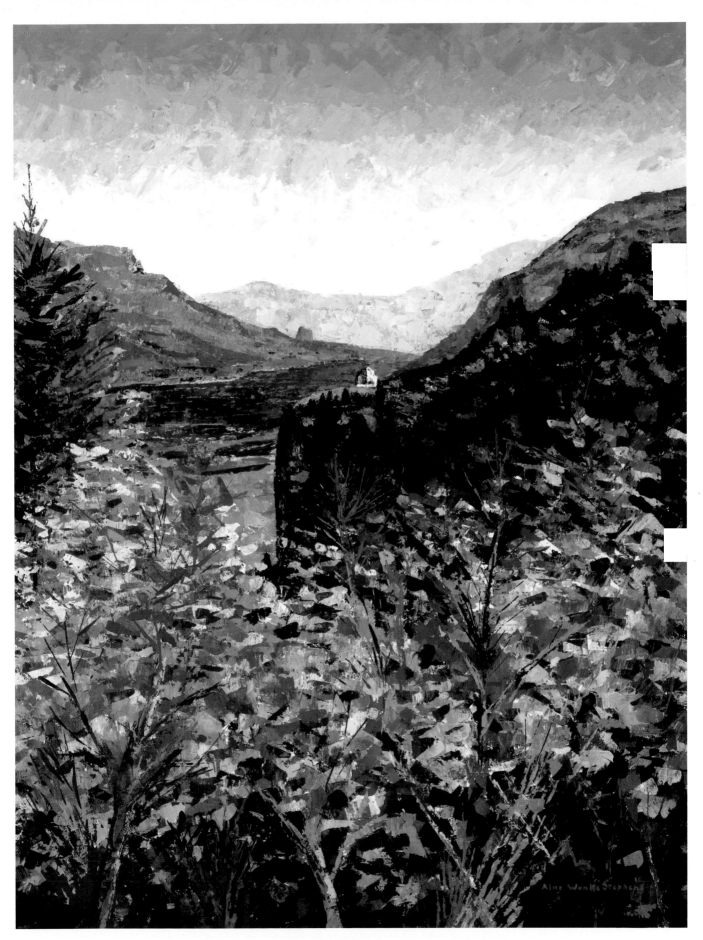

Crown Point and Vista House, 2005. Acrylic on linen, 40" x 30".

Alice Wanke Stephens

Sylvia Tait

Bau-Xi Gallery

Sylvia Tait studied for four years at the Montreal Museum of Fine Arts under Arthur Lismer, Jacques de Tonnancoeur, and Eldon Grier. She received three scholarships, Top Student Award, and Honour Diploma. Since the 1950s she has exhibited across Canada, in Mexico, and Ecuador in solo and group shows. Sylvia Tait has been represented by the Bau-Xi Gallery since 1977. Her paintings are in corporate and public collections in Europe, USA, Canada, South America and Hong Kong. Selected collections include Musee de l'Art Contemporaine, Quebec; Vancouver Art Gallery, BC; Winnipeg Art Gallery, Manitoba, and the Art Gallery of Greater Victoria.

As a Canadian painter I have the privilege of space and the freedom to experiment. My belief is that painting is a language of its own. Like music one has to learn the "speech" and the idioms of the time. Painting for me is a conversation with your inner self, dealing with the daemons as well as the pure sensuality of the surface of things. The abstractions and poetry of the world are in contrast to the reality and grief that are obsessive today. The revenge is the process and search for personal expression. The passion for the aesthetic is a means to getting at the source of feelings. So abstract art strips away the propaganda of politics, stories, and lies, to allow the purity of color relations, rhythms, and essential structures for delivering human feelings.

Descending Fifths, 2008. Oil on linen, 20" x 18". *Photo by Bau-Xi Gallery.* Musical language and insinuations is an entrance to a visual picture. The implication is that sound and eye can meet in harmony or as an opposite sensation.

Phoenix, 2007. Oil on linen. 42" x 52". *Photo by Bau-Xi Gallery.* This painting is one of a series of "phoenix" ideas. The return from ashes to renewal is a global hope. Breaking out from a solid form into fragments is a device that particularly suits me at this time.

For A Darkly Splendoured Earth, 2007. Oil on canvas, 56" x 87". *Photo by Bau-Xi Gallery.*
This painting began after hearing a work by Canadian composter, R. Murray Schafer with
the same evocative title. It is a rather dark piece with decidedly hopeful resonances. I
want the painting to be rich and sensual with implications of both darkness and vitality.

Sylvia Tait

Carol Tarzier

Dennis Rae Fine Art / Lesa Johnson Gallery

I began sculpting in 1993. Sculpture became my primary form of artistic expression, with water-based clay as a medium. My sculpture covers a wide range, from abstract rugged form to high-polish bronzes. I use form to convey mood and emotion. I find satisfaction in abstracted as well as figurative work, and believe that the best artwork incorporates elements of both. My commissioned projects include the C.L. Dellums Memorial at Oakland's Amtrak station and the life-size memorial to George Hasslein at Cal Poly San Luis Obispo.

In 2006 I began studying oil painting, and it's infinitely intriguing. Oil painting is challenging, frustrating, and joyful all in one. I began with landscapes and plein air painting, and have been studying and teaching still life painting for the last two years. I love to create light with value and even more with color and transparency. I'm discovering a new world, and am grateful that it is opening its doors to me.

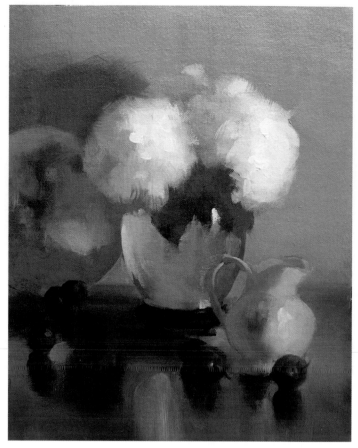

Hydrangeas and Cherries, 2009. Oil on canvas panel, 14" x 11". Transparency and reflections are a joy to paint. My goal was the light flowing onto the flowers and through the blue glass vase.

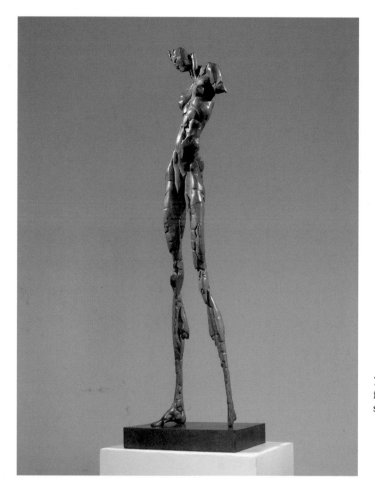

Tall Nude, 1994. Bronze, 42" x 12" x 9". This piece is abstracted figuration. My concern is the gesture and the movement of form in space. The model was a lovely woman, strong and elegant.

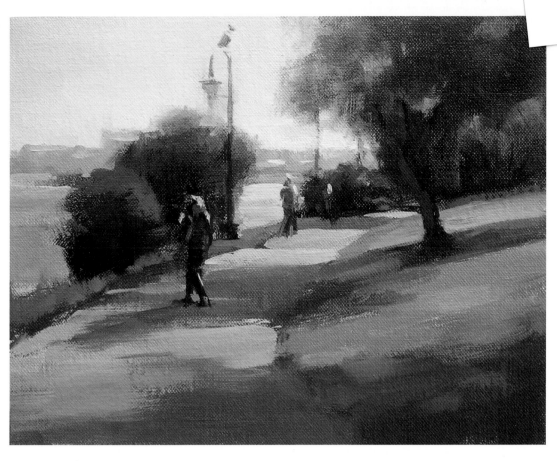

Lake Merritt Pathway, 2009. Oil on canvas panel, 8" x 10". I like the warmth of afternoon and evening light. I wanted to capture the lakefront in downtown Oakland and a moment in time for the people walking by the lake.

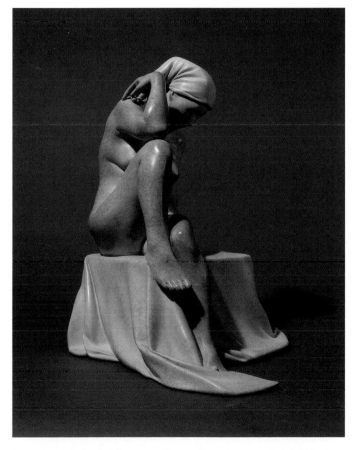

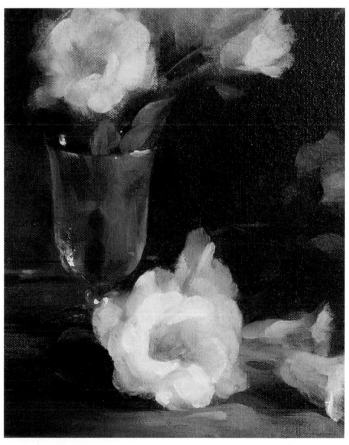

Venus Seated, 2002. Bronze, 15" x 10" x 13". I loved the delicacy and gentleness of this model. As with "Tall Nude," though it's a figurative piece, the goal is the movement and flow of form more than the representation of a specific person.

White Lisanthium, 2008. Oil on canvas panel, 10" x 8". Creating petals with brushstrokes is a treat. The transparency of glass is a gift to the artist.

Carol Tarzier

Whiting Tennis

Greg Kucera Gallery / Derek Eller Gallery

Whiting Tennis received his BFA from the University of Washington in 1984. After living and working in New York for several years, he returned to the Northwest in 2005. Major works by Whiting Tennis were recently purchased by the Seattle Art Museum, Tacoma Art Museum, Portland Art Museum and the Nerman Museum of Contemporary Art at Johnson County Community College, Overland Park, Kansas.

Hippopotamus (spraypaint), 2008. Spraypaint on cardboard, 18" x 12". *Courtesy of the artist and Greg Kucera Gallery.*

Postcard, 2001. Acrylic and collage on canvas, 22" x 17". *Collection of Alberto Castaneda.*

Bovine, 2006. Lumber, found plywood and found objects, 96" x 168" x 90". *Collection of the Seattle Art Museum.*

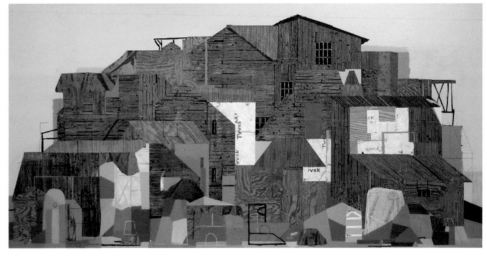

Camp, 2007. Oil on canvas, 32" x 46". *Courtesy of the artist and Greg Kucera Gallery.*

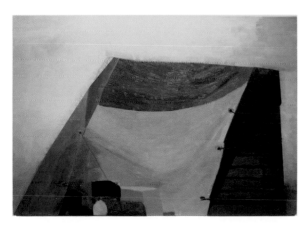

Brown Crystal, 2006. Acrylic and collage on canvas, 36" x 72". *Courtesy of collection of Thamer Abaname.*

Joe Thurston

Elizabeth Leach Gallery

Celebrated in the art press and Oregon area venues. In his recent works, Thurston paints highly textured planes, hand-carved for hours, creating a tactile quality beneath vibrant surfaces. The work functions as both micro and macro, as aerial views imitate cosmology, and as flat panels function as form and pattern.

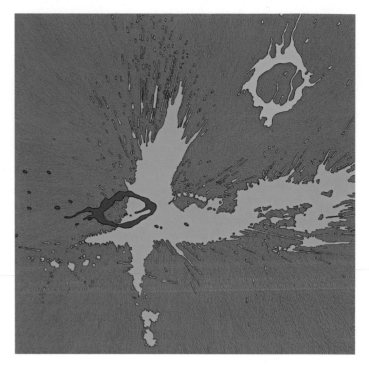

Fact Of Substance, 2007. Relief painting on panel, 68" x 68". *Photo by Dan Kvitka, Courtesy of the artist and the Elizabeth Leach Gallery.*

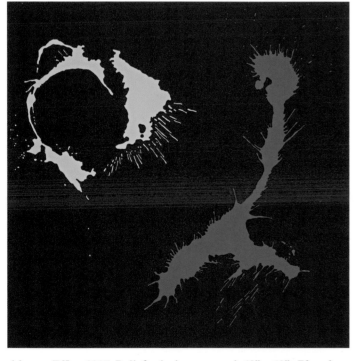

Advance Effigy, 2007. Relief painting on panel, 68" x 68". *Photo by Dan Kvitka, Courtesy of the artist and the Elizabeth Leach Gallery.*

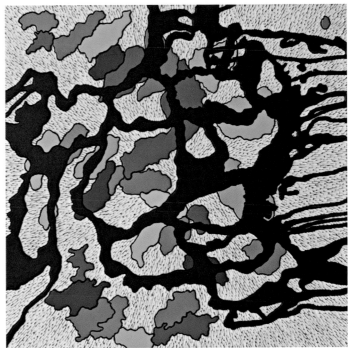

Further or Faster, 2008. Relief painting on panel, 23.75" x 23.75".
*Photo by Dan Kvitka, Courtesy of the artist and the Elizabeth Leach
Gallery.*

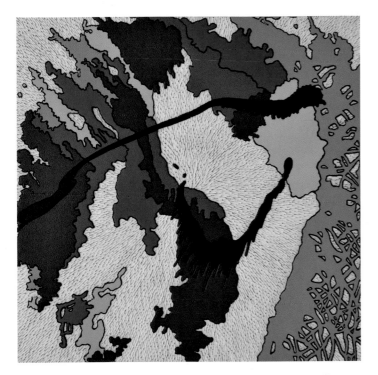

Effects of Great Subtlety, 2008. Relief painting on panel, 23.75" x
23.75". *Photo by Dan Kvitka, Courtesy of the artist and the Elizabeth
Leach Gallery.*

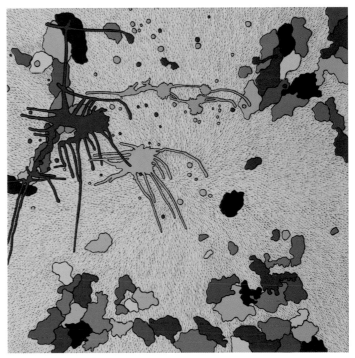

A Complete Inversion of Basic Principals, 2008. Relief painting on
panel 36" x 36". *Photo by Dan Kvitka, Courtesy of the artist and the
Elizabeth Leach Gallery.*

Joe Thurston

Bonese Collins Turner

Orlando Gallery

With masters degrees from California State University, Northridge, and the University of Idaho, Bonese Collins Turner has taught as adjunct art professor at L.A. Pierce College, Moorpark College, L.A. Valley College, and as professor at California Sate University, Northridge. Her work has been exhibited in the White House, the Smithsonian Institute, Butler Institute of American Art, and much more.

This series "in the beginning" is an outgrowth of my long, ongoing exploration by visual means. Simply speaking, it is an artist's musing on science and our world shaped by personal experience and the excitement of out time. Memories of childhood visits to my father's laboratories still retain that feeling of wonder and mystery. These works attempt to express some of that same wonder and mystery; they are also a small tribute to my father and others like him those that question, seek knowledge, explore, and strive.

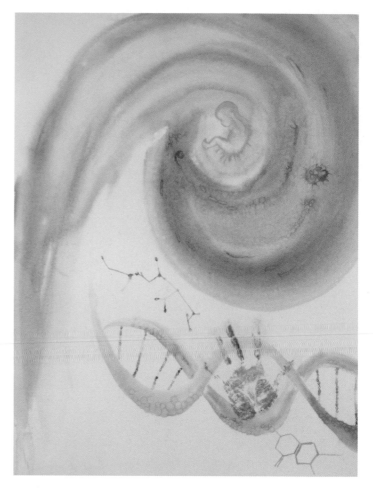

In The Beginning #4, 2006. Watermedia with collage, 37" x 30" x 1.25". *Photo by Paul Moshay.* #4 expresses man's research into creation.

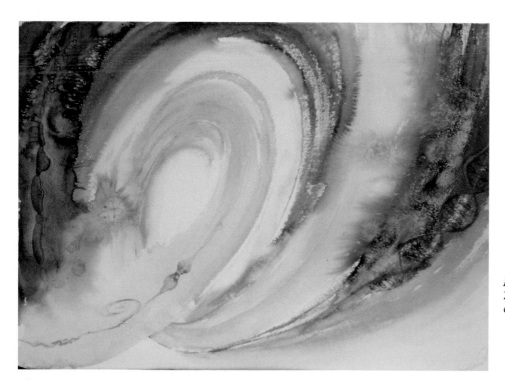

In The Beginning #7, 2006. Watermedia, 28" x 36" x 2". *Photo by Paul Moshay.* #7 deals with the creations forces.

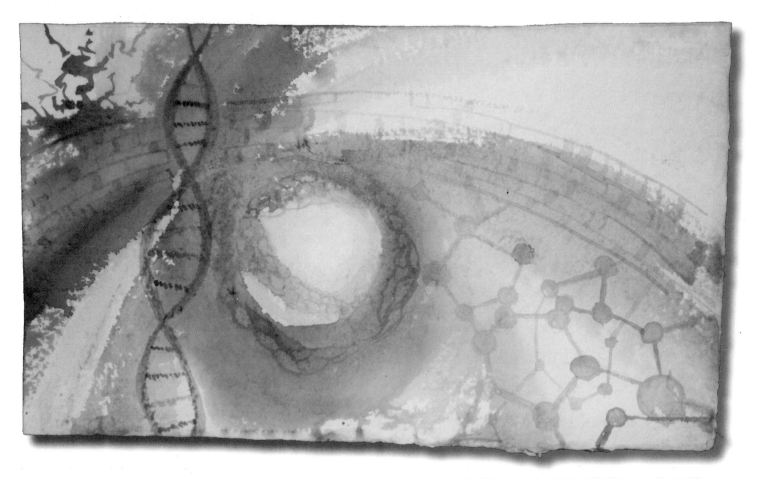

In The Beginning #11, 2007. Watermedia, 11.5" x 15.5" x 1". *Photo by Paul Moshay.* #11 deals with science, creation and nature.

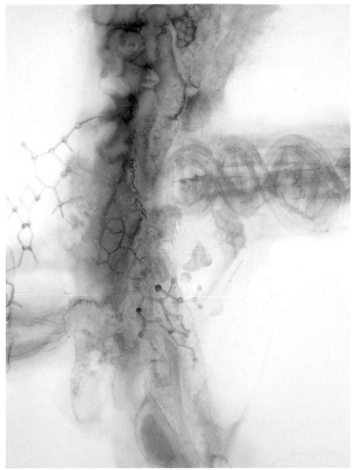

In The Beginning #1, 2005. Watercolor, 34" x 27.5" x 1.5". *Photo by Paul Moshay.* #1 deals with creation.

Bonese Collins Turner

Li Turner

Gallery 110

Li Turner grew up in an isolated, small New England town and won her first art completion at 12 years of age with a charcoal drawing of her grandparents' home. In her recent work, a series of monotypes titled Rural Views, she seeks to elicit a meditative response, inviting the viewer to experience their natural essence. Turner helps the viewer became reacquainted with stands of trees, wild flowers, and grasses. This body of work encourages us to pause and take a long clear breath.

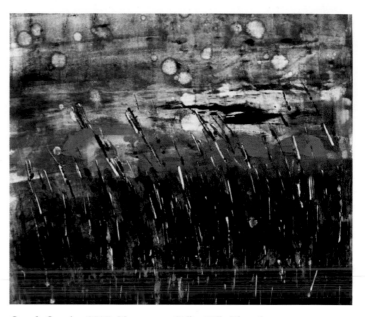

Seattle Sunrise, 2007. Monotype, 20" x 18". *Photo by Merrill Photography, Courtesy of Gallery 110.*

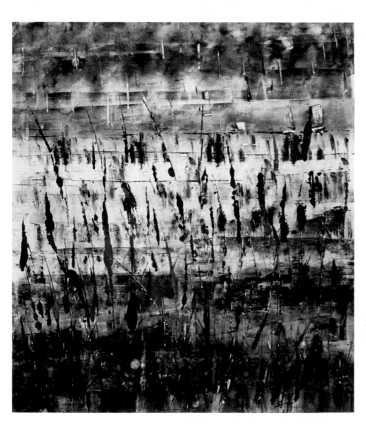

Delphinium Blues, 2007.Monotype, 18" x 20". *Photo by Merrill Photography, Courtesy of Gallery 110.*

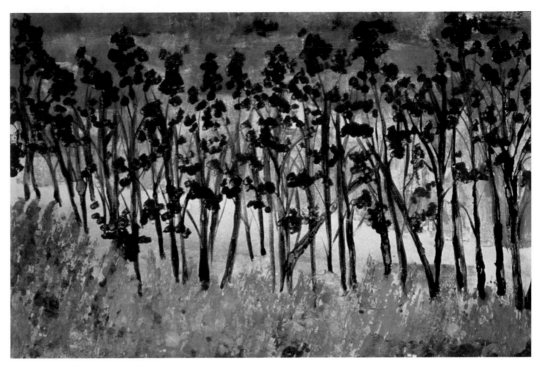

Bainbridge Island, 2007. Monotype, 12" x 18". *Photo by Merrill Photography, Courtesy of Gallery 110.*

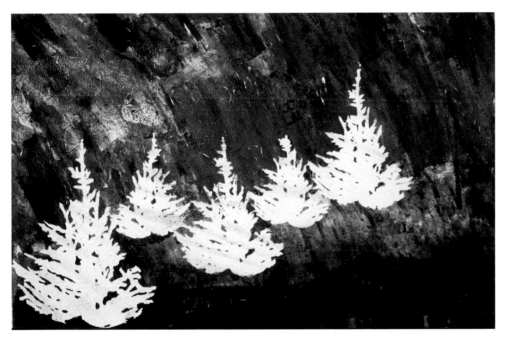

Mountain Storm, 2007. Monotype, 12" x 18". *Photo by Merrill Photography, Courtesy of Gallery 110.*

Li Turner

Terry Turrell

Sue Greenwood Fine Art / Mason Murer Fine Art / Galerie Lefor Openo / American Primitive Gallery / Tanner Hill Gallery / Grover/Thurston Gallery

My paintings and my sculpture are a natural progression of each other. The surface texture of both plays a major role in the final result. At this point, my work continues to be figurative in nature. The process begins by taking a flat surface, preferably wood or metal, and rubbing paint at random until it is covered. I do this several times, using only my hands, to build up layers of semi-dried paint. As the painting evolves into abstract shapes, I begin to look for images. Once I establish rough forms, I then define them and work with the image that emerges. I always work on several pieces simultaneously in order to keep the images fluid.

When working on sculpture, the process is very similar. I generally start by carving the head and work with the face to find the emotion I want to convey. I interchange parts, i.e., arms, legs, etc., until I find the right combination. The layering of the paint, like the paintings, is an important part of each piece. I never intentionally set out to make statements of any kind. The outcome of a given work is usually as new to me as to the viewer. The emotion created is important. I strive to create compassion, humility, and humor along with a serious edge. I let both mediums choose the way and allow me to follow.

A Lot To Remember, 2007. Oil, enamel and wood with glass eyes, 15" x 11" x 9.5". *Photo by Loni McIntosh, Courtesy of Boise Museum.*

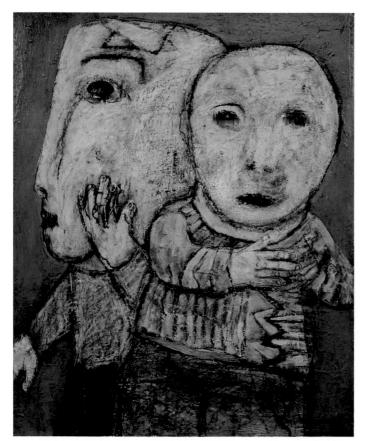

Cheek to Cheek, 2007. Acrylic on wood panel, 21" x 16.5". *Photo by Loni McIntosh*

Turquoise, 2007. Oil, enamel, paper & tin on wood panel, 8" x 8". *Photo by Loni McIntosh.*

Tail Wind, 2007. Acrylic on wood panel, 21" x 14.5". *Photo by Loni McIntosh.*

End of Summer, 2007. Encaustic and mixed media on wood panel (framed), 24" x 24". *Photo by Loni McIntosh.*

Terry Turrell

Paul Vexler

Susan Woltz Gallery / Brian Ohno Gallery

Paul Vexler has a BFA from Penn State University, and his career has included high school art teacher, general contractor/carpenter, and manufacturer of high-end, custom wood windows and doors. He has dedicated himself to sculpture full-time since 2006.

In modern day architecture, there seems to be a void in articulating sculpture for overhead spaces, a void that fascinates me the most to fill. The introduction of motion into sculpture is challenging, but rewarding when effectively conveying a sense of appreciation towards the passage of time. Whether it is static or kinetic, the sculpture allows the eye and the body experience it from multiple points of view. The experience reminds the viewer that the space is a reality and not an illusion - something a painting can never do. This is the power of sculpture!

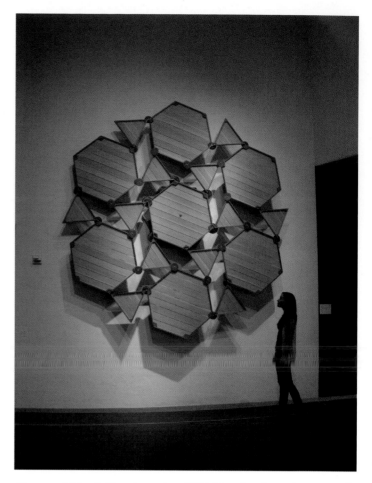

Hexagonal Mosaic Transformation, 2009. Douglas fir, mahogany, 12" x 12" x 1". *Collection of the Bellevue Arts Museum.*

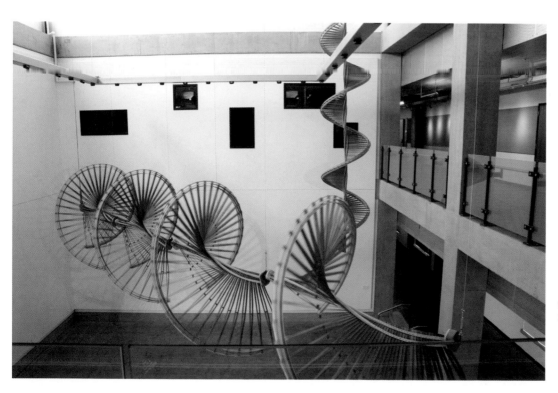

Whitehorse Horizontal Rotating Helix, 2008. Douglas fir, mahogany, oak, 8" x 35" x 8".

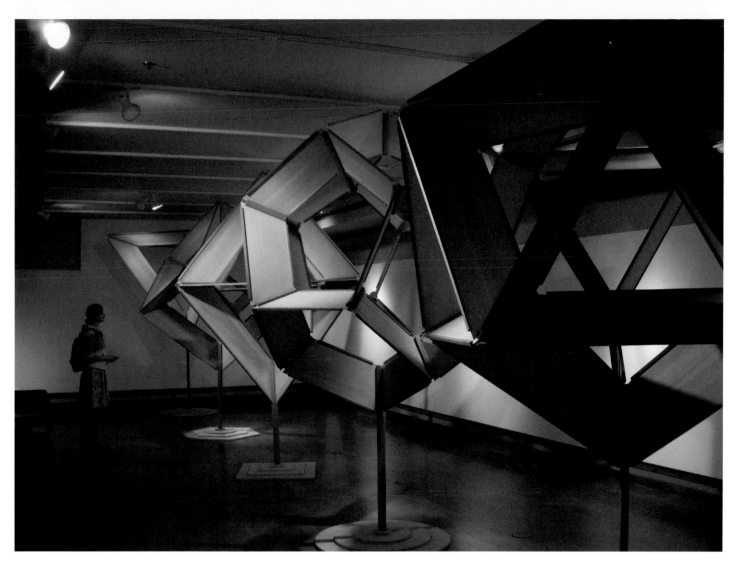

The Five Platonic Solids, 2008 Douglas fir, mahogany, 7' x 7' x 7' each.

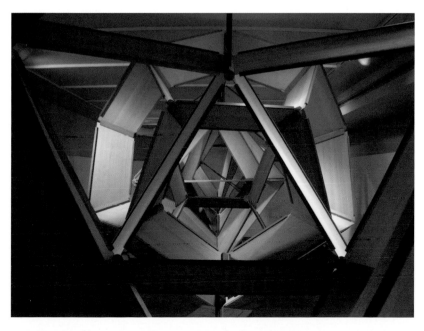

The Five Platonic Solids. (Close Up), Douglas fir, mahogany, 7' x 7' x 7' each.

Paul Vexler

Dan Webb

Greg Kucera Gallery

Dan Webb was born in 1965 in East Lansing, MI, and lives and works in Seattle. He graduated in 1991 with a BFA (Magna Cum Laude) from Cornish College of the Arts, Seattle, WA. He is the recipient of various awards including Artist Trust/Washington State Arts Commission Fellowship (2004), Betty Bowen Award, Seattle Art Museum (2004), Gap Award, Artist Trust, Seattle, (2000), Pollock-Krasner Award (1999), Seattle Arts Commission Grant, Seattle, (1995). His work is represented in the collections of Altoids Curiously Strong Collection of Contemporary Art, New Museum, NY, King County 4Culture, Seattle, and Seattle Art Museum.

I am a compulsive maker of things. Jacob Bronowski once said that "the hand is the cutting edge of the mind" and, in my case at least, he is quite literally correct; I carve, mold, build up, and break down objects as a way of exploring the things that interest me. Making things requires constant revision, because nothing turns out exactly as planned. The negotiation between my the initial ideas, and the physical facts as they unfold becomes a gut check to any theories, assumptions, or baggage I might bring, making each less precious, and each more complex.

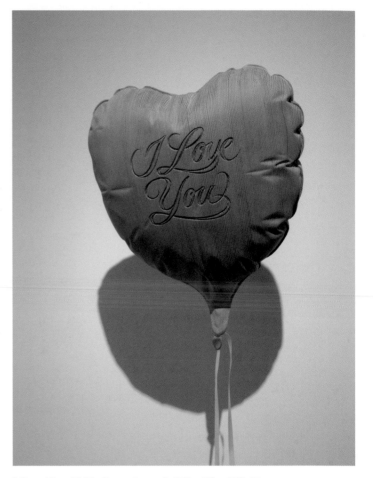

I Love You, 2006. Carved wood, 20" x 9" x 15". *Courtesy of collection of Cathy and Michael Casteel.*

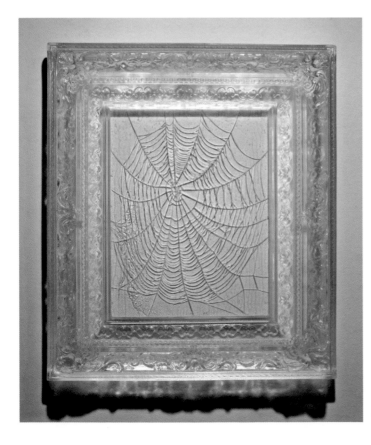

Untitled, 2009. Etched, cast resin, 15" x 13" x 2". *Courtesy of the Artist and Greg Kucera Gallery.*

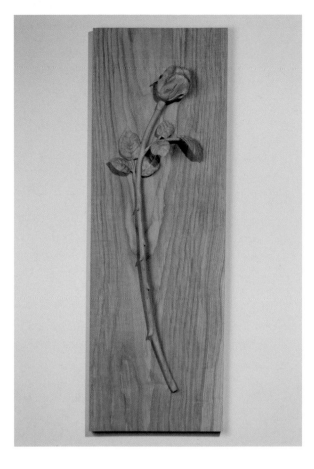

Plastic Rose, 2006. Carved wood, 27" x 9" x 4".

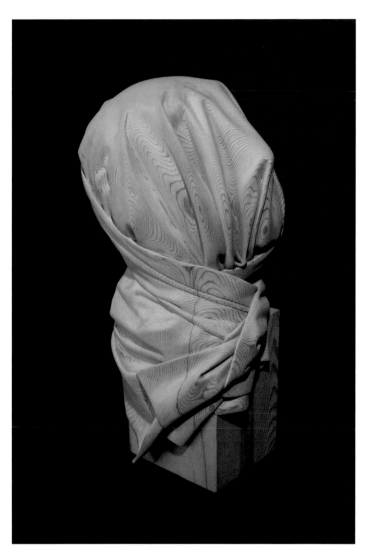

Shroud, 2008. Carved wood, 22" x 7.5" x 11". *Courtesy of collection of Seattle Art Museum.*

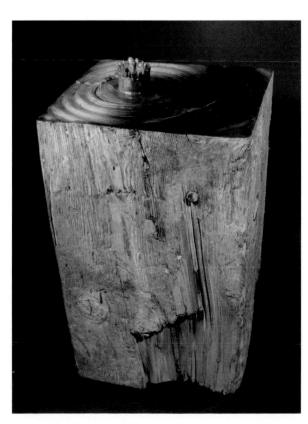

Splash, 2007. Carved wood, 16" x 14" x 14". *Courtesy of collection the artist and Greg Kucera Gallery.*

Dan Webb

William T. Wiley

John Berggruen Gallery / Crown Point Press / Charles Cowles

William T Wiley was born in Bedford, Indiana, in 1937. He studied at the San Francisco Art Institute where he completed a Bachelors of Fine Arts in 1960 and a Masters of Fine Arts in 1962. Since completing his studies in San Francisco, he has taught at the University of California at Davis and appeared regularly in individual and group shows on a national and international level, including major exhibitions such as the Whitney Biennial and Venice Biennale. He is represented in the collections of The Museum of Modern Art, The Art Institute of Chicago, The Los Angeles County Museum, The Stedelijk van Abbemuseum, Eindhoven, The Netherlands and numerous others.

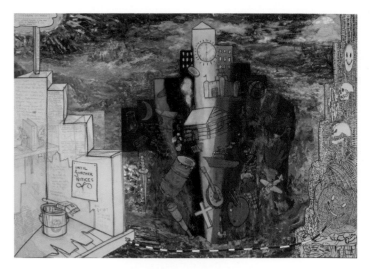

Until Further Notice, 2006. Acrylic and charcoal on canvas, 53.75" x 83.25". *Photo courtesy of John Berggruen Gallery.*

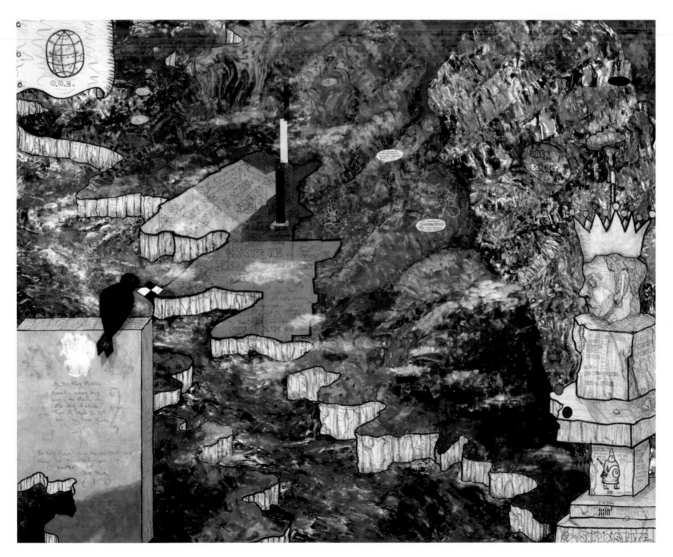

King Minus @ Gorge US & a Bridge Too Short, 2006. Acrylic on canvas, 59.25" x 72.5". *Photo courtesy of John Berggruen Gallery.*

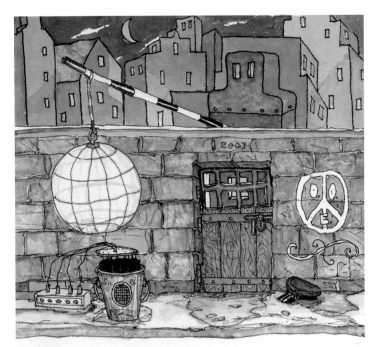

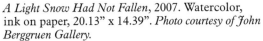

A Light Snow Had Not Fallen, 2007. Watercolor, ink on paper, 20.13" x 14.39". *Photo courtesy of John Berggruen Gallery.*

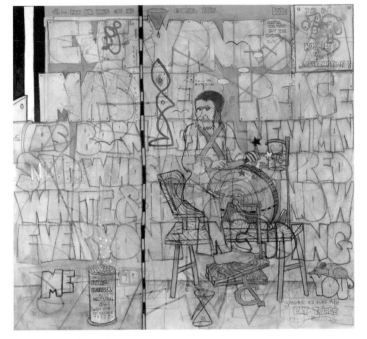

Born Again Newman, 2007. Acrylic, charcoal on canvas, 59.5" x 62.75". *Photo courtesy of John Berggruen Gallery.*

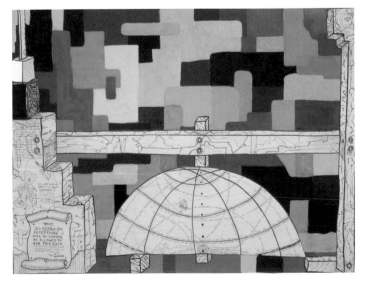

Color Barrier, 2006. Acrylic, charcoal, graphite on canvas, 60.25" x 78.25". *Photo courtesy of John Berggruen Gallery.*

William T. Wiley

Sherrie Wolf

Laura Russo Gallery

Sherrie Wolf graduated from the Museum Art School, now the Pacific Northwest College of Art, in Portland, Oregon, in 1974 and received an MA from the Chelsea College of Art in London, England in 1975. She began exhibiting her work in the mid 1970s while teaching art at PNCA. Her work is included in such collections as The Vivian and Gordon Gilkey Center for Graphic Arts, Portland Art Museum; Hallie Ford Museum, Salem, OR; City of Seattle; Washington State Art Collection; and Southern Oregon State College, Ashland.

I have always been a still-life painter. My images have evolved from a love of art history and a desire to present multiple levels of expression to my viewer. Content often derives from interactions that are discovered by experimentation. I enjoy finding resonance that did not at first occur to me.

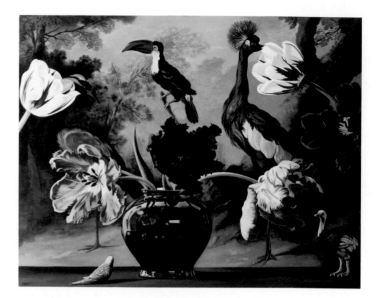

Parrot Tulips with Cranes, 2008. (Reference: Jean-Baptiste Oudry, 1686-1755) Oil on canvas, 24" x 30". *Courtesy of Laura Russo Gallery.*

Cacophony, 2008. (Reference: Frans Snyder, 1579-1657) Oil on canvas, 48" x 72". *Courtesy of Laura Russo Gallery.*

Yellow Roses, 2007. (Reference Albert Bierstadt, "Half Dome, Yosemite," c. 1866) Oil on canvas, 36" x 60".

Tulips with Landers Peak, 2007. (**Reference:** Albert Bierstadt, 1830-1902) Oil on canvas, 48" x 36". *Courtesy of Laura Russo Gallery.*

White Tulips with Red Drape, 2007. (**Reference: "Death of the Virgin,"** Caravaggio, 1571-1610) Oil on canvas, 50" x 30".

Sherrie Wolf

Thomas Wood

Lisa Harris Gallery

For over thirty years I have been a printmaker and painter in the Pacific Northwest, finding in the natural and cultural surroundings a source of fantastic landscapes and mythological images as well as more naturalistic subject matter. I sketch and paint outdoors while camping in forests or sailing on the sound, in all sorts of weather. I tend a garden, and enjoy making things grow.

While I see myself as part of a continuum of Northwest artists who have responded to the region's distinctive landscape and native culture, I am also deeply connected to the European printmaking tradition, and have worked and exhibited abroad, most often in Italy. My realistic representation of landscapes, myths, and imaginings are inspired by my studies of the European masters, styles, and techniques. Sometimes a social comment, an historical reference, or some humor will appear in these interpretations, which are an outgrowth of my forays into nature.

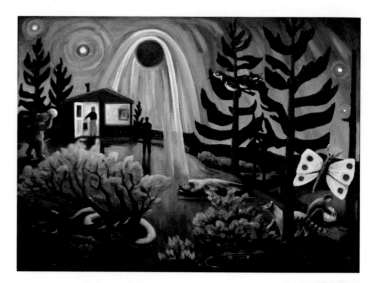

Eclipse At Midpines, 2006, Oil, 36" x 18". Collection of Michael and Linda Bashaw.

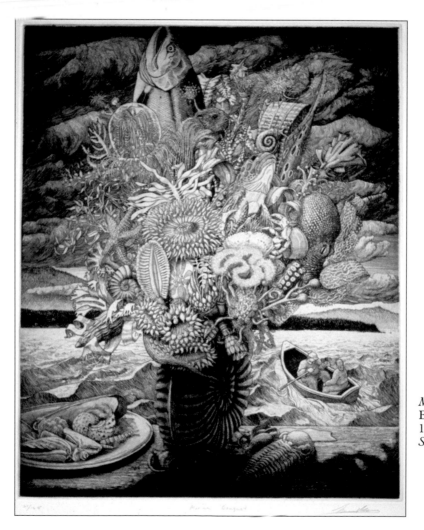

Marine Bouquet, 2000. Etching with engraving, 17.5" x 14". *Collection of Susan Ball.*

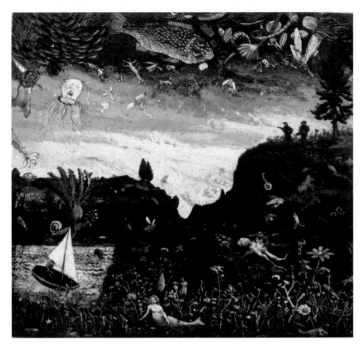

The Mermaid Hunters, 2008. Three color etching and aquatint, 10" x 10.5". *Collection of Beth Lowry.*

The Harvest, 2004. Etching with aquatint and chine colle, 11" x 17.75". *Collection of Jean Cuncannan.*

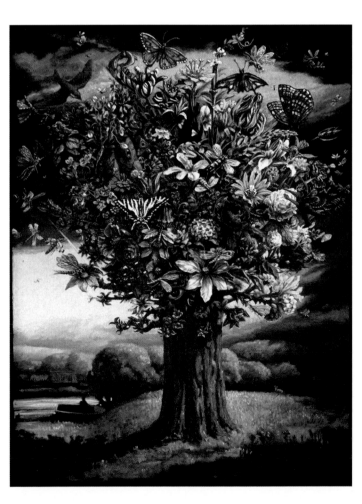

The Pollinators, 2004. Oil 40" x 30". *Collection of Ann Wilson.*

Thomas Wood

Darlyn Susan Yee

Tag Gallery

Darlyn was born in Texas, and was raised in cities from the Mid-Atlantic to the Deep South. She is happily working away in her private Los Angeles studio creating new work that celebrates the cultural significance of traditional fiber methods and their influence on contemporary art. She combines traditional fiber methods of knotting, knitting, weaving, coiling, sewing, and embroidery to create unique sculpture. Her consuming passion is the aspect of each tiny detail interacting with the others to form a whole.

She uses techniques that were once considered women's work, or home arts, to create pieces of museum quality fine art. Her work has been shown in a wide range of galleries and museums. Her fiber sculptures and mixed media works have won numerous awards in local, national and international competitions.

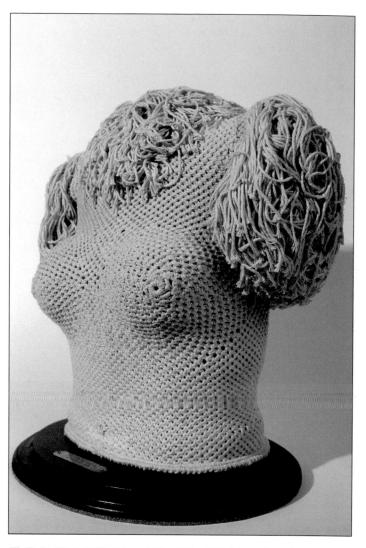

Fit To Be Tied, 2001. Fiber, 18" x 18" x 12". I have been inspired by the complexity of the human form. My interpretations of these classic subjects contain elements of both comedy and tragedy.

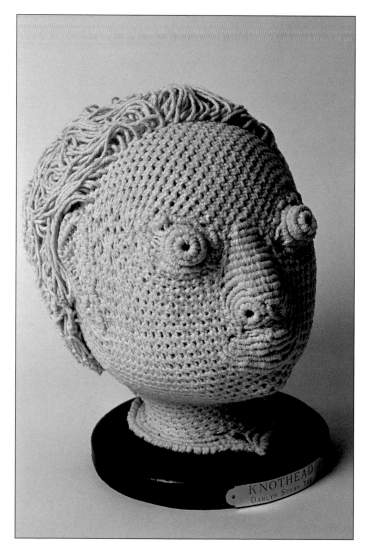

Knothead, 2000. Fiber, 13" x 9" x 10". I create sculptural artwork using traditional fiber methods such as knotting, knitting, weaving, coiling, sewing and embroidery.

Knotted Vessel, 2003. Fiber, 14" x 7" x 7". My consuming passion is the aspect of each tiny detail interacting with the others to form a whole.

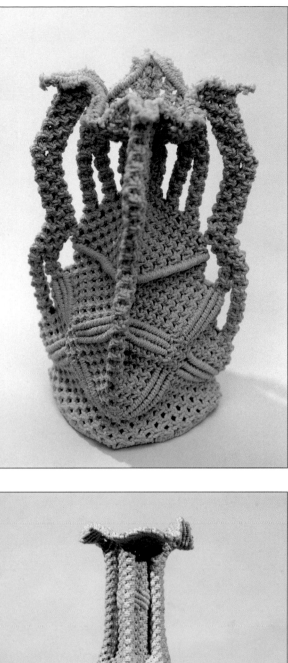

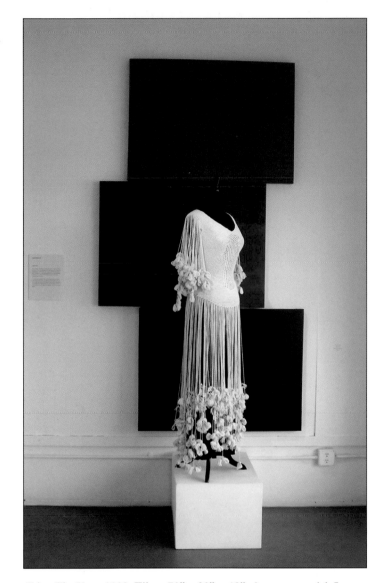

Tying The Knot, 2008. Fiber, 70" x 32" x 48". As a young girl, I fantasized about becoming a bride. I regularly dressed my fashion doll in a wedding gown and I hopped her on down the aisle to her destination: wedded bliss. I also owned a collectible bride doll that I didn't dare play with, so she would maintain her value. Both experiences contributed to an attitude where marriage was the ultimate, most beautiful thing in the world. I've since come to realize that the clothing, trappings and trimmings a bride wears for that one day are merely the outward expression of her sense of self, inner beauty, and confidence. *Tying The Knot* is displayed in an unfinished state to represent that I am a work in progress, and that in a healthy relationship both parties encourage each other to continue their growth.

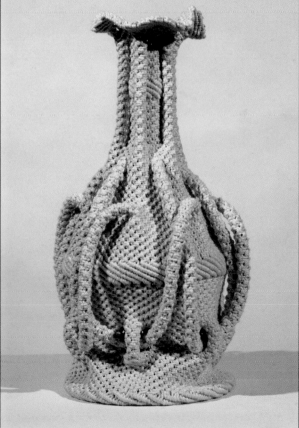

Loopy, 2005. Fiber, 14.5" x 8" x 8". The materials and knot patterns I develop encourage the various shapes.

Darlyn Susan Yee

Jeffery Yeomans

Studio 7 Gallery

Jeff Yeomans pursued his talents and interests in a career as a muralist, illustrator, graphic designer, and award-winning art director for public television in San Diego. Since 2002 he has dedicated his efforts to oil painting, focusing on "the fragile beauty of California and the growth and connected urban landscape that impact it."

I feel a responsibility to document California today. I grew up in Southern California and have seen it change, so I paint to remember the "fabric" of who we are and how we live. I hope that my work celebrates the diversity of our region and also explores our shared experiences.

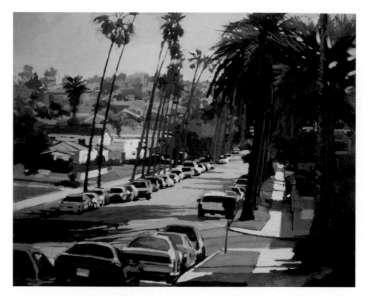

Rusty's Route, 2007. Oil, 24" x 30". Our dog Rusty showed me this spot during one of our neighborhood walks. The palm trees, light and shadows created a great composition to work with.

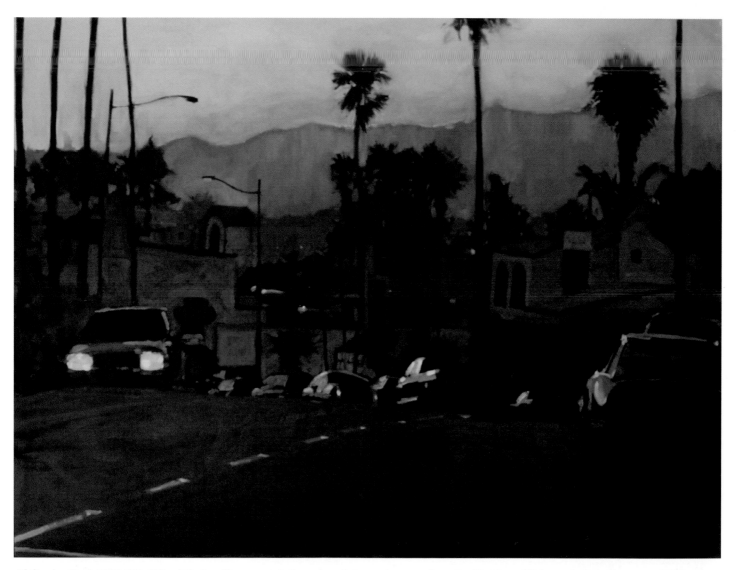

El Camino Real, 2008. Oil, 30" x 40". An effort to catch the color of the setting sun along Pacific Coast Highway in San Clemente, California.

When's Your Heat, 2007. Oil, 16" x 20". Early morning at a girls surf contest at San Onofre, a popular Southern California surf spot.

Hollister Ranch #2, 2007. Oil, 30" x 40". From a trip to Hollister Ranch, a legendary surf spot north of Santa Barbara. Access is difficult unless you know a property owner. It's a pristine section of coastline.

Summerstroke, 2007. Oil, 24" x 48". My kids on a trip to Mexico at one of our favorite beaches. Late summer, warm water and good waves add up to a lot of fun.

Jeffery Yeomans

Alex Zecca

Anne Reed Gallery

Born in San Francisco in 1970, Alex Zecca studied art at California College of the Arts and in Italy before earning my MFA in painting at The San Francisco Art Institute.

My work's central focus continues to be on process. The new drawings are ... an exercise in precision and focus. Each piece is made by drawing straight lines, one at a time, with ballpoint pens. I stick to a very precise, pre-determined process in which the sequences of repeated color determines the saturation of color. The formula I choose, the sequence, and how the colors relate, determine the final optical, visual appearance. The pens come in a relatively limited range of colors – approximately 10 or 12; it is actually the arrangement of the colors in each piece that determines the visual color effect. My tools are a straight edge and pen. I have developed a special ruler that allows me to work on a perfect radius. The ruler attaches directly to my worktable, and the table is on a kind of revolving platform so that I can spin it around while working. There can be 2,000 to 3,000 lines, or more than two miles of lines in one drawing.

Nov. 9. 2007, 2007. Ink on paper, 30" x 30". *Courtesy of Anne Reed Gallery.* My goal is to execute a specific sequence or algorithm of radius structures. In doing so the process reveals unique and unpredictable interference and moiré patterns. My work is an exercise in precision, consistency, and the implementation of a system.

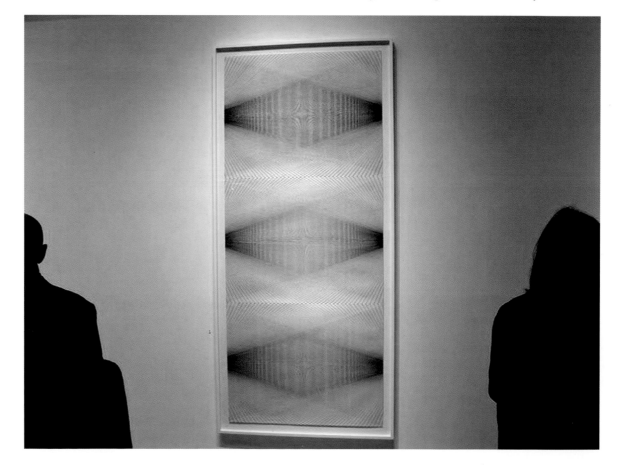

Nov. 20. 2007, 2007. Ink on paper, 30" x 38". *Courtesy of Anne Reed Gallery.*

Alex Zecca

Galleries Mentioned in the Text

Acuna-Hawsen Gallery
Los Angeles, California
206-624-0770
ahgallery.com

A Gallery Fine Arts
Palm Desert, California
760-346-8885
agalleryfineart.com

American Primitive Gallery
New York, New York
212-966-1530
americanprivitive.com

Ames Gallery
Berkeley, California
510-845-4949
amesgallery.com

Anne Reed Gallery
Ketchum, Idaho
208-726-3036
annereedgallery.com

Art Expressions Gallery
San Diego, California
858-270-7577
artexpressionsgallery.com

Artworks Gallery
Vancouver, BC Canada
604-688-3301
artworksbc.com

Augen Gallery
Portland, Oregon
503-224-8182
augengallery.com

Bau-Xi Gallery
Vancouver, BC Canada
604-733-7011
bau-xi.com

Benham Gallery
Seattle, Washington
206-622-2480
benhamgallery.com

Bernard Jacobson Gallery
London, England
0207-734-3431
jacobsongallery.com

Bingham Gallery
binghamgallery.com

Braunstein/Quay Gallery
San Francisco California
415-278-9850
braunsteinquay.com

Bryan Ohno Gallery
Scattle, Washington

206-459-6857
bryanohnogallery.com

b. sakato garo
Sacramento, California
916-447-4276
bsakatagaro.com

Carl Schlosberg Fine Art
Los Angeles, California
310-556-5430
malibusculpture2005.com

Carmel Art Association
Carmel California
carmelart.org

Charles Cowles
New York, New York
212-741-8999
cowlesgallery.com

Circa Gallery
Minneapolis, Minncsota
612-332-2386
circagallery.org

The Churchill Gallery
Newburyport, Massachusetts
978-462-9891
churchillgallery.com

Coda Gallery
Palm Desert, California
760-346-4661
codagallery.com

Crown Point Press
San Francisco. California
415-974-6273
crownpoint.com

The Dennis Morgan Gallery
Kansas City, Missouri
816-842-8755

Dennis Rae Fine Art
San Francisco, California
415-292-0387
dennisraefineart.com

Derek Eller Gallery
New York, New York
212-206-6411
derekeller.com

Desert Art Collection
Palm Desert, California
760-674-9955
desertartcollection.com

Dolby Chadwick Gallery
San Francisco California
415-956-3560
dolbychadwickgallery.com

Donna Seager Gallery
San Rafael, California
415-454-4229
donnaseagergallery.com

Dragon Fire Gallery
Cannon Beach, Oregon
503-436-1533
dragonfirestudio.com

Edward Thorpe Gallery
New York, New York
212-691-6565
edwardthorpegallery.com

Edenhurst Gallery
Palm Desert, California
760-346-7900
edenhurstgallery.com

Elizabeth Leach Gallery
Portland, Oregon
503-224-0521
elizabethleach.com

E.S. Lawrence Gallery
Aspen, Colorado
800-646-9504
eslawrence.com

Fairmont Gallery
fairmontgallery.com

Frank Lloyd Gallery
Santa Monica, California
310-264-3866
franklloyd.com

Foster White Gallery
Seattle Washington
206-622-2833
fosterwhite.com

Four Star Gallery
Indianapolis, Indiana
317-686-6382
4stargallery.com

Freed Gallery
Lincoln City, Oregon
514-994-5600
freedgallery.com

Fountainhead Gallery
Seattle, Washington
206-285-4467
fountainheadgallery.com

Gail Severn Gallery
North Ketchum, Idaho
208-726-5079
gailseverngallery.com

Galerie Lefor Openo
Paris, France

01 46 33 87 24
leforopeno.com

Gallery 16
San Francisco, California
415-626-7495
gallery16.com

Gallery 110
Seattle, Washington
206-624-9336
gallery110.com

Gallery 322
Seattle, Washington
206-478-1187
gallery322.com

Gallery Henoch
New York, New York
917-305-0003
galleryhenoch.com

George Billis Gallery
New York, New York
212-645-2621
georgebillisgallery.com

Gerald Peters Gallery
Santa Fe, New Mexico
505-954-5700
gpgalery.com

G. Gibson Gallery
Seattle, Washington
206-587-4033
ggibsongallery.com

Greg Kucera Gallery
Seattle, Washington
206-624-0770
gregkuceragallery.com

Grover/Thurston Gallery
Seattle, Washington
206-223-0816
groverthurston.com

Herringer Kiss Gallery
Calgary AB Canada
403-228-4889
herringkissgallery.com

Hespe Gallery
San Francisco. California
415-776-5918
hespe.com

Hauk Fine Arts
Pacific Grove, California
831-373-6007
haukfinearts.com

Imago Gallery
Palm Desert, California

760-776-9890
imagogalleries.com

Jacobson Howard Gallery
New York New York
212-570-2363
jacobsonhoward.com

Jancar Gallery
Los Angeles, California
213-625-2522
jancargallery.com

J. Cacciola Gallery
New York, New York
212-462-4556
jcacciolagallery.com

John Berggruen Gallery
San Francisco, California
415-781-4629
berggruen.com

Kingston Art Gallery
Kingston, Washington
360-297-5133
kingstonartgallery.com

Knowlton Gallery
Lodi, California
209-368-5123
knowltongallery.com

Lanning Gallery
Sedona, Arizona
928-282-6865
lanninggallery.com

Laura Russo Gallery
Portland, Oregon
503-226-2754
laurarusso.com

Lesa Johnson Gallery
Lafayette, California
925-962-0980

Leslie Levy Fine Art
Scottsdale, Arizona
480-947-2925
www.leslielevy.com

Lisa Harris Gallery
Seattle, Washington
206-443-3315
lisaharrisgallery.com

Logan Fine Arts
Houston, Texas
713-781-2402
loganfinearts.com

Lucia Douglas Gallery
Bellingham, Washington
360-733-5361
luciadouglas.com

Lyons Head Gallery
Carmel Valley, California

831-659-4192
lyonshead.com

Martinos Interiors
Los Gatos, California
408-354-9111
martinosinteriors.com

Mason Murer Fine Art
Atlanta, Georgia
404-879-1500
masonmurer.com

Meyer Gallery
Park City, Utah
800-649-8180
www.meyergallery.com

Miami Art Group
Miami, Florida
305-576-2633
miamiartgroup.com

Morgan Lehman Gallery
New York, New York
212.268.6699
morganlehmangallery.com

Nancy Dodds Gallery
Carmel, California
831-624-0346
nancydoddsgallery.com

Oregon Society of Artists
Portland Oregon
John Reece , President
oregonsocietyofartists.com

Orlando Gallery
Tarzana, California
empken.com/Orlando/html

Paulson Press
Berkeley, California
510-559-2088
paulsonpress.com

Pete Mendenhall Gallery
Los Angeles, California
323-936-0061
petermendenhallgallery.com

Peter Miller Gallery
Chicago, Illinois
312-951-1700
petermillergallery.com

PDX Contemporary Art
Portland Oregon
503-222-0063
pdxcontemporaryart.com

Portland Art Museum Gallery
Portland Oregon
503-224-0674
portlandartmuseum.org

Principle Gallery
Alexandria, Virginia

703-739-9326
principlegallery.com

**Rental Sales Gallery of
the Portland Art Museum**
Portland Oregon
503-224-0674
portlandartmuseum.org/visit/
rsg/

Rogers Gardens Fine Art Gallery
Corona del Mar, California
949-640-5800
rogersgardens.com

Ruth Bachofner Gallery
Santa Monica, California
310-829-3300
ruthbachofnergallery.com

Sardella Fine Art
Aspen, Colorado
970-925-9044
sardellafineart.com

Scott Milo Gallery
Anacortes, Washington
360-293-6938
scottmilo.com

**Scott White Contemporary
Art**
San Diego, California
619-501-5689
scottwhiteart.com

Selby Fleetwood Gallery
Santa Fe New Mixico
505-992-8877
selbyfleetwoodgallery.com

Skinner / Howard Contemporary Art
Sacramento, California
916-446-1786
pamelaskinnergallery.com

Smith Andersen Editions
Palo Alto, California
650-327-7762
smithandersen.com

Spanierman Gallery
New York, New York
212-882-0208
spanierman.com

Studio 7 Gallery
Laguna Beach, California
949-497-1080
studio7gallery.com

Sue Greenwood Fine Art
Laguna Beach California
949-494-0669
suegreenwoodfineart.com

**Sullivan Goss, An American
Gallery**
Santa Barbara, California
805-730-1460
sullivangoss.com

Susan Street Fine Art Gallery
Solana Beach, California
858-793-4442
susanstreetfineart.com

Susan Woltz Gallery
Seattle, Washington
206-652-4414
swoltzgallery.com

Swarm Gallery
Oakland, California
510-839-2787 (ARTS)
swarmgallery.com

Tag Gallery
Santa Monica, California
310-829-9556
tagartgallery.net

Tanner Hill Gallery
Chattanooga, Tennessee
423-280-7182
tannerhillgallery.com

Tirage Gallery
Pasadena, California
626-405-1020
www.tirageart.com

Vail Village Arts
Vail, Colorado
970-476-2070
vickerscollection.com

Vickers Collection
Beaver Creek, Colorado
970-845-7487
vickerscollection.com

**Villas & Verandas Fine Art
Gallery**
Capistrano, California
949-493-7200
villasandvarandas.com

Wallace Galleries
Alberta Canada
403-262-8050
wallacegalleries.com

Index and Artist Resource Guide

Angell, Tony
www.tonyangell.net
pages 6, 7

Batty, Theresa
pages 14, 15

Aoki, Kathy
www.kaoki.com
pages 8, 9

Baumgartner, Caryn
pages 16, 17

Ball, Laura
www.laurasgallery.com
pages 10, 11

Bell, Larry
www.larrybell.com
pages 18, 19

*Photo by Anthony Friedkin, Courtesy
of the Frank Lloyd Gallery.*

Barnes, Ursula
pages 12, 13

Blackwell, Evan
www.evablackwell.
com
pages 20-24

Bonifacho, Bratsa
www.bonifacho-art.
com
pages 24, 25

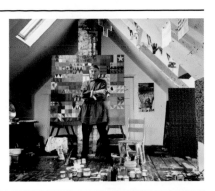

Brubaker, Joe
pages 34, 35

Bortolazzo, Ken
pages 26, 27

Brunswick, Michael
www.michaelbrunswick.
com
pages 36, 37

Bourdette, Christine
www.christinebourdette.com
pages 28, 29

Burnham, Drew
pages 38, 39

Brock, Joel
pages 30, 31

Carnwath, Squeak
www.squeakcarnwath.com
pages 40, 41

Brown, Christopher
pages 32, 33

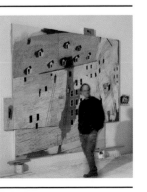

Chang, Warren
www.warrenchang.com
pages 42, 43

Cherchi, Giuseppe "Pino"

Christensen, Linda
www.lindachristensen.net

Cooke, Judy

Cramer, Tom

Photo by Gus Van Sant

Crooks, William Glen

Daly, Drew

Deane, Gregory
www.gregorydeane.com

Dillon, Sarah

Filla, Stephen
www.stephenfilla.com

Foggitt, Simona
www.simonafoggitt.com

Florek, Karen
www.karenflorek.com
pages 64, 65

Gormally Studios, Tom
www.tomgormally.com
pages 74, 75

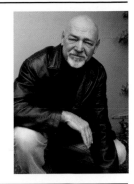

Frederick, Robilee
pages 66, 67

Gregory, Michael
pages 76, 77

Freifeld, Mitch
www.mitchellf.com
pages 68, 69

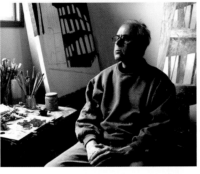

Hall, Michael
www.michael-
hallpaintings.
com
pages 78, 79

Gates, Jane Schwartz
pages 70, 71

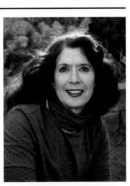

Hall, Robin
www.robinhall.com
pages 80, 81

Goldberg, Joseph
pages 72, 73

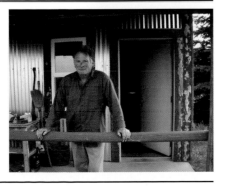

Harlow, Robin
www.harlowgallery.com
pages 82, 83

Haven, Victoria
www.vichaven.com
pages 84, 85

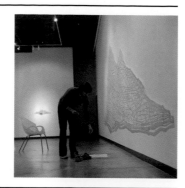

Hoff, Terry
www.terryhoff.net
pages 86, 87

Huston, Katina
www.katinahuston.com
pages 88, 89

Photo by Janet Delaney

Hutter, Richard
www.richardhutter.com
pages 90, 91

Isaksen, Eva
www.evaisaksen.com
pages 92, 93

Kauffman, Craig
pages 94, 95

Courtesy of the Frank Lloyd Gallery

Kean, Katherine
www.katherinekean.com
pages 96, 97

Kelly, Lee
pages 98, 99

Kosuge, Michihiro
pages 100, 101

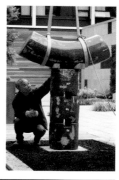

Laky, Gyöngy
www.gyongylaky.
com
pages 102, 103

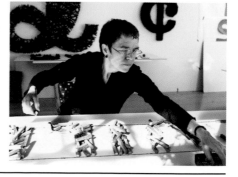

218

Lord, Carolyn
www.lordanglin.com
pages 104-107

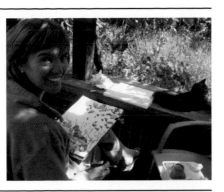

Mason, John
pages 116, 117

*Photo by Anthony Cuñha, Courtesy
of the Frank Lloyd Gallery.*

Mahaffey, Rae
www.mahaffeyfineart.com
pages 108, 109

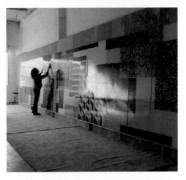

McConnell, Michael
www.poopingrabbit.com
pages 118, 119

Maki, Ann
www.finnhillfiberarts.
com
pages 110, 111

McCorkle, Mery Lynn
pages 120, 121

Maley, Sharon
pages 112, 113

McKinley, Tom
pages 122, 123

Mason, Alden
pages 114, 115

Medow, Cheryl
www.cherylmedow.com
pages 124-127

Morioka, Aiko
www.aikomorioka.com
pages 128, 129

Morris, Ann
www.annmorrisbronze.com
pages 130, 131

Moses, Ed
pages 132, 133

Photo by Vicki Phung, 2008

Mower-Conner, Pamela
www.pamelamower-conner.com
pages 134, 135

Munakata, Grace
www.gracemunakata.com
pages 136, 137

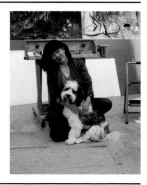

Nealy, Gordon
www.ArtOperations.com
pages 138, 139

Nebeker, Royal
pages 140, 141

Ness, Glenn
www.glennnness.com
pages 142, 143

Palagyi, Enzo
www.enzopalagyi.com
pages 144, 145

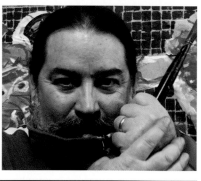

Parker, Lucinda
pages 146, 147

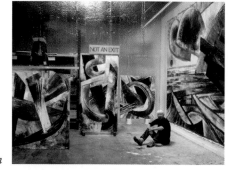

Photo by Jim Lommasson

Parvin
artofparvin.blogspot.com
pages 148, 149

Pratchenko, Paul
pages 158, 159

Peters, Tony
www.tonypetersart.
com
pages 150, 151

*Looking Inward, 2008. Oil on canvas, 36" x 48".
Exhibited: Pasadena Museum of California Art,
California Art Club's 98th Annual Gold Medal
juried exhibition. One of two large new paint-
ings of mine, both inspired by a quote by the
famous psychologist and author, Carl Jung...
"Your vision will become clear only when you look
into your heart. Who looks outside, dreams. Who
looks inside, awakens."*

Raybould, Barry John
www.BJRgallery.com
pages 160, 161

Petersen, Aaron
www.aaronpetersenart.com
pages 152, 153

Reilly, Chris
pages 162, 163

Petterson, Andre
pages 154, 155

Robinson, Will
pages 164, 165

Powell, Pamela
pages 156, 157

Roski, Gayle Garner
www.gaylegarnerroski.com
pages 166, 167

Ruddell, Gary
pages 168, 169

Solcyk, Phyllis
www.PhyllisSolcyk.com
pages 178, 179

Saxe, Adrian
pages 170, 171

Photo by Lloyd Solly

Stephens, Alice Wanke
www.alicewankestephens.
com
pages 180, 181

Shire, Peter
pages 172, 173

Photo by Allan Amato

Tait, Sylvia
pages 182, 183

Simons, Barry
pages 174, 175

Tarzier, Carol
www.tarzier.com
pages 184, 185

Smith, Mark R.
pages 176, 177

Tennis, Whiting
pages 186, 187

Thurston, Joe
pages 188, 189

Webb, Dan
www.danwebbart.com
pages 198, 199

Turner, Bonese Collins
www.bonesecol-linsturner.com
pages 190, 191

Wiley, William T.
www.williamtwiley.com
pages 200, 201

Turner, Li
pages 192, 193

Wolf, Sherrie
pages 202, 203

Turrell, Terry
pages 194, 195

Wood, Thomas
www.artgallerywest.com/wood/
index.html
pages 204, 205

Vexler, Paul
www.paulvexler.com
pages 196, 197

Yee, Darlyn Susan
www.darlynsusanyee.com
pages 206, 207

Yeomans, Jeffery
www.jeffyeomans.com

Zecca, Alex
www.alexzecca.
com